The Complete
Watercolor Course

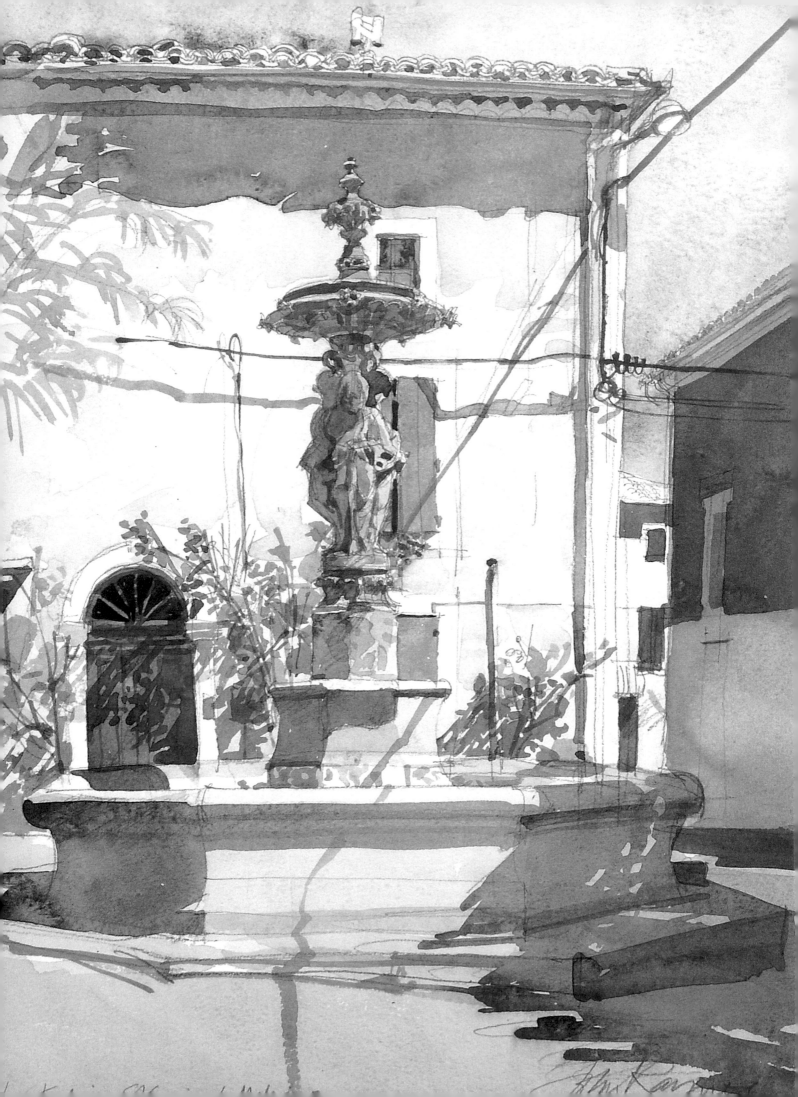

The Complete
Watercolor Course

A comprehensive, easy-to-follow guide to watercolor

JOHN RAYNES

COLLINS & BROWN

First published in Great Britain in 2004 by
Collins & Brown Ltd
An imprint of Chrysalis Books Group plc
The Chrysalis Building
Bramley Road
London W10 6SP

An imprint of **Chrysalis** Books Group plc

Project Manager: Sarah Hoggett
Designer: Roger Daniels

10 9 8 7 6 5 4 3 2 1

British Library Cataloguing-in-Publication Data:
A catalogue record for this title is available from
the British Library.

ISBN 1–84340–008–1 (hb)

Reproduced by Classicscan Pte Ltd
Printed and bound in Malaysia by Times Offset

Contents

Watercolor is an ancient medium, much older than oil paint. From cave paintings and Egyptian wall paintings, through Chinese, Japanese, and Indian paintings on rice or silk paper to illuminated manuscripts and Renaissance frescoes, water, bound with gum arabic, wax, or the yolk of eggs, was the universal medium.

But in Europe by about the year 1700, watercolor as an art form had been largely forgotten, so dominant had oil painting become. In the sense that I use the term in this book and as it is now usually understood and accepted, watercolor began—or perhaps we should say was rediscovered—in England in the early 1700s.

A uniquely English school of painting was led by Thomas Girtin, John Sell Cotman, and J.M.W. Turner. I do not mean to suggest that these three worked together, although Turner and Girtin did study together for a while when they were training as topographical artists. What united them was a love of real landscape, as opposed to the romanticized or formal views that had previously prevailed, and they used clear, transparent watercolor to express real atmosphere and light. Despite this shared enthusiasm for a new natural vision, their styles were very different and Turner and Cotman were destined to achieve greater fame than Girtin.

Turner's approach was dramatic and increasingly centered on the depiction of light above all else. Cotman was a much quieter talent, his technique more controlled and calm. Although posterity has confirmed Turner as the more original and important of the two, perhaps even the greatest ever English artist, it was Cotman's technique of overlaying successive layers of flat, translucent washes that was to become accepted as the traditional western style of watercolor painting.

During the rest of the eighteenth century and into the nineteenth, the interest in watercolor proliferated and in 1866 the American Water Color Society was formed in New York, following the styles prevalent at

"GRETA BRIDGE" BY JOHN SELL COTMAN Painted in 1806, this watercolor is a splendid example of the distinctive Cotman style. Wonderfully complex tones and hues have been built up by overlaying many washes in simple, flat shapes with crisp outlines.

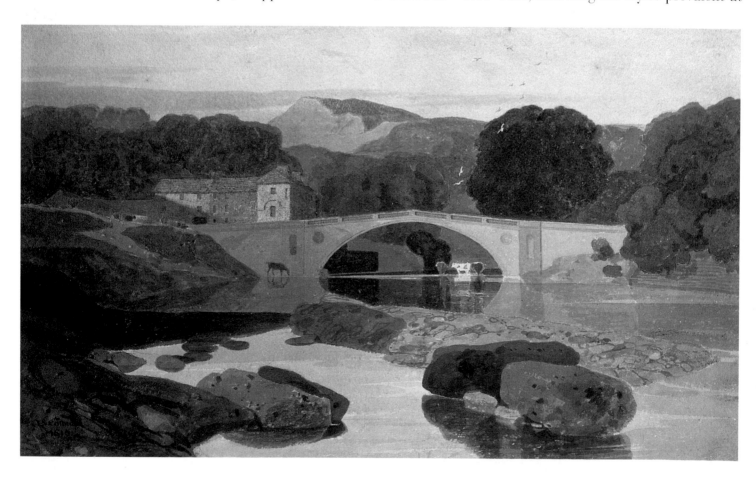

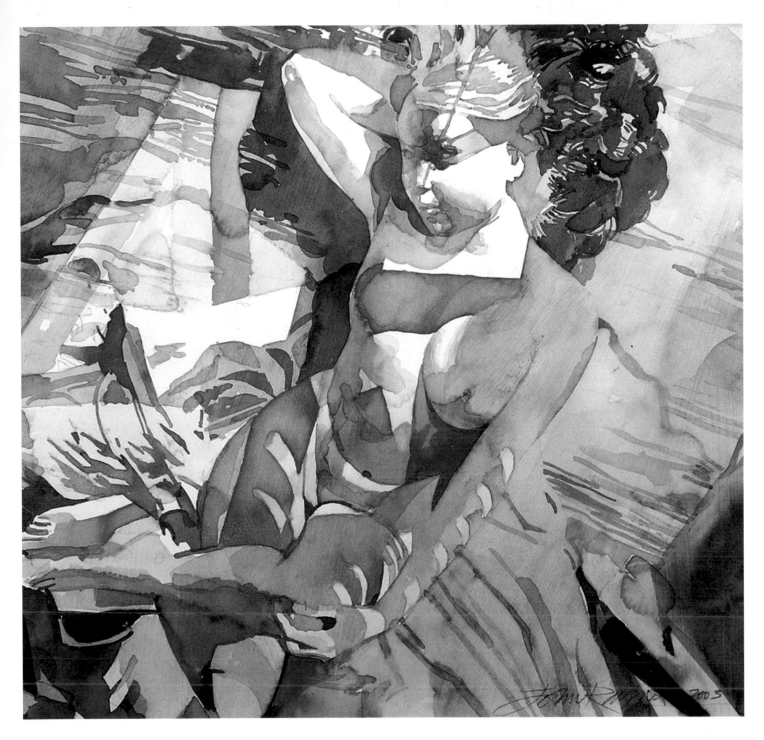

the time in England. Later in the century the American artists Winslow Homer and John Singer Sargent came into their own with their idiosyncratic and brilliant use of watercolor as a medium.

In the twentieth century probably the most known and revered exponent of watercolor painting in the US has been Andrew Wyeth, who combines wonderfully free washes with meticulous dry brushwork.

It is to these masters that I aspire when offering this treatise on the craft and practice of watercolor.

What's special about watercolor

If one attempts to define what is special about watercolor, the one factor above all others that separates it from other paint media is its luminosity.

In watercolor paintings that exploit this quality, color is applied in washes. Since this is a term that will be used constantly throughout this book I shall try to describe what it means.

A wash is a mixture of pigment and a quantity of water. It may range from being almost clear to being quite densely colored.

PATTERNS OF LIGHT 1

This is number one in a series of four paintings in which I explored the effects of projecting patterns onto the figure. Colors interchanged freely to produce patterns that both disguised and revealed the forms of the figures.

However strongly colored it is, it will still be composed mostly of water—the most important point being that, however pale or strong the pigmentation of any wash, it should always be of a consistency that will allow it to be floated onto the paper surface. If its consistency requires it to be dragged or stippled on, or anything other than floated on, it is not a wash.

A wash can be allowed to flow over the paper surface, staining as it flows, or it can be allowed to stay where it has been placed, the water gradually evaporating to leave the pigment. Color applied in the form of a wash will always be transparent or nearly so.

To make a painting utilizing washes generally means starting with relatively pale mixes that are made up of lots of water and very little pigment, waiting for the first washes to dry, and then overlaying them with other washes so that the total amount of pigment in the combined layers of color gradually increases.

Light penetrates the layers of transparent color washes, bounces off the white base, and rebounds into the viewer's eye seemingly as color illuminated from within. Even the darkest tones retain this translucent quality, composed as they are of many successive layers of wash, each precluding a little more reflected light but never actually cutting it off entirely. It is not unheard of for these darker tones to be a result of ten or more successive layers of wash.

So you can see that the process of making a traditional watercolor painting is essentially one of progressing from light to dark. You start with the white of the paper and progressively add more and more washes. Once any passage becomes too dark it has to stay that way; you can't go back. (Of course, as with all generalizations, that's not strictly true; there are ways of recovering a watercolor that has become too dark, some more radical than others, but as a general rule such manipulations are best avoided.)

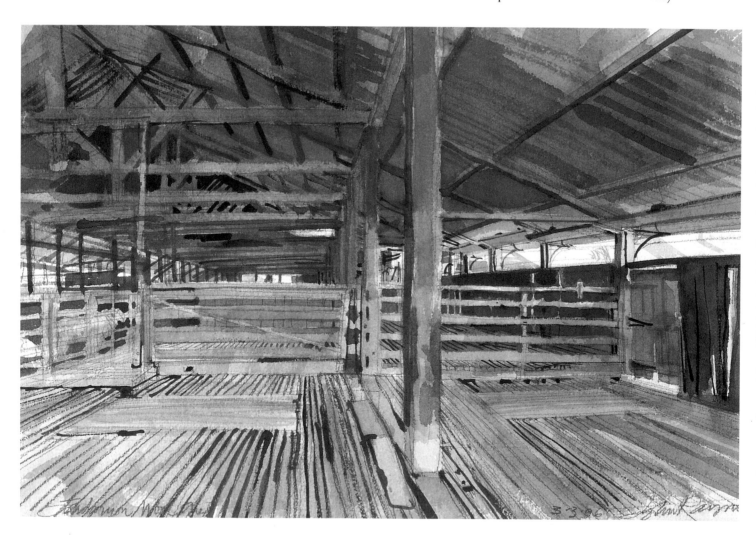

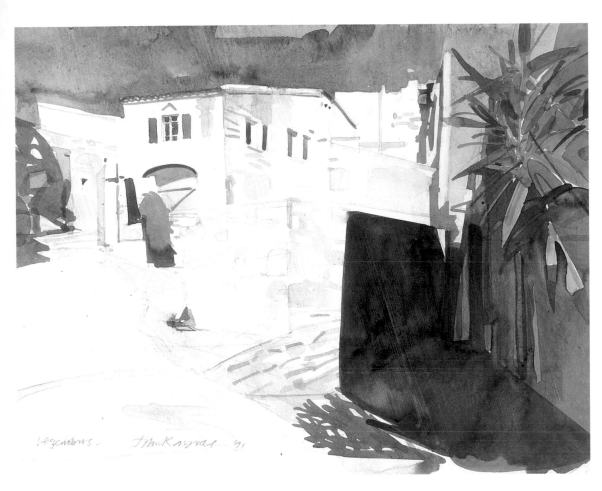

VEZENOBRES,
SOUTH OF FRANCE
Pattern of a different
kind was the principal
interest here—the
pattern of light and
shade. The combination
of areas of deep shade
and powerful sunlight
on light-colored
stonework produces
immensely strong tonal
contrasts, which impart
an abstract quality to
the streets in this
beautiful old hill town.

As with all painting methods, there are no
hard-and-fast rules—if there are, they are
made to be broken—but I think it is helpful
to know something of how other artists have
exploited watercolor's unique characteristics.
Whenever you get the chance, examine the
paintings of the acknowledged masters of
watercolor. You will gain something from
good reproductions, but much more from
looking at originals, and will undoubtedly
glean insights that you can exploit in your
own paintings.

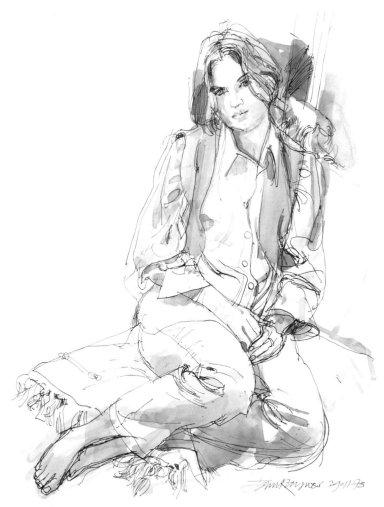

SEATED GIRL
The technique used to
create this image is
best described as "line
and wash," most of the
description of the pose
and the clothing being
imparted by the use of
pen line, with the wash
merely performing a
supporting role.

How to get the best out of watercolor

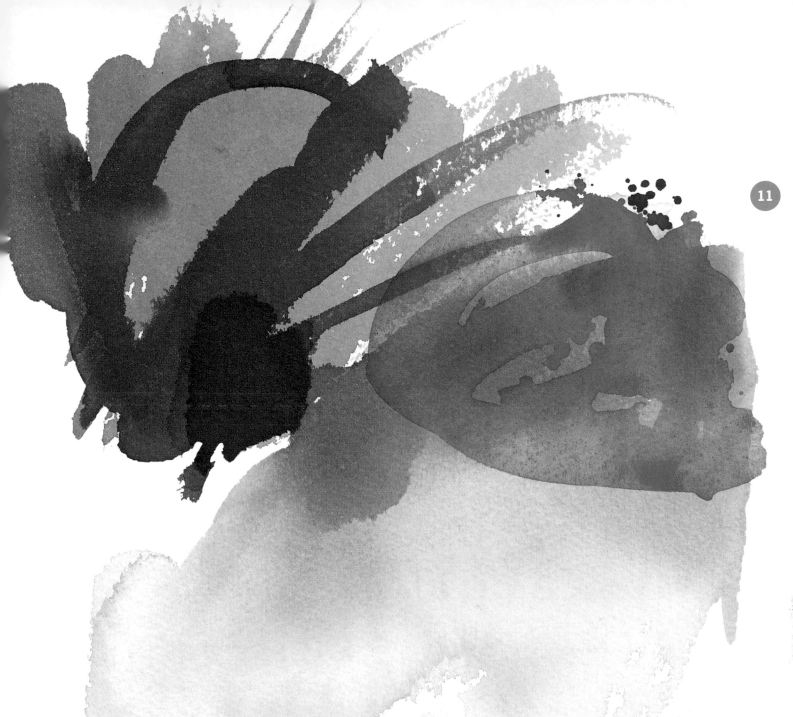

From the forgoing introduction, you will have realized that the unique quality of watercolor—its transparency—is dependent on a particular technique. You might say that this applies equally to all media, but in the case of what I have called the traditional manner of watercolor painting (which is what I intend to concentrate on) it is rather more critical.

For this reason I have devoted the first part of this book to materials and the various methods of using them. You will find suggestions for the range of paints that you will need to make watercolor washes, the brushes with which to apply them, and the surfaces on which you can paint.

I will also describe techniques to enable you to make the best use of these materials, along with a range of exercises for you to try out. There are exercises in applying washes in various ways and in judging how colors register as tones, as well as on using masks and resists and on creating textures in your work.

Because, when describing the effects of overlaid color washes, we need to use terms such as color temperature, complementary and primary hues, tertiary mixes and so on, I have included a section on the theory of color.

As I have said, the main thrust of my remarks and advice is toward making paintings using transparent washes, but there is also some instruction in the use of body color—that is, color in which water is the principal medium but washes are opaque, as well as (or rather than) transparent.

Paints

In order to make the best use of the special luminosity that watercolor can offer, you need to have good-quality materials. The first requirement is paint made from first-class pigments.

POCKET PAINTBOX
I mostly use a paintbox that contains 24 whole pans of pigment and has depressions in the lid for mixing large washes and a fold-out area for small ones—but this neat little pocket version, with 12 half-pans and its own water container, is good for making quick watercolor sketches outdoors.

Weakly pigmented paints or paints that are too full of things other than pigment, such as substances that are designed to increase shelf life, are no good. You should, therefore, choose good-quality paints from respected manufacturers. Artists' quality paints are always better than student colors. They are more expensive, but it is better to invest in a few good-quality colors than a huge range of inferior ones. That is not to say that it is impossible to fine good colors at cheaper prices: they do exist—but you may have to try out a lot of inferior paints before you discover them.

The durability of pigments is something else that you need to consider with all watercolors,

and most good manufacturers mark their paints with some indication of their degree of permanence. Beware of buying colors that have the word "lake" in their title: they will be composed of an inert stained powder rather than a real pigment. Also avoid colors with titles that end with the word "hue:" this just means they are approximating to the pigment color named.

If you are in any doubt about the durability of a color, the following test will help. Apply a strong swathe of the color to a piece of white paper, cover part of it with black paper, and leave it exposed to sunlight for a week or two. When you reveal the part protected by the black paper, it will immediately be obvious if the color is likely to fade. However, no color is 100 percent light fast and it is always best to hang watercolor paintings out of direct sunlight.

Pans or tubes?

An early choice that you have to make is between watercolors in tubes and watercolors in pans. The advantage of tubes is that paint freshly squeezed out is unsullied by accidental

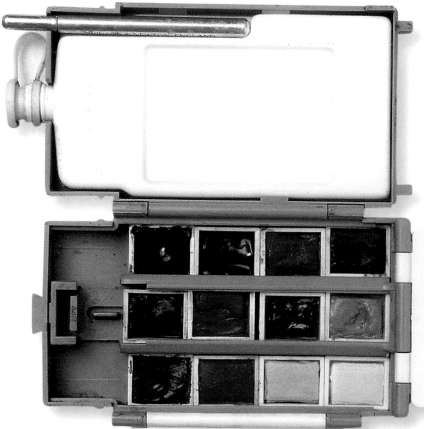

mixing with neighboring colors and has the ideal soft consistency for mixing readily with water. The disadvantage is that paint has to be chosen, squeezed onto a palette, and replenished as needed. It should not be left too long on the palette, as it does not mix so easily when dry.

Pans, on the other hand, are instantly available, your whole range visible and ready to be mixed with water to make washes. One disadvantage of pans is that they must be maintained at a consistency that allows the pigment to be picked up easily by the brush. Again, good-quality colors can be expected to remain malleable, while poor ones dry out and shrink. Another disadvantage is that adjacent colors can run together somewhat; for this reason, whole pans are preferable to half pans.

The kind of watercolors you use really is a matter of personal preference. I personally choose to use pans—principally, I think, because I am not disciplined enough to put the brush down, reach for the appropriate tube, and replenish a color when I need it; it simply seems to slow me down.

Having made the choice between pans and tubes, you now have to decide on a box or range of paints. Ideally, your paintbox should contain the paints and also provide some palette areas for mixing, including two or three deep wells for larger washes—although you can always buy palettes separately if needed, or even improvize by using white china plates and dishes.

Liquid watercolors

There are literally hundreds of colors available from various manufacturers and not just in tubes and pans: watercolors also come in liquid form. Liquid watercolors are often liable to be fugitive, which means that they fade or darken quickly when they are exposed to light. When you need a special brightness in what may need to be quite a watery, light-toned wash, a concentrated liquid watercolor may be the only pigment that will provide it—but you must check that it is reasonably permanent.

WATERCOLOR TUBES
A china palette, with separate wells, is ideal for squeezing out and mixing tube colors.

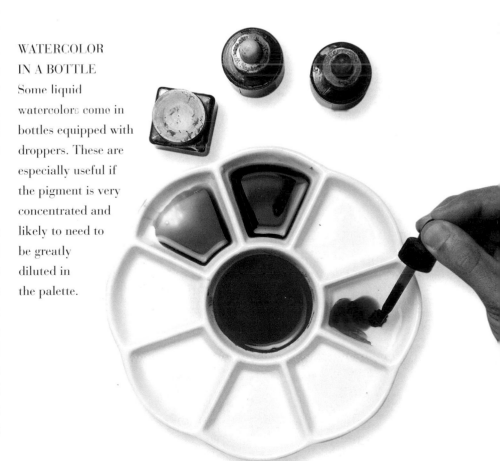

WATERCOLOR
IN A BOTTLE
Some liquid watercolors come in bottles equipped with droppers. These are especially useful if the pigment is very concentrated and likely to need to be greatly diluted in the palette.

Choosing your colors

You do not need to have a large range of colors—particularly if you're just starting out in watercolor. Some painters even go so far as to limit themselves to a range of perhaps only four or five, claiming that good harmonies result from a limited palette; this may be so, and if you find it suits your way of working, then I would not argue against it. However, if you want to be able to match any color that you see, you will need just a few more colors than that—perhaps a minimum of eight colors.

Starting from the red end of the spectrum, in order to match cool, clear pinks you will need a red that has no hint of orange in it, such as Magenta or Permanent Rose. For a more general-purpose red, Vermilion is good. Then you will need a yellow, and it is best to have two—a mid-yellow such as Cadmium Yellow, and a Lemon Yellow, which is cooler and greenish. There is only one essential green—a bluish one such as Viridian or Phthalocyanine Green. All other greens can be mixed by the addition of small amounts of yellow and/or black.

It is difficult to manage with less than two blues—one greenish, such as Prussian Blue or Phthalocyanine Blue, and one nearer to mauve, such as Ultramarine Blue. You will need the latter in order to mix violets and purples.

Lastly, the controversial black. I prefer Lamp Black, which does not have the slightly warm tinge of Ivory Black. There are many people who consider black to be a non-color and would ban it from any palette, but my argument for including it even in a list of minimum requirements is that it provides a wonderfully quick means of modifying clear primary colors into rich olives, burnt oranges, browns, and so on. Of course, it must be used with discretion: too much black can easily overpower and muddy the essential clarity of a watercolor.

So those are my recommended minimum eight pigments.

But you don't have to limit yourself to this short list. Many of the colors referred to above that can be obtained by small additions of black already exist as the earth pigments—Raw and Burnt Umber, Raw and Burnt

SUGGESTED BASIC PALETTE
Clockwise from top left:
Viridian or Phthalocyanine Green, Prussian or Phthalocyanine Blue, Ultramarine Blue, Lamp Black, Lemon Yellow, Cadmium Yellow, Vermilion, Magenta or Permanent Rose.

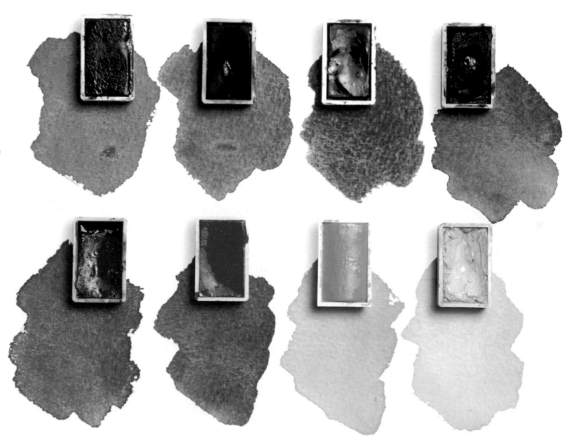

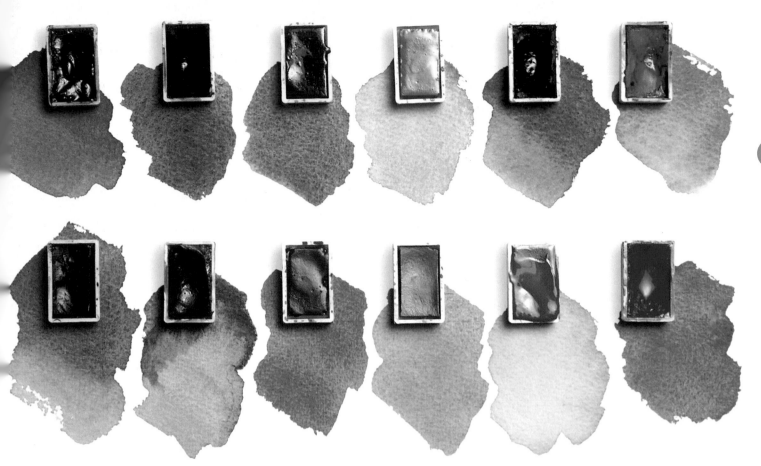

Sienna. They are inexpensive, permanent, and can be used as they are or to further modify other brighter colors.

Gamboge is a useful yellow. Having an orange in your palette saves you having to do too much mixing of yellow and red and is also often brighter than you can mix. Cadmium Orange is good but expensive; Chrome Orange is a cheaper alternative.

I find Cobalt Blue and Cerulean to be useful additions to the blue range and it is nice to have a good strong violet such as Cobalt Violet (expensive) or Quinacridone violet (a cheaper, modern pigment).

As I have said, all the greens can be easily mixed from the one basic Viridian, but some artists like to have a couple more proprietary greens to hand. Hooker's Green and Sap Green are both quite popular.

I usually include Indigo or Payne's Gray in my range, as the dark blackish-blue shade can be useful as a basis for cast shadows.

If you added to your basic palette all the last colors mentioned, you would have twenty colors—and that should certainly be more than enough to enable you to mix almost

anything you might need, both quickly and easily.

Of course, there are many more colors than these to be found in the catalogs of paint manufacturers; in fact, the range can be quite intimidating. The temptation to try them all can be difficult to resist, and if any color really appeals to you, then by all means add it to your collection—but be careful not to make your range so large that it becomes unwieldy.

My guiding principle is that you should try to arrive at a palette of colors that will enable you to match any color that you encounter, and to do this as conveniently and as simply as possible. You need to strike a balance between the simplicity of a small palette, which may require you to spend more time mixing colors, and a large, perhaps cumbersome, one from which many colors can be dispensed without mixing.

As you progress you may find that, as a result of your personal style and the kind of subjects that you enjoy painting, you may not use some of the colors in my suggested list. That's fine: the range that works for you is the one to use.

SUGGESTED EXTENDED PALETTE

Clockwise from top left: Indigo or Payne's Gray, Cobalt Violet or Quinacridone Violet, Cobalt Blue, Cerulean Blue, Hooker's Green, Sap Green, Cadmium Orange or Chrome Orange, Gamboge, Raw Sienna, Burnt Sienna, Raw Umber, Burnt Umber.

Opaque watercolor

Not all watercolor paintings are made solely by overlaying transparent washes. Watercolors can be used as opaque paints in a similar manner to oil paints by exploiting the totally different characteristics that opacity confers. Special paints are made which are variations on what I have been referring to as "traditional" watercolor painting.

White pigment is, by definition, opaque. If it is introduced into a watercolor painting, then you can lay a light color on top of a dark one. In other words, the usual order can be reversed —lost light areas can be recovered. Admixing white with other colors will render them opaque, too, so that the painting becomes very different—one in which light areas may be built up with thicker and thicker paint. Such a painting may be richly textured and colorful, but it will have sacrificed the transparent luminosity of traditional washes.

Paints intended to be used in this way are specially manufactured and are known as body color or gouache. Body color or gouache is normally sold in 14 and 37ml tubes although white, which is used more liberally than other colors, is available in larger tubes and also in pots.

Exhibitions of watercolors generally accept gouache and body color paintings and sometimes even acrylic paintings, too. The problem is that if solubility with water is the criterion of whether a paint is watercolor or not, it becomes difficult to draw a line anywhere: even oil color is available in water-soluble form! For these reasons, I intend in this book to concentrate on the use of transparent washes with only brief excursions into some body color additions and admixtures.

The point to remember is that the term body color is really almost more descriptive of a method than of a type of paint. Gouache, acrylic paints, even oil paints, although they are not designed to be used in this way, could be manipulated to simulate the transparent "watercolor" method and true watercolors can be transformed into body color by mixing them with white.

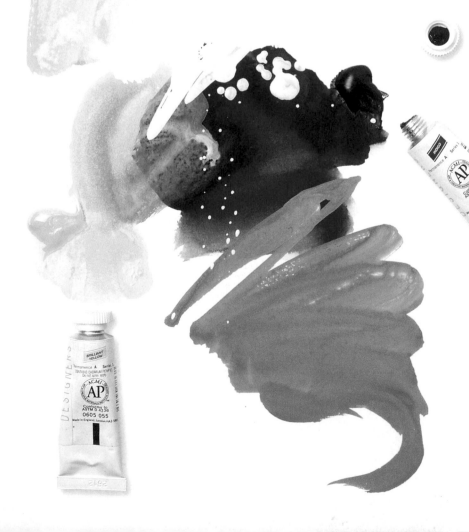

GOUACHE OR BODY COLOR
Some body colors are more opaque than others. Depending on their opacity and how on thick the color is mixed, they can be overlaid either to modify the layers beneath or to obliterate them completely.

Surfaces

Watercolor paintings can be made on almost any appropriately prepared surface: ivory has been used, as have silk and other fabrics and wood panels prepared with a special ground, but the most commonly used surface is paper of one type or another.

Papers specially manufactured for watercolor painting are available in three types of surface finish. The smoothest is hot-pressed—so called because it is pressed between sheets of metal during manufacture. Slightly smoother is NOT surface, so called because it has not been hot pressed. The most heavily textured paper is called rough surface, which is dried between rough sheets of felt without pressing.

Rough paper is probably the easiest surface on which to apply flat or evenly gradated washes. By tipping the surface back and forth,

PAPER SURFACES
Here you can see the three types of paper surface and the kind of marks you make expect to make on them.
From the top:
Hot-pressed, NOT (that is, not hot pressed), and rough.

washes can be persuaded to deposit pigment in the miniature depressions and create attractive dappled textures.

NOT surface papers, although not as heavily textured as rough surface, are not completely smooth and they accept washes nearly as well; some people would say just as well, but there is a subtle difference and it is very much a matter of personal preference. My feeling is that washes are not quite so luxurious on NOT surface as on rough.

Hot-pressed (often abbreviated to HP) surfaces are very different. Washes float about without penetrating the smooth surface and may dry unevenly. It is often possible to modify color or even lift it off with a brush and clean water. It is much harder to achieve flat washes over large areas on HP surfaces.

All finishes are usually available in a few pale colors, but I prefer not to use them as they take away your ability to render a true white except by adding body color.

All these papers are made in a variety of thicknesses. They are designated by weight expressed as pounds per ream (or grammes per square metre), the thickest ones normally being up to 300lb (640 gsm) and the thinnest 90lb (190 gsm). Some hand-made papers can be found in an even heavier weight, 400lb (850gsm), which feels rather like cardboard.

Stretching Paper

When a generous wash of watercolor is floated onto paper, water is absorbed and the paper swells. When the paper has absorbed all the water that it can, it may buckle—the paper becomes corrugated so that washes settle in the hollows and dry in unpredictable ways. The lighter the paper and the bigger the sheet, the more likely this is to happen. The paper

1 Wet the underside of the paper thoroughly with a sponge soaked in clean water, or immerse the paper thoroughly. Let the paper absorb the water for at least five minutes—longer for heavy papers.

2 While you are waiting for the paper to swell, cut four pieces of gummed paper strip to the length of the four sides of your paper. Dampen the first of the pieces.

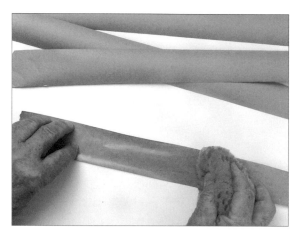

3 Turn the paper dry side up on a rigid board (plywood or compressed woodchip will do, although a proper wooden drawing board is better) and tape it down. Make sure that all four pieces of tape are securely stuck to both paper and board.

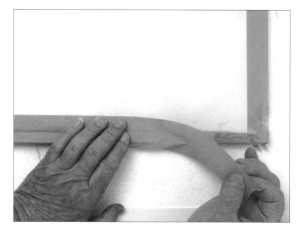

4 Leave the board flat to dry naturally. Don't worry if the paper looks slightly cockled shortly after it has been stuck down. It will flatten as it dries and will stay that way, even when washes are applied.

may remain buckled even when dry, making it difficult to flatten it for mounting and framing. Heavier papers, being able to absorb more water, resist buckling better than the thinner ones.

You can get around the problem by stretching the paper before you use it—ideally the day before. The principle of stretching is that by thoroughly soaking the whole sheet of paper and allowing it to expand fully, and then pinning it in place by some method, you prevent it from contracting back to its normal size as it dries. While it remains in this stretched condition, even very wet washes flooded on to the paper will not result in any further expansion and consequent buckling.

Any method that securely pins the soaked paper will do the trick. You can staple it to a board, or wrap the paper around a stretcher frame and tack it in the same way as you would stretch an oil canvas; there is even an elegant procedure where the paper is pressed into grooves and secured with fitted battens. However, by far the most common method is to tape the paper down on a board using gummed paper strip. The gum must be water soluble—nothing else will adhere to wet paper—and the board must be sufficiently rigid to resist the pull of the paper as it tries to contract.

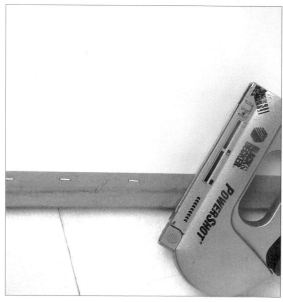

Stapling

For extra security, staple the edges of the paper to the board at frequent intervals.

Other types of paper

Although it is pleasant to work on special watercolor paper, it is not absolutely essential. Good-quality drawing paper can be stretched successfully, as can other papers, but do not to try to stretch very thin paper as it may rip as it dries and contracts.

Pre-mounted paper on board is one alternative to stretching watercolor paper. It may be hard to find with good-quality paper and it is fairly expensive compared with unmounted paper of the same weight, but it has one very major advantage, in that it is foolproof as far as buckling is concerned.

Watercolor blocks—stacks of perhaps 20 or 25 sheets of paper sealed around 90 percent of their edges—are widely available. The weight of the paper will be stated on the pack: heavier weights are preferable, as the blocks

are only mildly pre-stretched and only resist buckling as long as washes are not too heavily loaded. When each painting is finished, remove it from the block by sliding a knife into the unsealed gap and releasing the edges.

WATERCOLOR BLOCK
Paper should only be removed from a block when the painting is finished.

Using a gesso ground

You can also prepare your own paper or card by painting on a ground base of some sort. Ready-prepared "gesso" grounds, so called because they bear some resemblance to the chalk and oil grounds used by muralists in Renaissance Italy, are generally available. They can be brushed on liberally and left textured, or applied in two or three thinner coats smoothed with sandpaper between each layer. Such surfaces are not as absorbent as untreated paper and render washes rather more difficult to control, with textural effects that are not to everyone's taste, but rather interesting nevertheless.

APPLYING A GROUND
Use a large brush to apply and "gesso" ground. Most gesso grounds can be diluted with water but are waterproof when dry, so always clean your brush as soon as you have applied the ground.

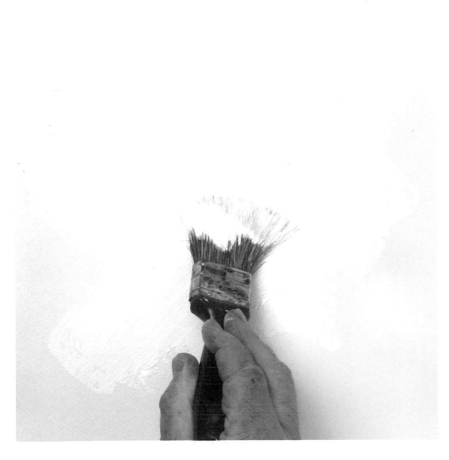

Brushes

The range of brushes available is large and can be confusing. However, watercolor painting does not require a large number or variety of brushes— a few well-chosen brushes of good quality are all that you really need.

It is easy to spend a great deal of money on watercolor brushes: pure sable hair brushes in the largest sizes can be extraordinarily expensive. They are nice to use but by no means essential. For applying background washes on all but the smallest pictures, you will need at least one large wash brush. All my large wash brushes are made of cheaper hair such as squirrel, goat, man-made fibers or mixtures. It is up to you whether you choose flat or round wash brushes, but at least one of them should be large—the equivalent of a number 12 round or 1½-inch (4-cm) flat. The largest size you use will naturally depend on the size of your paintings: for very large watercolors (beyond, say, 22 x 30 inches/ 55 x 75 cm), you may need brushes that are

even larger than this. It is not unheard of for household painting brushes and even make-up blending brushes to be pushed into service for applying really large washes. A wash brush need not come to a point, but the hairs should keep nicely together so that each stroke of color made with it has clean edges.

You will also need at least one, and preferably two or three, medium-size brushes, either flat or round. (I generally prefer round.) These should be around sizes 5, 6, and 7 (½-inch, ⅝-inch, ¾-inch flat). Several manufacturers market squirrel-hair brushes which look rather like Chinese brushes, their ferrules often bound with fine wire. A good brush of this type is somewhat less expensive than a sable, but it should be capable of

Cleaning Brushes

Brushes will remain in good condition much longer if they are regularly washed. Rinsing them in clean water is not enough: gently stroking the brush on a bar of soap under warm water until the water runs clear is the only way to be sure that all traces of paint that have built up close to the ferrule have been cleared. Clean all your brushes in this way after every painting session. Apart from preserving the set of the brush, it will also ensure that the next washes that you mix will be absolutely clean and unadulterated by residues of paint on the brush.

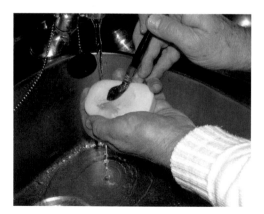

Warm water and soap wash
As you gently agitate the brush against the soap, you will find that even a brush that has been quite thoroughly rinsed will shed a surprising amount of color.

Ease out the color.
Gently squeeze the soapy froth from the ferrule to the tip with your thumb to remove every trace of pigment.

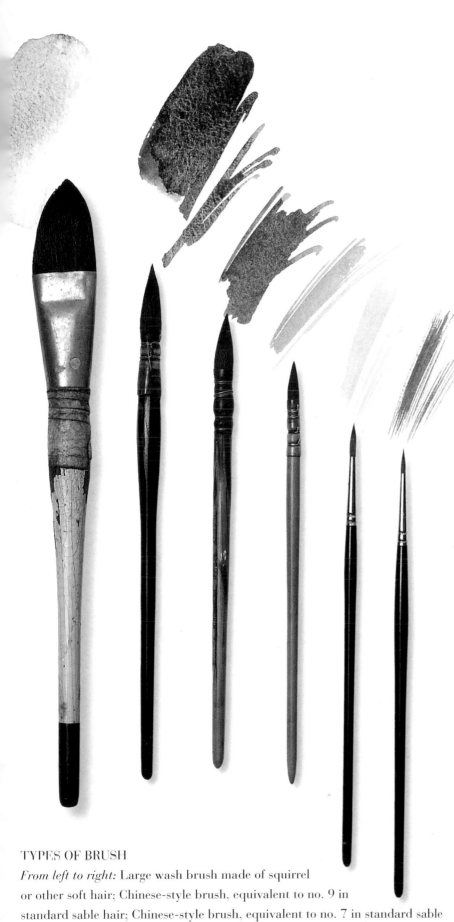

maintaining a good, fine point while holding a generous quantity of color.

This matter of holding a fine point is important: a brush that splits into two or three points as soon as it is loaded with color or applied to the surface is more or less useless —and very irritating, to boot. Brushes made of an unspecified type of hair or other fibers are often dressed with some sort of water-soluble adhesive in order to make it look good in the store and it is therefore impossible to tell whether it will maintain a good point until you take it home and wash out the dressing. Try to find them untreated or to persuade the storekeeper to provide water in which to wash it out.

For small brushes used to paint fine detail, there really is no substitute for a well made sable: sizes 1–3 are not too expensive and you should opt for two or three of the best-quality series in any manufacturer's range. It is even more important that these small sables should come to a single, sharp point and keep their points when full of color. Unlike squirrel-hair brushes, they are not normally dressed and you should always insist on checking them by loading them with water and rotating the point very gently on your hand. If the point keeps splitting into two or three, don't buy it.

You should never need any brush smaller than a number 1, which will have as fine a point as a 0 or 00 and will hold more color.

Personally, I have little use for very long-haired brushes known as riggers and liners, which are designed to make long, smooth lines, nor do I like very stubby, short-haired brushes. Fan brushes, intended for blending colors, I also have no need of. If any of these appeal to you, try them by all means—but beware of using them for gimmicky special effects.

TYPES OF BRUSH
From left to right: Large wash brush made of squirrel or other soft hair; Chinese-style brush, equivalent to no. 9 in standard sable hair; Chinese-style brush, equivalent to no. 7 in standard sable hair; Chinese-style brush, equivalent to no. 5 in standard sable hair; Round brush, pure sable hair, size 3; Round brush, pure sable hair, size 2.

Pencils and pens

Sometimes you will need to preface your application of watercolor with some drawing, so include some pencils in your painting kit. For watercolors in which the linework is an integral part of the picture, you can also include pens of various types and maybe some chalks and crayons.

If your drawing is to be more or less hidden by subsequent washes, you will need to choose a grade of pencil that gives you the freedom to draw clearly without applying too much or too little pressure. Pencils make different marks on different types of paper—darker on hard, rough papers and lighter on soft or smooth papers—so have a range of grades ready, from HB to 4B. If you choose too soft a grade, the marks will be too black and difficult to control: if you choose one that is too hard, you may have to use a lot of pressure, denting the paper, to make marks that will provide enough guidance. Try them out on the edge of your chosen paper and choose the one with which you can draw sharp, positive marks without having to press too hard.

Mention should also be made of watercolor pencils. Marks made with these colored pencils or crayons can be spread into washes of color by applying a water-filled brush. In my experience, washes derived from the pencils have been disappointingly weak, but the best of the crayons are a different matter altogether. They can be used as crayons and can then be changed into washes very easily by dampening the marks with a water-filled brush or even with a moistened finger. Strongly drawn lines remain visible even after water has been applied, giving the combination of linearity and fluid washes that is typical of line-and-wash work. The range of colors can be excellent (up to eighty or more), which is useful as it is difficult to premix colors.

These pencils shown on the left are not the only pencils on the market, but they are just about all that you are likely to need for watercolor painting. The ones that make black or gray marks are for preparatory drawing; the colored ones are water soluble, which means that they can be used without further color application.

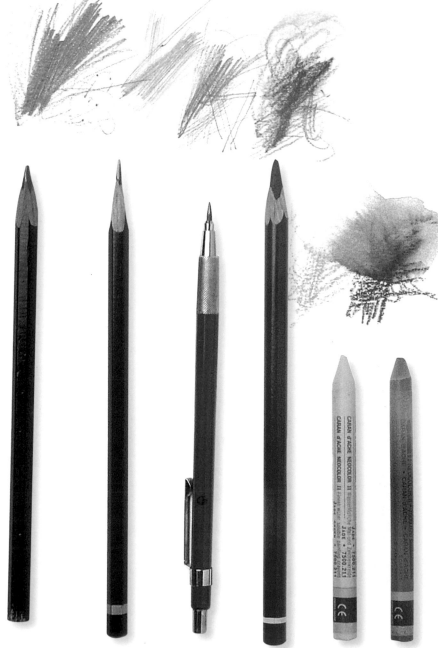

From the left: Soft (4B) pencil;
Medium to hard (HB) pencil;
Mechanical pencil—the leads can
be any grade; Watercolor pencil;
Water-soluble crayons.

On occasions you may prefer to allow the line to be more dominant: a softer pencil with a darker mark will be better for this. This opens the door to even more prominent line work which pen and ink provides. Such works are known as line-and-wash paintings (see pages 52–55). Pens come in a huge variety of shapes and sizes and the ones you choose will depend on the size and detail of your work. My preference is for a medium-size dip pen, with a nib that is reasonably flexible but strong enough to be used vigorously when necessary.

The ink that you use with a dip pen need not necessarily be black. Colored inks are available in almost as many colors as you will find watercolor paints. Choose waterproof inks if you wish to have control when adding the washes—although the random effects of applying washes over non-waterproof ink can be exciting. Of course, you can always lay the washes first, let them dry, and then draw over them with pen and ink—in which case, it won't matter whether they are waterproof or not. You can also dilute both black ink and colored ones by dipping in water as you draw. Distilled water is recommended for this, but I have never had a problem with ordinary tap water.

Technical pens have in-built reservoirs that you fill with ink. Their "nibs" are fine tubes with a central wire which permit ink to flow at a controlled rate, producing an even line, the thickness of which depends on the diameter of the tube. They are designated by the width of line that they produce—the smallest normally being 0.13 mm and the largest around 0.7 mm. Although they lack the flexibility of a dip pen, they are good for fine, controlled hatching and cross-hatching.

Other self-inking pens include felt tips, fiber tips, and rollerballs; all can be used for line drawing to be combined with watercolor. Check whether the inks that they contain are waterproof, as the same hazards apply as when using dip pens. Ordinary fountain pens are very pleasant to draw with, but the inks recommended are non waterproof—although I know at least one artist who successfully uses waterproof ink in a fountain pen.

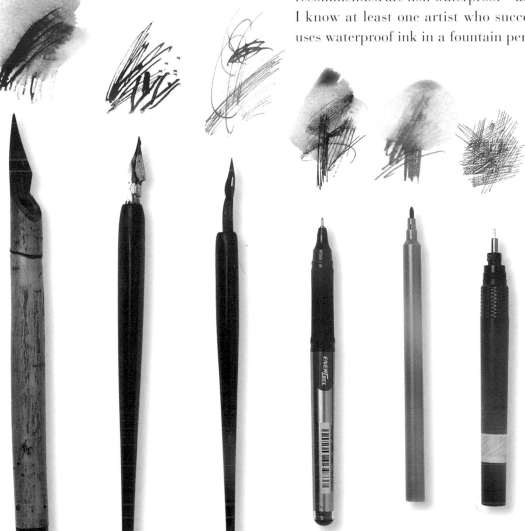

From the left: Bamboo pen; Metal dip pen with reservoir; Metal dip pen with medium-size flexible nib; Fine-tipped water-soluble pen; Colored ink felt pen; Technical pen.

Watercolor accessories

There are a number of other tools that you will find useful, or even indispensable, in your watercolor kit. Although the additives mentioned are no substitute for sound watercolor technique, most are worthy of a trial run.

Masking fluid (see pages 56–59) fulfills a genuine need. When you want to leave spots, stripes, or other small details untouched when applying a wash, first cover them with masking fluid. Masking fluid can be applied with a brush or other implement; when dry, it protects the areas that it covers. When the covering wash has dried, remove the masking fluid by rubbing gently with a fingertip. Larger areas can be masked out with low-tack masking tape.

Clockwise from top left: Masking tape; gum arabic; masking fluid; gummed paper strip.

You will need gummed strip for sticking down stretched paper. A staple gun, powerful enough to drive staples into a board, is also useful as a back-up when gummed strip fails (as it sometimes does).

Gum arabic can be mixed with color and is claimed to be a preservative: it also increases gloss and transparency and makes washes more easily modified or removed. Ox gall increases wetting and flow of water; dropped into an existing wash, it produces a startling, starburstlike texture.

Salt and sugar crystals sprinkled into wet washes make dappled textures. I always carry a piece of candle wax to use as a textural resist (see pages 54–57).

You will probably feel the need for an eraser, although I think it should be used as rarely as possible. A kneaded eraser is best, not only for erasing but also for general cleaning-up.

A sponge or two are useful, both for flooding the paper when stretching and for applying textured color.

An old toothbrush is useful for applying spattered color. For a finer spray of paint, you should still be able to buy a simple little device

called a mouth spray. Otherwise a used hand spray bottle can used for the same purpose.

My watercolor kit also includes a craft knife and a scalpel. Both can be used to scrape back highlights: the former is also for pencil sharpening (I hate pencil sharpeners). Finally, clean rags or paper towels are essential for blotting, drying, and cleaning brushes.

Some receptacle in which to carry water is essential if you intend to paint on location. The kind of water bottles used by cyclists are ideal—they are light and strong and you can squeeze out just what you need without spillage.

A brush roll is good for carrying all your brushes, pens, pencils, and other implements and again, if you are going to paint outdoors, a backpack of some sort will make life easier.

Folding stools and chairs are available in many shapes and sizes: taking one with you means that you don't have to search for somewhere to sit when painting outdoors.

The need for an easel is debatable. Watercolors are generally best painted on a near-horizontal surface and not all easels permit this or hold the painting very well if they do. Provided you are securely seated, you can support the painting surface on your lap. There are folding easels, generally quite expensive, which provide both good support for your board and have an integral seat.

Clockwise from top right: sponge: kneaded eraser: household candle: scalpel: craft knife: toothbrush.

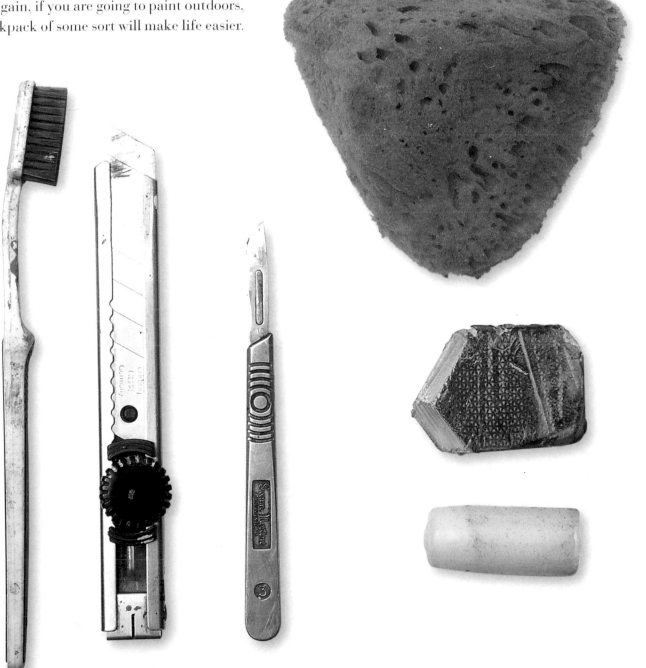

Washes

SEE ALSO

• Surfaces, page 17

A wash is a mix in which a relatively small amount of pigment is suspended in a much greater volume of water. The special qualities of washes are their transparency and the luminosity they gain from the whiteness of the paper.

Materials

90-lb (185-gsm) NOT watercolor paper, pre-stretched

Large wash brush

Watercolor paint:
 Prussian or
 Pthalocyanine Blue

Flat wash

The first skill to master as a watercolorist is that of laying a flat wash. Although a wash does not always need to be of even density and color, it is as well to acquire the ability. The basic principle of a flat, even wash is that it should flow over the paper. To accept this, the paper needs to be stretched before use (see page 18) or be otherwise proof against "cockling"—a term used to describe what happens when paper absorbs the water of a wash and expands, causing corrugations to appear.

To mix a wash, you will need a reasonably deep reservoir of water, containing at least an egg cup full of water for a wash of, say, 6 inches (15 cm) square. For larger areas you will, of course, need larger quantities of wash: experience will enable you to judge how much you need to mix, but as a rule of thumb you should mix what you consider to be enough, double it, and add a little more.

Before you begin to apply the colour, prop your drawing board at a slight angle. This ensures that the wash flows downward and pools along the base of each brush stroke.

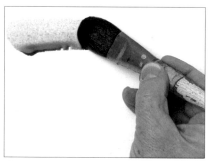

1 Using a large wash brush generously loaded with paint, lay down one smooth stroke from left to right.

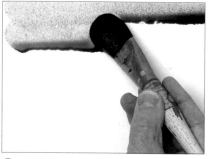

2 Re-load the brush and, where the paint pools at the base of the first stroke, lay down another stroke, taking care not to touch the stroke above.

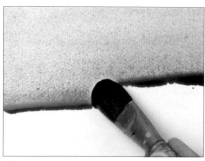

3 Continue until you have covered the paper.

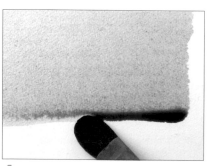

4 Squeeze your brush dry and gently pull it along the base of the last wash stroke to pick up any excess paint and leave a neat edge.

The completed flat wash

The paper is evenly covered and no brush marks are visible. Note how the paint has dried to a much lighter tone.

Materials

90-lb (185-gsm) NOT
watercolor paper
Large wash brush
Watercolor paint: Cobalt Blue

Gradated wash

Laying a gradated wash is a similar procedure, but instead of loading the brush from your pre-mixed mixture as before, you add clear water—a little more with each stroke—so that the color grades from full color to no color at all.

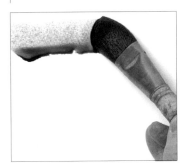

1 Using a large wash brush generously loaded with paint, lay down one smooth stroke from left to right.

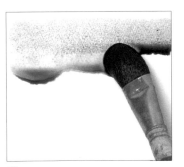

2 Add more water to the paint, re-load the brush and, at the point where the paint pools at the base of the first stroke, lay down another stroke, taking care not to touch the stroke above.

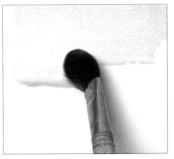

3 Repeat Step 2, adding more water with each stroke. If stronger color from the previous stroke starts to flow downward into the paler area of wash, tilt your board away from you.

The completed gradated wash
The wash gradates from full color at the top of the paper to no color at all.

Materials

400-lb (850-gsm)
watercolor paper,
unstretched.
Large wash brush
Watercolor paints:
Vermilion, Carmine,
Cadmium Yellow,
Pthalocyanine Blue

Variegated wash

A variegated wash, in which there is a gradual change from one color to another, is slightly more difficult to control than a single-color wash and needs practice. There is always an element of risk when wet paints run together, but for me the unpredictability of watercolor is one of its charms. You can maintain some degree of control by tipping the painting while the washes are wet and flowing and by using a hair dryer to push the washes around.

Uneven drying may result from this, creating multiple edges to the wash, a feature that many people find attractive. On some papers, washes dry with an edge that is slightly darker than the interior of the wash. This is an effect that I personally like very much—so much so that I sometimes take out some of the color in the middle of a wash area with a paper towel to accentuate the darker edge.

1 Mix a warm red from Vermilion with a little Carmine and, using a large wash brush, lay down one smooth stroke from left to right.

2 Wet the paper for about 1 inch (2.5 cm) below the red wash. Rinse your brush, re-load it with Cadmium Yellow, and lay down another stroke so that the two colors run together.

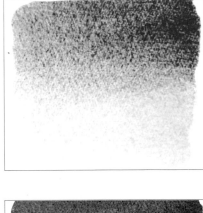

The completed variegated wash
Repeat Step 2, using very dilute Pthalocyanine Blue. Where the blue runs into the yellow, a transitional green will appear. Tip your board to encourage the colors to run together.

Wet into wet

You will often hear this term in connection with watercolor. Although a variegated wash is technically an example of wet into wet, the term generally refers to an even more unpredictable procedure, in which color is dropped into wet washes or onto paper that has been dampened with clear water.

SEE ALSO

• Washes, page 26

Materials

400-lb (850-gsm) watercolor paper, unstretched.

Large and medium wash brushes

Watercolor paints: Cobalt Blue, Lamp Black.

Wet into wet on very damp paper

When a colored wash is dropped onto a wet surface, the color initially spreads out very rapidly in tendrils that usually coalesce later into soft shapes. If the paper is too wet, however, all the shapes may run together and be lost.

The success of wet-into-wet washes depends on your ability to judge when the receiving wash or damp paper is at just the right stage of moistness to allow the desired spread of color and no more. Ideally, the additions will stay more or less where they are put, but will spread a little, with soft, blurred edges.

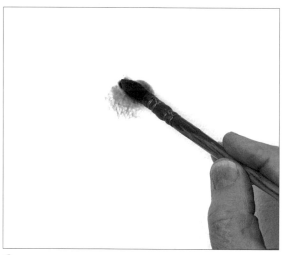

1 Using a large wash brush, wet the whole of the paper with clean water. While the paper is still wet, load your brush with a mix of Cobalt Blue and lightly touch the tip of the brush onto the paper.

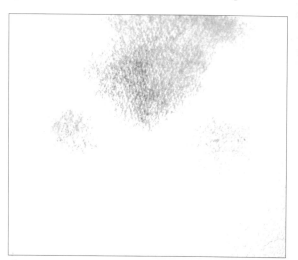

2 The color will spread outward in a circle, feathering at the edges.

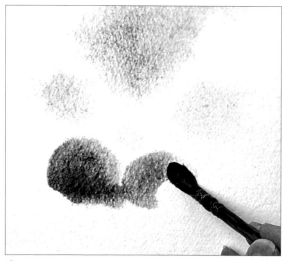

3 Allow the paper to dry a little and then touch in some shapes with a fairly strong wash of Lamp Black.

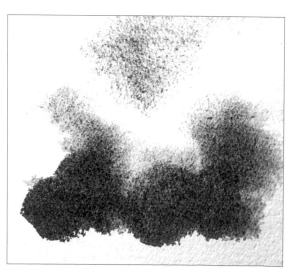

4 The shapes will spread gently to resemble dark clouds. This method is often used for cloudy skies.

Wet into wet on partially dry paper.

This exercise allows you to mix wet into wet with layered washes, in much the same way as you would do in a full-scale painting.

There is an element of risk when painting wet-into-wet passages, but allowing them to dry and then overlaying additional washes can give you a certain degree of control.

1 Repeat the variegated wash exercise and allow it to dry.

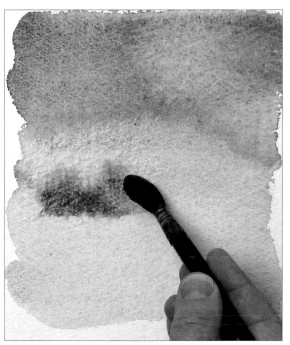

2 Re-wet a small area in the middle of the paper and run a brush loaded with paint through this and onto a dry area. Here I used a mixture of Cadmium Orange and Burnt Sienna.

3 Lay other washes over dry areas, allowing them sometimes to touch and run together. The point is to play with washes and to discover what they can do.

Overlaying colors

Overlaying colors is the basis of a method that became established as a classic English style of watercolor. As I recounted in the introduction, this style quickly spread to the US and has been followed with enthusiasm to this day.

SEE ALSO

• Washes, page 26

In this method, each wash is pre-mixed with lots of water and very little pigment and left to dry thoroughly before the next wash is applied. The lightest colors and tones are put down first; as other layers are added, they combine to make the darker tones. Because the translucent layers are illuminated by the white of the underlying paper, subtle and unexpected combinations of colors appear that are quite different from dark tones applied in a single coat.

This exercise shows how colors and tones can be built up by laying a series of flat and gradated washes. Rather than merely overlaying colors in an abstract pattern, I suggest that you allow the forms to suggest an imaginary landscape.

If you make sure that every wash is transparent and only a little darker in tone than the previous one, you will find that you can easily overlay ten or more washes in some areas without them becoming too dark and dense. It's a good idea to make a habit of playing in this way whenever you have a few minutes to spare—perhaps when you are waiting for stretched paper or other washes to dry, or as a kind of limbering-up exercise before you start a painting.

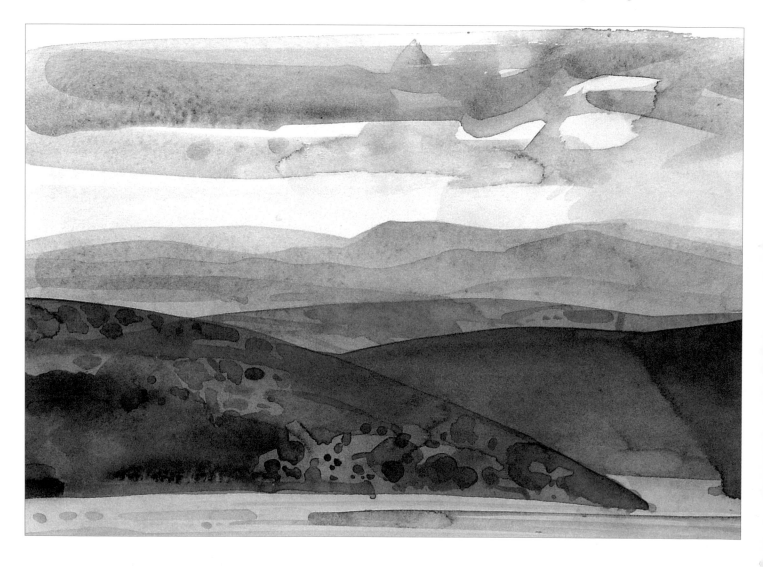

Materials

NOT surface watercolor
 board
Watercolor paints: Cobalt
 Blue, Indigo, Ultramarine
 Blue, Phthalocyanine
 Blue, Viridian, Raw Sienna,
 Phthalocyanine Green,
 Cadmium Yellow,
 Cadmium Orange,
 Gamboge
Brushes: Large wash,
 medium round

1 Using a large wash brush, lay a pale, gradated wash of Cobalt Blue over the paper, watering it down so that the lower part is almost pure water. Leave to dry. Add a little very pale Indigo to the Cobalt Blue and brush on a shape like the outline of a range of hills. Tilt the board so that water runs back to the top of the "hills," giving them a dark tip. Leave to dry.

2 Mix Ultramarine Blue with a little less Indigo and brush on another shape, just below the first, to imply a nearer hill, again tilting the board so that paint runs back to the "summit." Apply this mixture as a gradated wash, fading to almost clear water near the base of the paper. Leave to dry.

3 Mix Phthalocyanine Blue with a little Viridian and brush it on in the same way as in Step 2, allowing it to run about halfway down the hill scene. Dab off any excess paint with a paper towel so that the green doesn't come too far down or form a definite line. Leave to dry. These washes accumulate and become darker as they are overlaid.

4 Mix Raw Sienna and Phthalocyanine Green to form a rich olive-green color and brush in the shape of a foreground hill. Keep the top edge sharp but allow the paint edge to soften toward the base. Leave to dry.

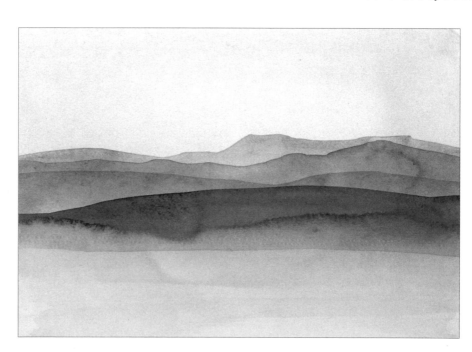

5 Add gradated wash of Phthalocyanine Blue to the top of the paper to darken it. Wash very pale Cadmium Yellow over the hills. Because the underlying washes are completely dry, the yellow merely warms up the overall scene without disturbing the colors underneath.

6 Next, turn your attention to the foreground. Wash very pale Cadmium Orange over the foreground and the dark green hill. (Although it looks very dominant now, it will almost disappear in later stages as more dark colors are added.) Note how the orange is starting to granulate where it overlaps the green. This happens with some pigment admixtures: the effect may disappear as the color dries, but it adds a pleasing texture. Leave to dry.

7 Add Burnt Umber to your original mixture of Cobalt Blue and Indigo to make a strong, browny-green and brush it over the foreground. While the paint is still wet, drop in some Gamboge to give a suggestion of foreground foliage and grasses. Dab on clear water in places to take off paint, allowing the wet edges to spread of their own accord.

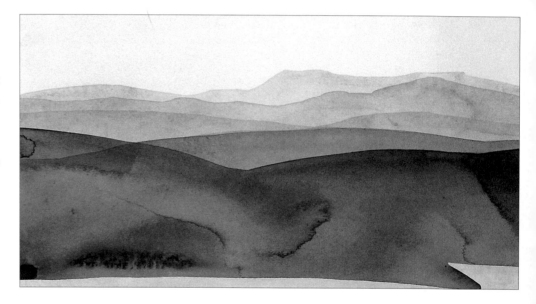

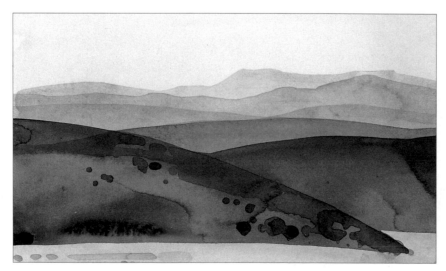

8 Using a mixture of Raw Sienna and Viridian and a medium round brush, darken the brow of the foregound hill and dot in some rough tree shapes. The foreground is starting to suggest water, so why not brush some broad strokes of Cerulean Blue over the foreground orange.

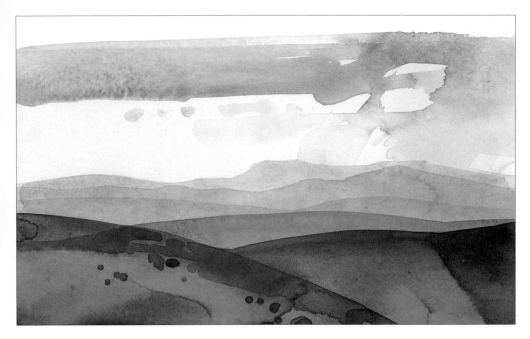

9 To darken the sky still further and maintain the tonal balance of the painting, brush a pale mixture of Ultramarine Blue and Indigo onto the sky to suggest heavy clouds.

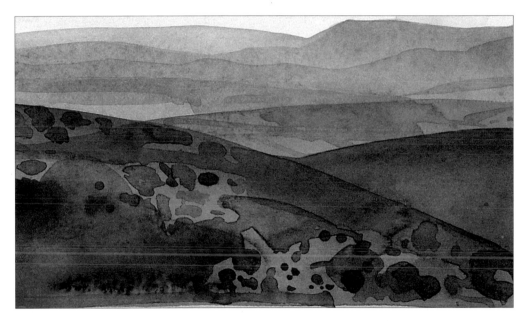

10 The painting is now in its final stages and very little more needs to be done. Allow the shapes and colors to suggest subjects to you: here I added some dark foreground detail and darkened the outline of the distant hills to balance the tones. I also removed paint from the center of the foreground hill with a paper towel to accentuate the edges and added a few more clouds.

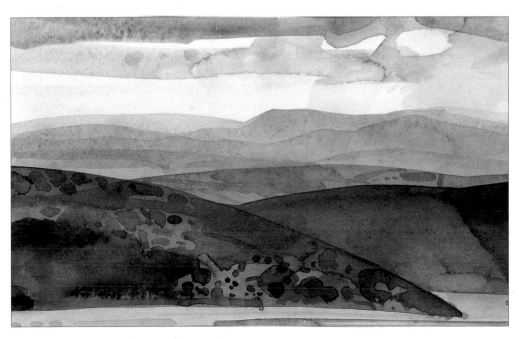

11 Finally, if the whole painting is looking a little cold and somber as here, try applying a very pale wash of Gamboge over the whole painting to warm the colors up a little. Remember that as long as the washes are completely dry, you can apply a light-colored clear wash over the whole picture at any time to change the overall color cast without affecting the detail.

TONAL VALUES

Seeing in tones

All colors have tones. By this, I mean that they have a value of lightness or darkness. Some colors, such as yellow, will, whatever their strength, always be in the higher-toned end of the range, while a color such as red may be at either end depending on its saturation and strength. Learning to assess the tonal value of colors is an essential part of becoming a good watercolorist, and the exercises on these two pages are designed to help you do just that.

SEE ALSO

• Using tone to create a 3-D effect, page 36

• Rounded objects, page 38

It is not always easy to determine the tonal value of a color. Cutting down the visual information by half closing your eyes helps—and, of course, photographing the scene in black and white (or making a black-and-white photocopy of a color photograph) shows exactly how the various colors are rendered as tones. The exercises on these two pages will help you improve your ability to judge tonal values by rendering in one color only.

Exercise 1: Judging relative tones

This exercise requires you to mix ten tones from black to nearly white, in stages that are as even as possible. Using watercolor, this means starting with a full-strength wash and gradually diluting it with water.

On a piece of watercolor paper, mark out ten small rectangles—each one approximately 2 x 1½ inches (5 x 4 cm). Mix a generous amount of a strong black wash and fill in the first rectangle. Wait long enough to be sure that it is going to dry as a good, dense black and then mix nine progressively lighter tones. The easiest way to do this is to have ten palette mixing areas ready and then to transfer some of each darker tone into the next palette and add more water; the very lightest tone will be almost pure water. You will probably need to move up and down the line of mixes, testing them and adding more water and pigment until you have an even gradation. When the nine dilutions are as even as you can make them, fill in the remaining rectangles.

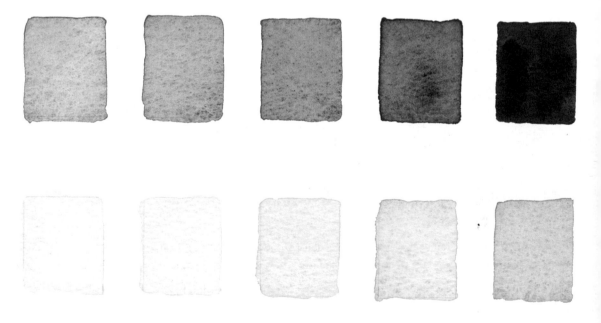

Exercise 2: Matching colors to tones

Now. on another piece of watercolor paper. paint some areas of strong bright colors and some paler ones. When they are dry. cut them out and try to match each of them tonally with one of your 1 to 10 grays. Half close your eyes to eliminate as much of the color in the squares as possible. as this will make it easier to assess the tones. The illustration below shows my attempt.

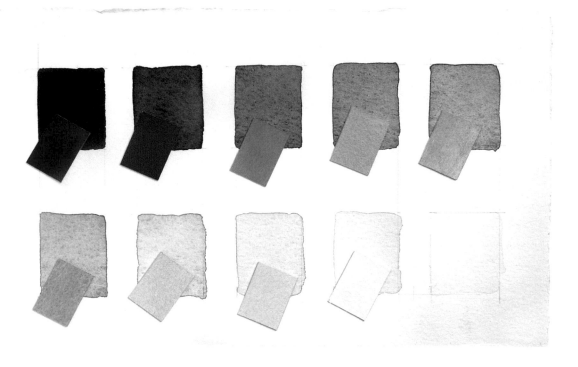

Exercise 3: Test your judgment

To test the accuracy of my judgment. I photographed the results of exercise 2 in black and white. (Alternatively, you could make a black-and-white photocopy of the results.) As you can see. some of the matches. such as the strong yellow on tone 4 and the red on tone 2. were quite accurate. while the blue on tone 1and the paler yellow on tone 8. were not.

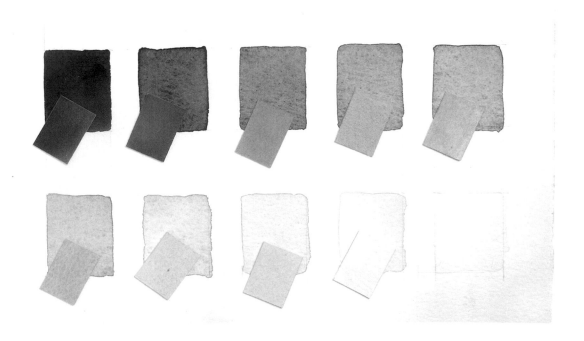

Using tone to create a 3-D effect

This exercise uses watercolor tones of only one color to improve your ability to assess tonal values. It also demonstrates how tones build up as they are overlaid—something that is fundamental to the majority of the methods described in this book.

SEE ALSO

• Seeing in tone, page 34

• Rounded object, page 38

Materials

HB pencil

90-lb (140-gsm) rough watercolor paper, pre-stretched

Watercolor paints: Lamp Black, Raw Sienna

Brushes: large wash, medium round, small sable

Assessing tones is important, as it enables you to render the fall of light and hence create a convincing impression of three dimensions.

Put together a mix of light and dark objects. To make it easier to judge the tonal values, choose mostly things that have little or no color—but include one object that is quite strongly colored to add visual interest and make the exercise a little more challenging for you. Look for objects that are simple in form and have sharp changes of plane, such as cubes or boxes.

Place the objects in front of a plain-colored background, such as a painted wall, and on a flat surface. Position a light to one side of the objects (a desk lamp will suffice) so that it casts interesting shadows. (You will probably need to alter the position of the light or the objects, or both, to get the right effect.) Arrange the boxes so that some are tilted with edges overhanging in places, so that there is a mixture of planes in shade and cast shadows. There might also be some areas where sharp contrasts in tonality occur and others where there is almost no discernible tonal change.

Start by mixing five tones of the same color. Here I used Lamp Black, adding a little Raw Sienna to warm the mixture a little and prevent it from looking dead. In the palette each tone will look very similar, so remember to test your mixtures on the edge of the paper and wait for them to dry in order to see what they really look like.

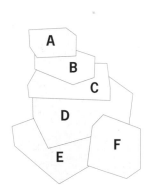

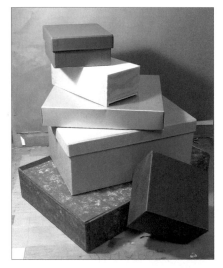

1 Using an HB pencil, draw the edges of the boxes and the shadow shapes, looking at both the positive shapes (the boxes themselves) and at the negatives shapes (the spaces between them). Ignore details at this stage: all you are trying to do is establish the planes of your subject.

The set-up

In a group such as this, it is comparatively easy to assess the tones of the various planes of the objects, the sides that face the light, the shaded sides, and the cast shadows. When the group includes stronger colors such as the red box, look at the subject through half-closed eyes as this reduces the impact of the color and enables you to see its true tone. For ease of identification, let us name the stacked boxes A to E from the top, and the leaning one in the foreground as F.

2 Wash the very lightest tone (tone 1) over everything that is not actually white. Here, I judged that only the top of box B was white. Leave to dry.

3 The second lightest tones are on the left side of box B and the top of box D. Wash tone 2 over everything except these areas and the area of the paper that you left untouched in Step 2. You may need to switch to a smaller brush in order to get sharp edges. Leave to dry.

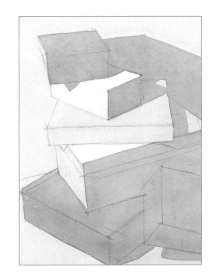

4 The next darkest tone is the red box A. Use tone 3 to paint in the box and the shadows it casts on box B, the end of box B and the shadow it casts on box C, the shadow of box C on box D and all areas other than those that you consider to be tone 1 or 2. Leave to dry.

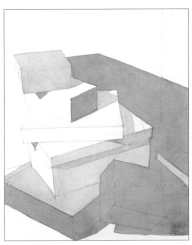

5 Lay tone 4 over the end of box B, the edges of box E, all of box F, and the background shadow except for the small strip of light at the bottom right, using a small sable brush first to delineate the edges and then continuing with the wash brush. The two triangular shadows of box A on B and box C on D are also tone 4.

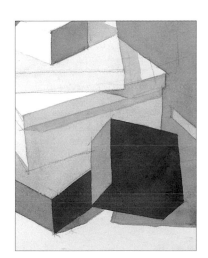

6 Now you can apply your darkest premixed tone to the right-hand edge of box E and the top and side of Box F. You do need not be too strict about the progression through the tones from light to dark: The shadow of the lid of box D was put in with a new intermediate tone that lies between tones 4 and 5.

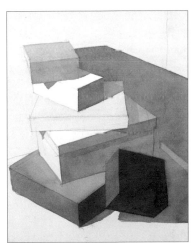

7 Now assess the tonal values. Remember that even light washes applied over darker ones still result in a darker combined tone. I used a second layer of tone 3 on the edge of box A, over the background shadow, the shaded areas of box A, and all over boxes E and F.

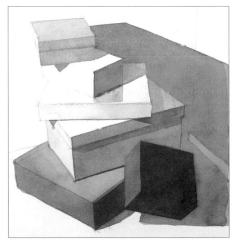

8 Some edges may have been lost during the painting process, as the pencil lines have been covered by washes, so you may need to redefine some of them with a fine brush. Use a Mahl stick (see page 00) to avoid smudging any of the wet paint. I gave the long side of box D a final wash which also darkened the lightest edge of F. I also added a reflection that I saw in the slightly shiny surface of box C.

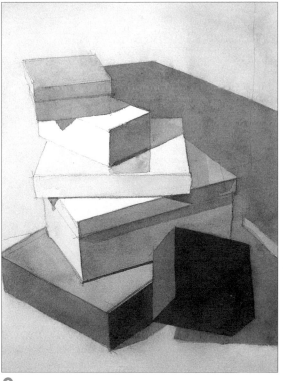

9 Finally I judged that the tone of the background needed to be darkened and an application of tone 2 was sufficient to do this.

Rounded object

SEE ALSO

• Seeing in tone, page 34

• Using tone to create a 3-D effect, page 36

This time, your task is to assess tonal values in a group of less regularly shaped objects that are more varied in color.

Go for simple, strong shapes and a range of light to dark tones: fruits such as apples are ideal for light to medium tones, a lemon would be perfect for a light tone, and you might choose an eggplant for a dark one.

Begin by searching for the lightest tone. If one of the objects has a shine or luster

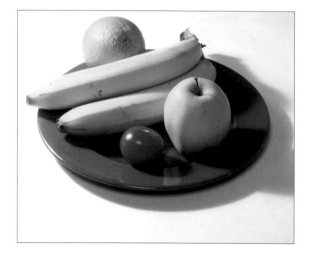

(difficult to avoid in many objects), the lightest tone may be a reflected highlight. This highlight may not be pure white, but may simply appear to be so by contrast with the surrounding area. To judge whether it is truly white, cut a small hole about ¼ in. (5 mm) square in a piece of white paper and view the highlight through it. Close one eye and move the paper until the small window encloses just the highlight, then you will see whether it really is white or slightly darker in tone.

As before, mix five tones of the same color. Here, I mixed Viridian with a little Gamboge.

The set-up

As well as having less obvious edges, this group is comprised of objects that are varied in color as well as tone, so it is even more essential that you judge the tones through half-closed eyes. Note that shadows are often lightened by reflection from adjoining light areas.

Materials

HB or B pencil

90-lb (140-gsm) rough
 watercolor paper,
 pre-stretched

Watercolor paints:
 Viridian, Gamboge

Brushes: large wash,
 medium round

1 Using an HB pencil, lightly sketch your subject, using loose but positive lines to indicate where you judge the edges of the shadow areas to be and also where you see highlights. Concentrate on establishing where each object turns away from the light: there's always a point at which one plane changes into another and the light source no longer illuminates that part of the subject.

2 Wash tone 1 over the whole painting, apart from the orange, the background, and the highlights on the plate and tomato. Leave to dry.

3 Using tone 2, paint over the apple (leaving two highlights), the bright side of the top banana, the shadow on the lower banana, and the plate, taking care to reserve the highlights on the plate as pure white. Clean up around the edge of the plate with water to soften the shadow on the table. Leave to dry.

4 Using tone 3, paint dimples on the orange. The blobs of paint will flow together, creating dark, textured areas. Near the stem, paint smaller dots for the highlights. Paint the shadow side of the top banana and the apple in the same tone, and go over the plate and tomato again, retaining the highlights. Darken the shadow under the plate. Leave to dry.

5 Using tone 4, apply a second wash to the orange, dimpling the paint as before to create the highlights. Add more tone to the tomato and plate, as in Step 4. Accentuate the point of change from light to dark on the apple, leaving much of the shadow side in the previous tone to indicate reflected light in this area. Leave to dry.

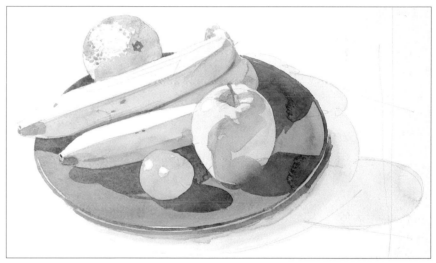

6 Using tone 4 again, paint the plate, reserving the highlights, and the dark shadow areas under the orange and between the two bananas. Leave to dry.

7 Use tone 5 for the very darkest tone—the shadows on the plate and some details around the stalk of the apple. You may also need to reinforce some of the intermediate tones—for example, on the shadow side of the apple—but try to do this without touching the very dark washes that you've just laid down.

8 Finally, re-assess the mid-tones to avoid having any very sudden transitions from light to dark, and reinforce the deepest shadow area.

Color theory

To be able to use watercolors to their full potential, you need to know something about the theory of color and how colors relate to one another.

SEE ALSO

• Balance, page 50

Much of the theory of color deals with how white light can be split into its component parts, its spectrum, as in the rainbow. Recombining some of the colored light into which white light has been split is known as additive mixing, because every addition of light makes the resultant color lighter. Green and red light combined, for example, makes yellow light. Blue and green together make a pale turquoise and if all three—blue, green, and red—are combined, white light is regained. So the primary colors of light are red, blue, and green.

But of much more immediate interest to us is the theory of color as it applies to paints and pigments, for which the primary colors are red, blue, and yellow. Theoretically, all other colors can be mixed from these three primaries. (In practice it is not so easy, as many pigments are not pure enough to make mixtures that are really clean and bright, a subject on which I will expand on the next pages.)

To understand the interactions of color as paint you need to try to imitate the pure colors (hues) of the rainbow or spectrum and bend them around to form a continuous circle—the color circle. As you can see, the violet color (midway between the red and the blue) is opposite the primary yellow, the orange (between the red and the yellow) is opposite the primary blue, and the green (between the blue and the yellow) is opposite the primary red. These three mid-way colors of violet, orange, and green are known as secondary colors

The colors that lie opposite the secondaries across the color circle are known as their complementaries. Thus red is the complementary of green, yellow of purple, and blue of orange. All the other variations linking these six are called intermediate colors and each of these is also complementary to the color that lies directly opposite it across the circle. The significance of this is that when complementaries are mixed together they make tertiary colors—rich grays, browns, and greens. Oddly enough, when they are placed close together, without mixing, they tend to clash.

Painting a color circle

You may have seen color circles before and you may have constructed and painted them. I make no apology for inviting you to do another one. Attempting to produce the purest possible succession of hues provides you with an ideal opportunity to discover whether your range of paints is up to standard—and it's fun, too.

I suggest that you do not try to make it too neat; a certain amount of spreading between adjacent colors, provided they don't completely obliterate each other, is closer to what happens in a real spectrum anyway.

Make the circle large enough to enable you to apply the washes freely with plenty of water and, if you can, let the palest (the most dilute) part of each color be toward the center of the circle. Start at the top, 12 o'clock, with the purest, brightest red you can make, then place a clear yellow wash at 20 past the hour and a middle blue (Ultramarine) at 20 minutes to the hour in your imaginary clock. These are the primary colors. Then place orange midway between the red and the yellow, green between the yellow and the blue, and violet between the blue and the red.

Allow plenty of time for them to dry thoroughly so that you can fill the remaining six spaces with colors that are midway between their neighbors: yellow-orange between orange and yellow, yellow-green between yellow and green, and so on.

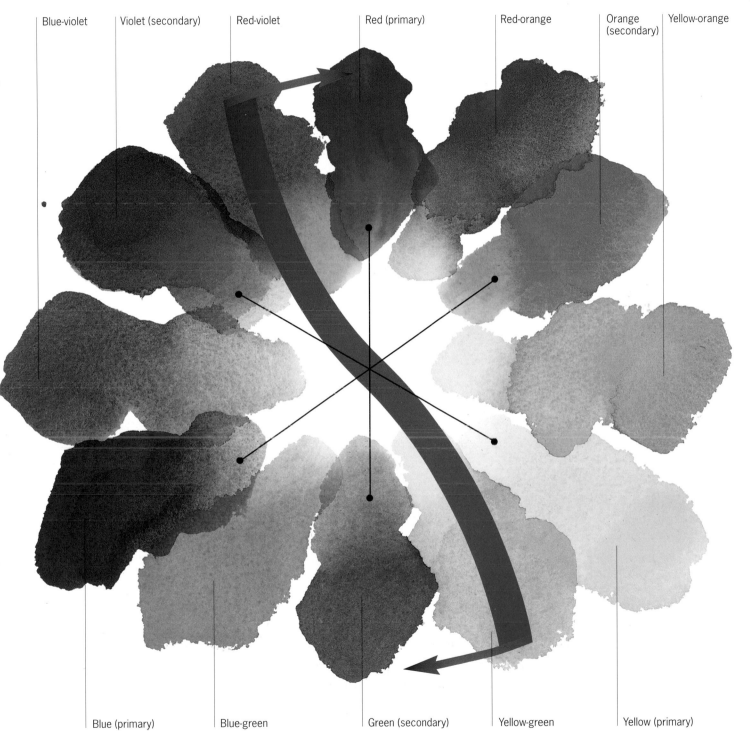

Blue-violet | Violet (secondary) | Red-violet | Red (primary) | Red-orange | Orange (secondary) | Yellow-orange

Blue (primary) | Blue-green | Green (secondary) | Yellow-green | Yellow (primary)

COLOR CIRCLE

This color circle is made up of twelve hues: it represents the spectrum
of visible colors which together make up white light—although the
real spectrum has infinite gradations from color to color.

Mixing colors

SEE ALSO

• Paints, page 12

• Color theory, page 40

The question I am most often asked in teaching painting is, "How do I mix this or that color?" Apart from a few well known and tried mixes—blue and yellow making green, red and yellow making orange, and so on—the answer is often just to experiment.

Theoretically we should be able to mix every color we need from the three primaries of red, yellow, and blue—but even with the best modern pigments, it is still difficult to choose just the right red, blue, and yellow to mix every other color. For example, a mixture of Phthalo Blue and Vermilion will make brown, not violet: you need Ultramarine Blue and Magenta to give a good violet color. Similarly,

Here I tried to match the color of the gray square (top left). I began by making a guess at the nearest hue. I started with a wash of ultramarine blue—much too blue, of course, but also too cool. I then added a generous amount of raw umber, which warmed it up, and darkened it until the checked color (top right) looked correct.

This target color is obviously much warmer, so I started by putting down Cadmium Orange. The result is a little too hot and definitely too yellow, so I added a little Lamp Black to cool it down and also darkened it to the right color.

For this reddish-brown color, I began with Vermilion. This was too bright and hot, so I added Ultramarine Blue.

you can't get a strong green from Cerulean Blue and Cadmium Yellow or a clear orange from Magenta and Lemon Yellow. This is why I recommend that you include a proprietary orange, green, and violet in your paint range.

Color matching and mixing

On the color wheel on the previous page I drew a line dividing the hues that are considered to be warm from those that are considered to be cool. There is some reality behind this: blue and violet light is actually cooler than red light while infrared, the invisible extension of the red end of the spectrum, can generate considerable heat.

Assessing the relative temperature is a very useful concept when color matching.

I must emphasize that there is no one way to match colors. In the examples shown below, only one added color was needed to match the target; at other times, you may need to make more adjustments to get it right. This process takes less time to do than it does to write it; it's a matter of a second or two to add and mix these colors.

When you have a few minutes to spare, practice matching the colors that you see around you by mixing watercolor paints. You will soon begin to discover how colors combine to make new ones and how even a slight adjustment the proportions of the pigments in your mixtures can make a substantial difference.

Adding black

Black is a pigment that is held in deep suspicion by many artists and teachers. It is true that the presence of black in the palette may present a temptation to use it to depict shadow, which is almost never

black, and to render black objects which also are mostly seen as many other colors, but used sparingly to modify other colors it is almost without peer.

Mixing complementaries

Complementary pairs mixed together are reputed to result in gray—although this is a gross over-simplification. Try the exercise shown below. Make a reduced color circle of the three primaries (red, blue, and yellow) separated by the three secondaries (orange, green, and violet). Add to the orange a small amount of its complementary blue and place the resultant color by it. Then mix the blue with a small amount of orange and place that mixture by the blue. Do the same with the other two complementary pairs and you will have six subtly varying tertiary colors.

From the top: Adding a little Lamp Black to Gamboge produces a clear olive green; Ultramarine Blue mixed with a little Lamp Black produces a glorious indigo; Vermilion plus Lamp Black give a clean Indian red. These are just a few examples of the way small amounts of black can be used to modify other colors.

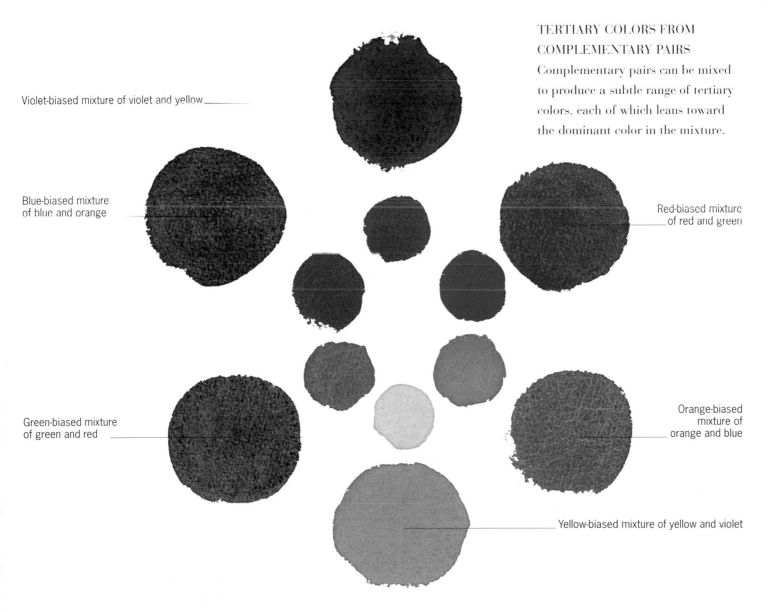

Violet-biased mixture of violet and yellow

Blue-biased mixture of blue and orange

Green-biased mixture of green and red

TERTIARY COLORS FROM COMPLEMENTARY PAIRS

Complementary pairs can be mixed to produce a subtle range of tertiary colors, each of which leans toward the dominant color in the mixture.

Red-biased mixture of red and green

Orange-biased mixture of orange and blue

Yellow-biased mixture of yellow and violet

Overlaying Colors

SEE ALSO

• Washes, page 26

Mixing paints together on the palette or in a dish is only one way of mixing color. The second and—for watercolorists—perhaps the most important way is to overlay washes of color.

Watercolor paints as used in the traditional way are made lighter not by adding white pigment but by adding water, thereby making a more dilute wash. This is important when it comes to mixing colors, as many of the subtle shades often seen in watercolor paintings are the result of overlaying many relatively pale and transparent washes through which the underlying white of the paper can still shine.

You have seen something of this on pages 30 to 33, the imaginary landscape. Now let's explore what happens when a multitude of colors overlay one another.

For this to work, you must allow every wash to dry thoroughly before you apply the next

one—otherwise, of course, the pigments will physically mix with one another, in the same way as they do when you mix colors in the palette.

The point of the following exercise is to discover the composite colors that your eye perceives as you look through a variety of multi-colored layers. I have specified which colors to use in this exercise, but you can repeat the experiment with any colors you choose to produce an infinite variety of complex shades. Because each layer adds to the tonality of the wash, it is more rewarding to keep the layers quite pale so as to increase the number that can be overlaid before the whole color becomes impenetrable.

1 Draw a square 10 x 10 inches (25 x 25 cm) and divide it into 25 2-inch (5-cm) squares. Then lay a wash of Lemon Yellow over the whole area and wait for it to dry.

2 Mix a wash of Cadmium Orange and cover ten small squares on one side of the large square. Mix a wash of pale Cobalt Blue and do the same over the opposite block of ten small squares.

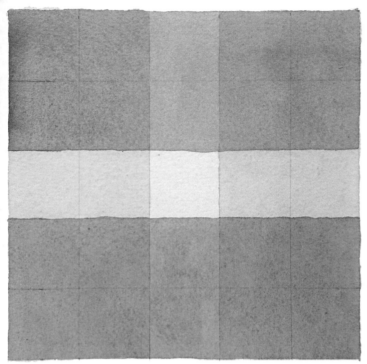

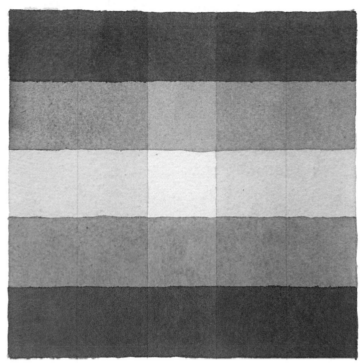

3 When these two washes are dry, lay a wash of deeper Cobalt Blue over the block of ten small squares on the third side and Vermilion on the last block of ten on the fourth side.

4 When all washes are dry again, put a wash of Ultramarine Blue on the five outside squares of the Vermilion wash and Prussian Blue over the five outside squares of the deeper Cobalt Blue block.

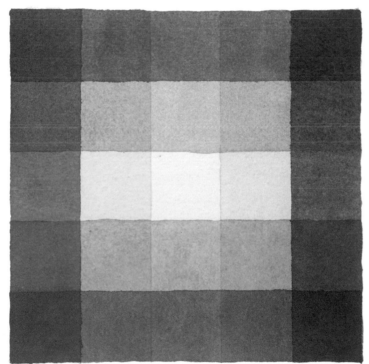

5 Lastly lay a wash of Magenta over the five outside squares over the Cadmium Orange block and Ultramarine Blue over the five outside squares over the pale Cobalt Blue block. You should have an array of twenty-five subtly different colors, the ones at the four corners each resulting from five overlaid washes.

Optical color mixing

If small spots of different colors are clustered close enough together, the eye—or, more precisely, the brain—will register them as an amalgam of those colors. This phenomenon is called optical mixing.

SEE ALSO

• Color theory, page 40

Optical mixing has been used most notably by a group of mainly French early twentieth-century painters known as the pointillists. They discovered that small dots of, for example, pale yellow, blue, and perhaps mauve, placed close together in a picture could produce an impression of a blue sky with an unusual vibrancy that could not be obtained from a pigment mix of the same colors. Moreover, by varying the number of dots of each color, the composite impression can be subtly modified to produce gradations of intensity of hue and tone. While such a method of painting is not a mainstay of watercolor paintings, which depend on composite colors produced by series of transparent washes, it can come into its own if body color is introduced.

Not quite in the same category, but related, is the use of linear cross hatching with either a brush or a pen. Thus lines of blue crossed by lines of yellow produce green by the same optical mechanism. A similar effect can be achieved by overlaying colored textures with a dry brush leaving some of the surface uncovered, a type of application commonly known as scumbling: layers of different colors so applied combine optical mixing where the marks do not coincide and overlaid mixing where they do.

In this enlarged section of the drawing, the individual orange, yellow, blue, and black lines can be clearly seen. The highlights have been left white and the tones built up with cross-hatching.

When the picture is viewed as a whole, the fine cross-hatched lines are combined in the viewer's brain to make the dark purple of the plums, the orange of the marmalade, and the blue shadows of the china hen.

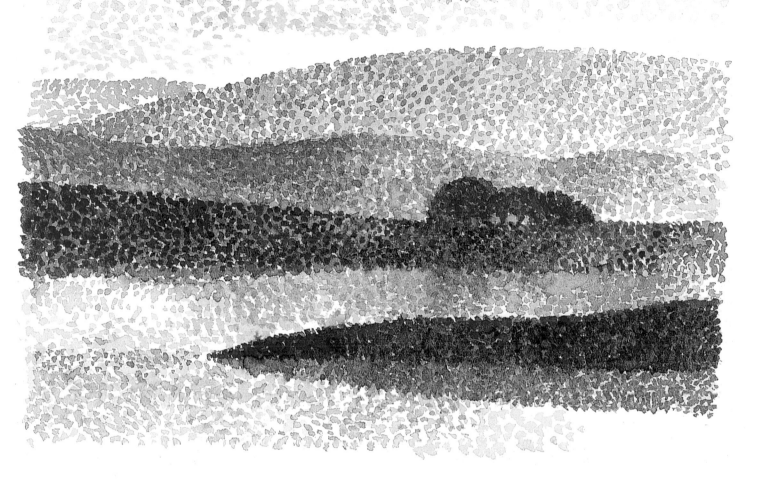

POINTILLISM

Above and left: Points of color placed close together so that they are combined in the eye is the same process that is employed in full-color printing—the only difference being that in printing. the points are too small to be seen without a magnifying glass.

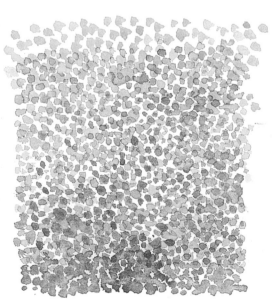

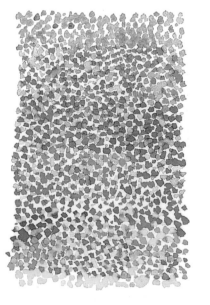

Composing with color

The way you choose to distribute colors within a painting has a profound effect on the mood of the work.

SEE ALSO

• Color theory, page 40

There are many theories that purport to say which colors go together to create harmonic compositions. Such theories presuppose that harmony is what you desire to achieve, which is not necessarily the case. Many successful compositions employ colors that create excitement by the way in which they clash in disharmony. As we have seen, complementary colors, when placed together, dazzle the eye and may be difficult to focus on. Paul Gauguin, the post-impressionist French artist, used this characteristic of complementary colors to wonderful effect. blue and orange, mauve and yellow, red and green repeatedly placed together.

On the other hand, colors that are close neighbors in the color circle present no risk of jarring clashes; they always sit easily together. For example, a composition in which the colors are all variations of blues and greens is likely to be acceptably harmonious and the same applies to compositions of blues and purples, or reds and oranges. The only problem with using these close harmonies is that they can be a little boring. Adding even a small amount of a contrasting complementary enlivens the composition and always works well.

Close harmonies and complementary spots

You can try out these combinations of complementary colors as abstract patterns. Remember that incorporating a small area of one of a pair of complementary colors to balance a large area of the other one can work just as well either way around: a predominantly green composition can benefit from a spot of red, just as a large mass of red can be made to sing with the addition of a little green.

The more you play with washes in this way, the more familiar you will become with the way that they behave, how intensities change as they dry, and how colors blend together and interact. Time spent experimenting in this manner is never wasted as it will free you up and carry over into the real situations when the strictures of observation and selection are often inhibiting.

BLUES AND ORANGE
A composition composed of a variety of blues works well with a spot of the complementary orange.

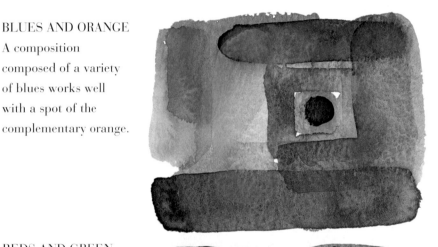

REDS AND GREEN
Similarly, swathes of hot reds are set off by a small amount of complementary green.

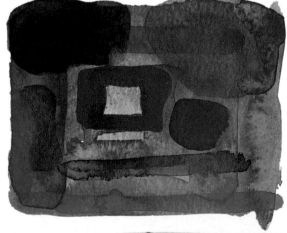

YELLOW AND MAUVE
In the same way, a mainly warm yellow composition benefits from the addition of a small, contrasting area of mauve.

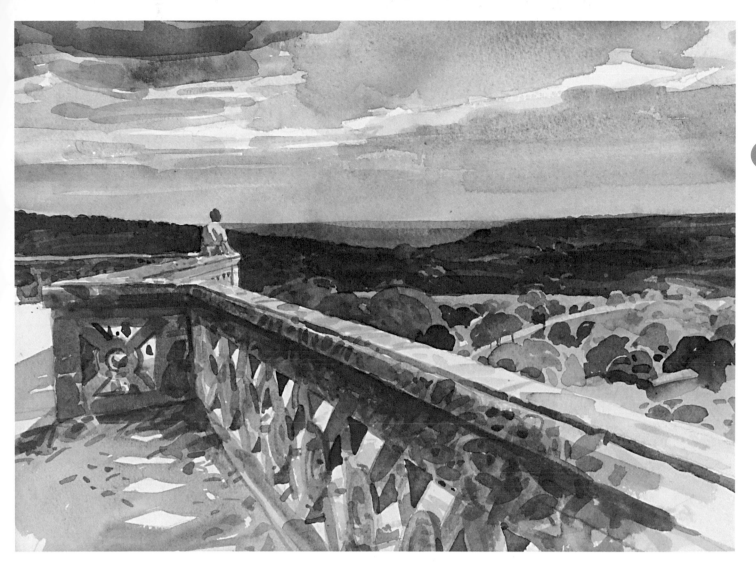

VIEW FROM CATHEDRAL, UZES

Look at this landscape composition. the strong perspective line of the wall leads in and looks as though it might slide straight out of the left of the composition but then cuts back; just as it turns left again, there is a figure in a pink dress, whose head breaks above the horizon and holds the eye inexorably. I am not suggesting that compositions should be contrived by the use of rules such as these. When you look at a subject, your choice of viewpoint may be made in an unconscious manner, the inherent pattern only revealing itself to you (and the viewer) as you work.

FELT PEN DIAGRAM

The prominence of such a small figure is due to both the bright contrast of the color and also its position. Although it is well away from the center of the picture, it seems to be at a center of active strong lines and is balanced by the broad triangle of forested hills and valley. Secondary interest in the right-hand middle ground is provided by the small variations of the lighter-colored trees, a sliver of pink roof, and the small arc of road.

Balance

Compositions also depend for their success on such qualities as balance and imbalance, primary and secondary centers of interest, and these are created by a combination of lines and forms as well as by color.

Just how these elements should be disposed in order to make a good composition, and why some arrangements seem to be more satisfactory than others, is not always clear. Balance is something that a composition needs —and clearly, a symmetrical arrangement in which the main subject is placed exactly in the center of the composition, provides this. However, arrangements that are completely symmetrical can become boring; moving the center of interest a little distance from the actual center of the painting, and balancing it with an area of secondary interest is another

way of achieving a pleasing sense of equilibrium.

There are some "rules" that suggest, for example, that you should avoid placing centers of interest too near the edges of a composition and that objects in the composition should either overlap or be well separated from others and not touching. Systems exist that enable pleasing shapes and divisions of shapes to be made mathematically, but in general the manner in which the elements of a picture are arranged is a matter of individual judgment.

BOATS ON BEACH,
PORTUGAL
Portuguese fishermen like to paint their boats with bright colors at least on their upper surfaces. In this picture of two boats on a beach at Lagos in the Algarve, small accents of brilliant reds, blues, yellows, and green offset the tones of yellow/brown and gray/mauve which cover most of the area of the painting. In the actual scene, a quite complex background of water and moored boats was visible but I chose to leave this out to keep attention on the shapes of the beached boats and their cast shadows.

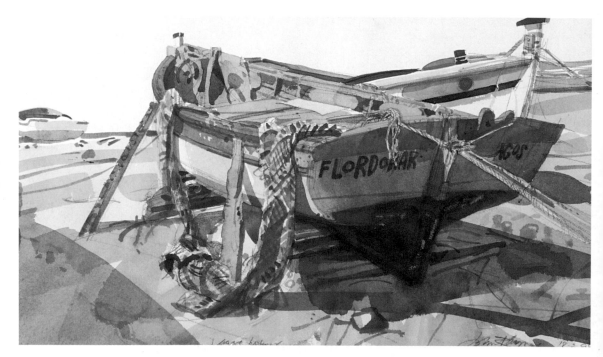

CONTE DIAGRAM
Here, the bright color is confined to a relatively small area that is balanced by large areas of muted colors with strong shadows.

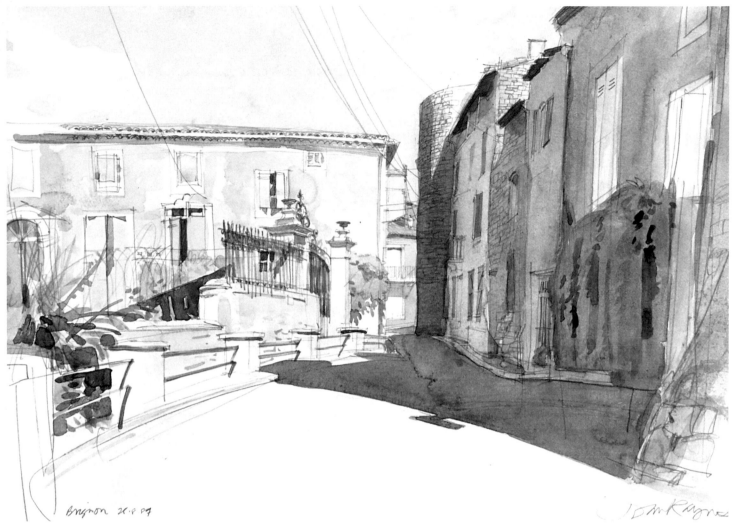

Brignon 26.8.04

BRIGNON, SOUTH OF FRANCE

The powerful summer sunlight gives this village street scene strong tonal contrasts, but the color is very muted. The stone walls are pale colored and even the metaled road is bleached by the sunlight to a lighter blue than the sky. Greens and blues are much favored paint colors for doors and shutters in this area of France, but roofs are generally pink or orange. So although the main compositional elements are the strong wedge of the shadowed buildings on the right and their cast shadow on the road, the rusty red on the railings of the gateway of the main house and the hint of warmer pinks as the street turns the corner in the middle of the picture enliven a composition that is still fundamentally calm.

CONTÉ DIAGRAM.
This simplified version shows how attention is concentrated on the gateway (circled in red).

Drawing and painting combined

In watercolor painting, any preliminary pencil drawing is normally submerged in the final painting. However, if the drawing remains dominant even after all the washes have been applied, the technique is known as line and wash.

SEE ALSO

• Pencils and pens,
 page 22

• Interior in line and wash,
 page 130

The drawing can be made with any linear medium—pencil, chalk, pen and ink—so long as the line work retains at least the same or more importance as the washes. The line work does not have to be black or even monochromatic: colored crayons or pen and colored inks work very well with watercolor washes. I often dip my loaded pen in water to dilute the ink. Although some artists recommend that you use distilled water to dilute inks, I have never found this to be necessary.

If your drawing is made with pen and ink, it is better to use waterproof ink to avoid the problem of the line work running when you apply subsequent washes of watercolor. Of course, the line work can be added after the washes have dried—but in this case you can't add any washes later.

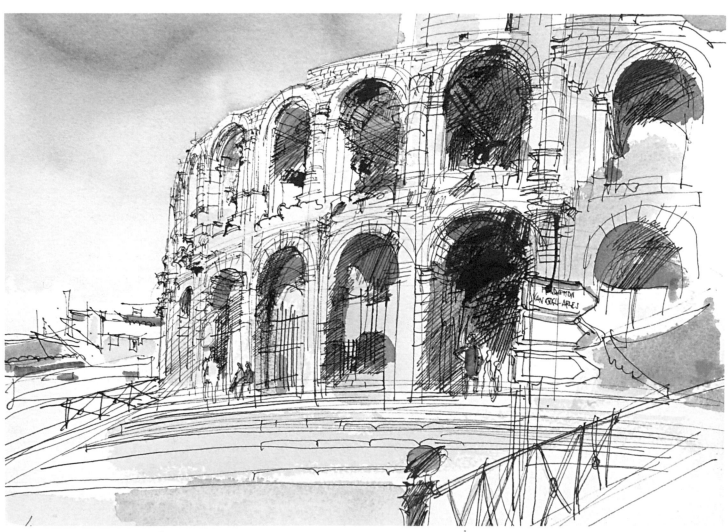

ARENES AT ARLES, FRANCE
This building is an ancient Roman amphitheater, which is still used for bullfighting (and gentler spectacles). I used a dip pen and waterproof India ink, creating some tones by crosshatching (sometimes smudged with the fingertip), and also by adding washes of black watercolor.

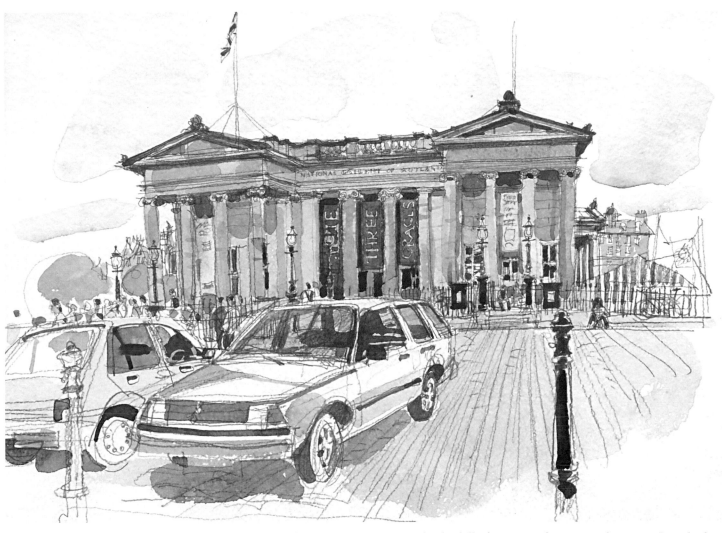

NATIONAL GALLERY OF SCOTLAND, EDINBURGH

I made this drawing during a visit to the Edinburgh Festival, which is held every August. Throughout the Festival, the streets are very lively, full of street performers and visitors. I made the drawing in pencil, sketching people as quickly as I could, and added the color washes later.

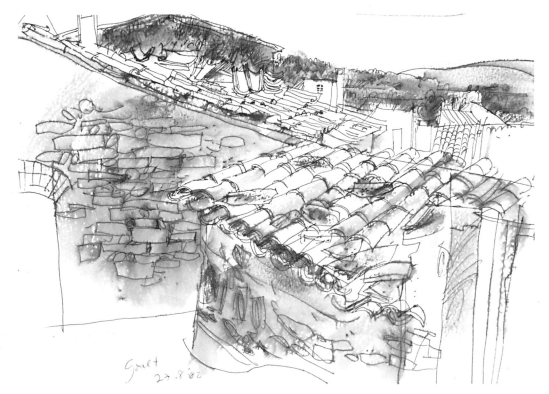

TILED ROOFS, PROVENCE, FRANCE

Line-and-wash drawings can be made with just a fiber-tipped pen so long as it is filled with watersoluble ink. You do not even need to have a brush: you can use your finger and saliva to spread the line work enough to create tones. The more close-hatched lines you draw, the darker the tone will be.

Materials

140-lb (300-gsm) rough watercolor paper

Medium dip pen

Black waterproof ink

Watercolor paints: Raw Umber, Raw Sienna, Cobalt Blue, Phthalocyanine Blue, Cadmium Yellow,

Permanent Magenta, Ultramarine Blue, Burnt Sienna, Viridian

Brushes: large wash

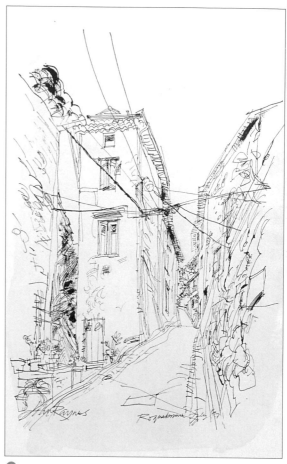

1 This street scene cries out for a strong, linear treatment. Using a medium dip pen and black waterproof ink, sketch the scene, taking care to establish the perspective correctly. Note that the roof, door, and window lines—that is, all the true horizontals—slope down by varying degrees as they converge on a vanishing point which is hidden by the rising road.

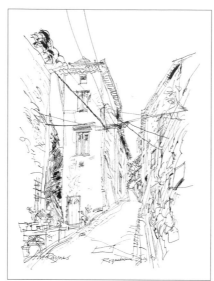

2 Start to add a little detailing in the stonework, remembering that as the bricks are laid in horizontal courses they will vanish to the same points as the windows and roofs. Loosely indicate some texture in the trees at the top of the street and in the buildings with loose scribbles or by smudging the wet ink with your finger

3 Mix a generous amount of a very watery, pale, stone-colored wash from Raw Umber and Raw Sienna. Using a large wash brush, wash it over the entire paper. Leave to dry.

4 Dampen the sky area with clean water. Mix Cobalt and Phthalocyanine Blue and drop onto the sky area while the paper is still wet. Drop pale Cadmium Yellow onto the bottom of the sky area, tilting the board backward so that the paint runs toward the top of the paper. Leave to dry.

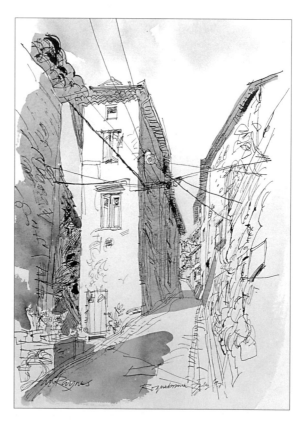

5 Add Raw Sienna and a little Permanent Magenta to the blue mixture used in Step 4 plus and wash it over all the areas that you know to be in shadow. Note that the main building on the left casts its shadow across the street and up the front of the building opposite. Dilute the mix slightly for the façade of the nearest building and its scallop-edged shadow. Leave to dry.

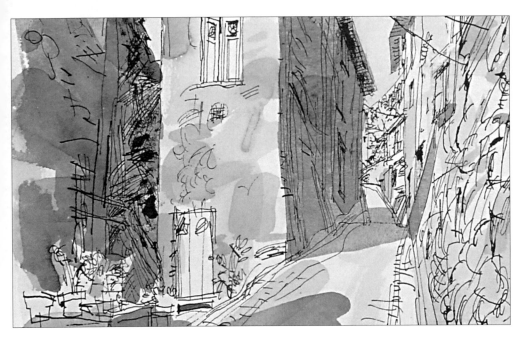

6 For the peeling plaster on the buildings, mix more Raw Sienna with a touch of the shadow mixture used in Step 5. Working within the lines of the drawing, brush this color over the buildings. Leave to dry.

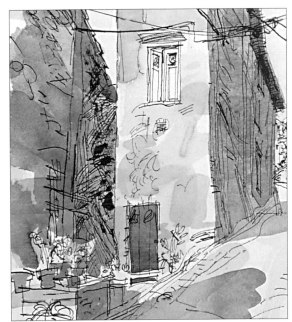

7 Mix Burnt Sienna with a touch of the shadow mix used in Step 5 and brush it on under the eaves to darken the shadows. Add more Raw Sienna to the mixture and paint the door at the bottom of the picture. Add yet more Raw Sienna and paint the shutters of the upper windows. Mix a dark orange from Cadmium Yellow and Burnt Sienna and paint the flowerpots.

8 Deepen the cast shadow that falls across the street and use the same color for the window recesses on the left-hand buildings. Add texture to the right-hand building by dropping in touches of the shadow color, wet on dry. Mix Viridian with a little Cadmium Yellow and dot in small areas of greenery among the plant pots and the trees at the end of the street.

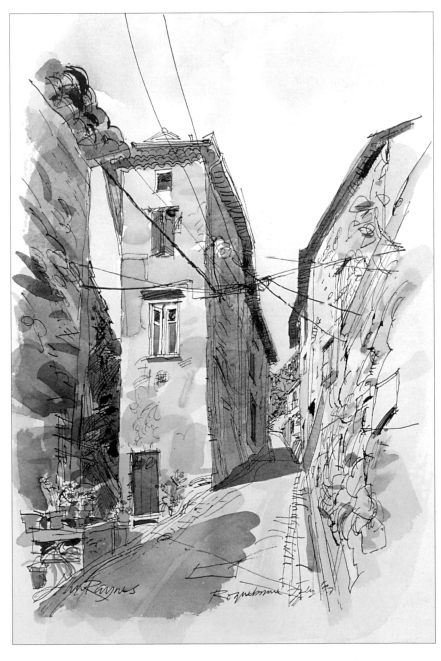

Types of mask

SEE ALSO

• Grasses and peeling paint, page 58

• Alternative methods, page 148

Masking is a means of protecting areas of the paper from paint, so that you can preserve either the whiteness of unpainted paper or your initial light-colored washes.

Traditional watercolor painting progresses from light to dark, which means that the lightest areas must be left alone as you gradually add washes around them to build up the darker tones. When these areas are small and detailed it can be very difficult to paint around them with the darker tones. The problem can be answered by masking off these areas to prevent watercolor washes from reaching them.

There are several methods of doing this, with varying degrees of precision and effectiveness. The following short practice exercises will allow you to master the techniques of using masks and resists before incorporating them into a larger project.

Note that masks and resists can be used to protect washes at any stage in a painting, not just at the beginning. Also, having masked an area and removed the masking material, washes can still be applied over all, moifying but not obliterating the effects.

Masking tape

Low-tack masking tape is good for covering large areas and can be trimmed for smaller areas. It masks areas effectively, giving crisp, clean edges to washes: you must take care not to position it too firmly, otherwise you may pull off some of the surface of the paper when you remove it.

1 Lay thin strips of low-tack masking tape down on a piece of watercolor paper. Brush on paint, leaving some areas of paper untouched, and leave to dry thoroughly.

2 Remove the masking tape, revealing crisp, sharp lines where the tape has protected the paper from paint.

3 Brush on more color, leaving some unpainted areas untouched.

Masking fluid

Masking fluid is a liquid form of rubber solution that can be applied with a brush or a pen and is totally impervious to water when dry. Washes can then be applied over the masked areas; when the wash is completely dry, you can remove the mask by gently rubbing off the fluid with your fingertips.

If you apply fluid with a brush, it is best to use an old one; although the fluid form can be washed off, it dries rapidly and is then almost impossible to dissolve. The dry, rubbery form of the liquid can be removed easily from pen nibs and other implements such as twigs and matchsticks can be discarded after use.

Wax

Candle wax resists washes, thereby masking areas that it covers. However, it cannot easily be removed and is somewhat random in its application. Herein lies its charm, of course: you can never be quite sure what will happen when you apply washes over waxed areas.

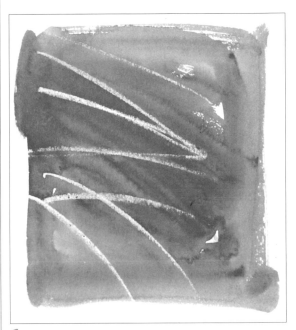

1 Rub an ordinary household candle over watercolor paper in a series of zig-zag lines. Apply a watercolor wash over the top and allow to dry. The wax resists the paint.

1 Apply masking fluid over a dry wash. Allow to dry thoroughly.

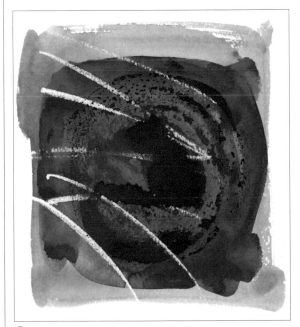

2 Paint over the masking fluid.
3 Rub off the masking fluid with your fingertips, revealing the initial wash.

2 Rub more candle wax over the top of the wash in a circular motion. Apply watercolor paint over the top. If you use enough paint, it will cover the wax—unlike masking fluid, which provides an impenetrable resist.

Grasses and peeling paint

Making precise renderings of the many textures that you might encounter is demanding and unnecessary. It is better to create completely new ones—and using masks and resists gives you the chance to do just that.

SEE ALSO

• Types of mask, page 54

• Textures and additives, page 60

Materials

4B pencil

Watercolor paints: Raw Sienna, Ultramarine Blue, Burnt Sienna, Permanent Magenta, Cobalt Blue, Cerulean Blue, Cadmium Yellow, Sepia, Lamp Black

Brushes: large wash brush, old fine brush

140-lb (300-gsm) rough watercolor paper

Household candle

Peeling paint can make beautiful patterns as it weathers to reveal underlying colors. By laying a wash to represent the lower paint layer, applying a wax resist, and then applying a wash of the top color, you can create a very realistic effect that would be difficult to create with washes alone.

The pattern of grasses against the shadow in the foreground of this subject could be rendered by carefully painting around the stems, but here they were masked with masking fluid. This saves time and, more importantly, allows you to paint in a much freer way.

1 Using a 4B pencil, sketch the outline of the boats and foreground grasses. Then wash very pale raw sienna onto the hulls of the foreground boats and apply a stronger mixture of Raw Siienna to the gunwale of the nearest two boats. Mix a gray from Ultramarine Blue and Raw Sienna and apply it to the gunwale of the next boat in. Leave to dry.

2 Lightly rub a small piece of household candle over areas of the boats where the paint is peeling.

3 Mix a rich, reddish brown from Raw Sienna and Permanent Magenta and apply it over the gunwale of the foreground boat; it will be resisted by the wax applied in Step 2. Brush a mixture of Cobalt and Cerulean Blue over the gray underwash on the other boat to create a similar effect. Leave to dry.

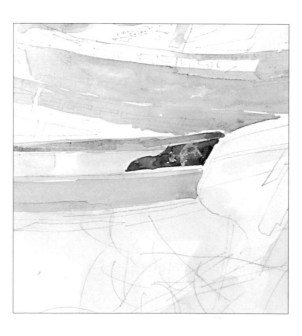

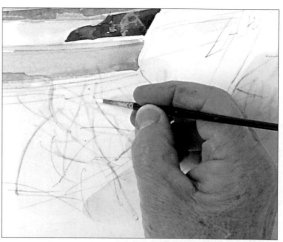

4 Using an old brush and washing it out after each stroke, paint in the lines of the foreground grasses with masking fluid. Leave to dry.

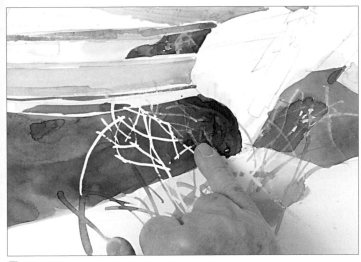

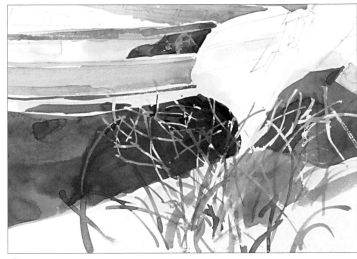

5 Apply a strong wash of Sepia mixed with Lamp Black over the foreground shadow area under the boats. Leave to dry. Mix the shadow wash with Raw Sienna and brush broad strokes of this color over the immediate foreground to suggest grasses. Leave to dry. Rub off the masking fluid, revealing fluid white lines where no paint has touched the paper.

6 Masked white lines on a dark background often look too abrupt, as they do here. If this is the case, apply washes of color over them to reduce the contrast and complete the impression of grass stems against shadow.

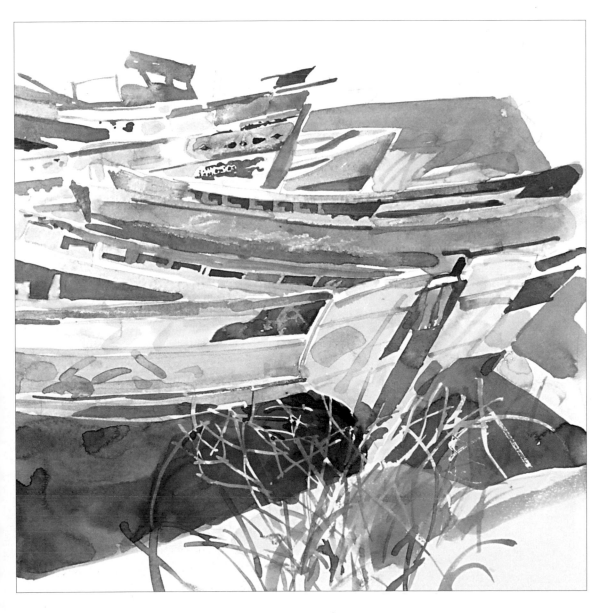

7 Continue working across the painting, filling in the colors of the boats in Cerulean Blue, Cobalt Blue, and Ultramarine Blue. Mix Ultramarine Blue with a little Lamp Black and use this color for recessed areas that are in shadow.

TEXTURES AND ADDITIVES

SEE ALSO

- Watercolor accessories, page 24

- Alternative methods, page 148

- Woodland collage, page 150

HOW TO GET THE BEST OUT OF WATERCOLOR

Although washes are usually applied using brushes, there are other ways of putting color down on paper, as well as various substances that can be added to paint—all of which can make a variety of enriching textures.

Firstly there are all the various ways of spraying color onto your paper. These range from tapping a loaded brush and pulling back the bristles of an old toothbrush to dislodge droplets of paint to creating fine spray by means of mouth-activated devices and airbrushes.

Then there are tools as primitive as twigs, feathers, and coarsely cut wooden pens, which make marks that are less controlled than manufactured pen nibs.

Color can be also be printed onto the surface using pieces of fabric or crumpled paper. Anything with a textured surface can be inked up, so to speak, and printed as part of a watercolor painting. If you are prepared to get a little messy, hands and fingers are also excellent tools for applying watercolor texturally.

There are also various substances that can be added to paint, or dropped onto wet paint on the paper. Ox gall is a wetting agent and increases the flow of color; if it is dropped neat into an already laid wash, it can produce an immediate and dramatic flow away from the point of impact. Gum arabic mixed with a wash renders it more fragile so that subsequent splashes of water (intentional or otherwise!) produce spots of reduced color. A similar effect results from scattering salt onto a wet wash, the crystals absorbing the color where they drop.

MOUTH SPRAY

Spray droplets as fine as this can produce sharp negatives of paper masks.

TOOTHBRUSH SPATTER

Larger, less controllable droplets flicked from a loaded toothbrush; the surrounding brush strokes are just for emphasis.

OX GALL

A small amount of neat ox gall dropped into a wet wash makes the color run away from it in a dramatic fashion.

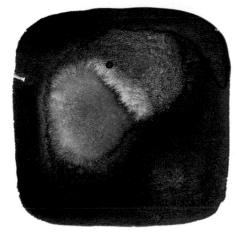

GUM ARABIC

If a little gum arabic is mixed with a wash it is rendered fragile so that, even when it is dry, it can be dissolved by drops of clean water.

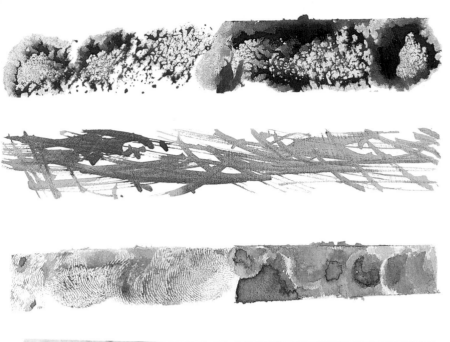

COLOR LIFT-OFF

This texture is produced simply by pressing pieces of paper onto wet washes and lifting them off.

BAMBOO PEN

Pens are not solely for ink: these marks are made with watercolor and a broad-nibbed bamboo pen.

FINGERPRINTING

You can create an interesting texture by dabbing a finger into a wet wash and spreading it by printing.

SPATTERING INTO WET

Spattering paint onto a wet wash using a mouth spray, toothbrush, or paint brush produces unpredictable results.

CARD EDGES

Brush paint onto the edge of a piece of card and press it onto the painting surface to create straight lines.

SALT CRYSTALS

When salt crystals are scattered on the surface of a still-wet wash, they absorb the color, leaving these characteristic marks.

FABRIC PRINTING

Brushing wet color onto various weaves of fabric and then pressing them onto the painting surface gives another whole range of textures.

CRUMPLED PAPER

Crumple paper, dip it into a wash of color, and press it onto the painting surface. Newsprint, tissue paper, tracing paper, and even things like plastic food wrap can all be used in this way to create different textures.

Opaque color

Gouache frees you from the need to progress from light to dark through overlaid washes and makes it possible to overpaint darker colors with lighter ones.

SEE ALSO

• Opaque watercolor, page 16

BODY COLOR AND WATERCOLOR

White and very light tints of blue and yellow body color were applied over a watercolor underpainting to emphasize the contrast between interior and exterior.

Gouache paints are manufactured to have more body and stronger coverage than pure watercolors and are intended to be used in opaque layers. Colors may be mixed on a flat palette rather than in dishes. If other pigments such as inks and even pastels are introduced, the method is known as mixed media.

A disadvantage of gouache is the loss of transparency that is characteristic of pure watercolor, although it is possible to retain luminosity in dark areas by using washes, applying thick layers only in light passages.

The big advantage of body color is that you can change and correct your painting more or less indefinitely. There is practically no limit to the number of layers that can be applied. However, there is one difficulty of which you need to be aware: colors placed over other thick layers appear one color as they are applied, but quite a different one as they dry. This means that you need to wait a while, note how the applied color has changed, and—if necessary—make appropriate changes to the mix.

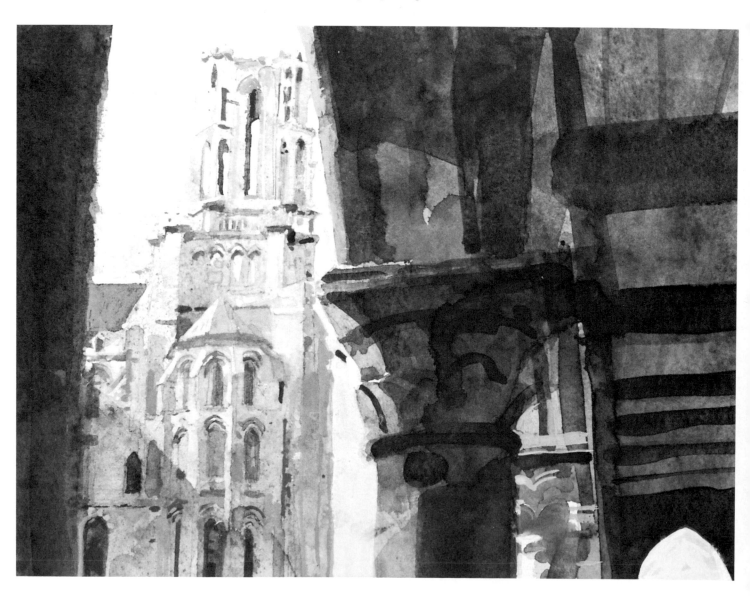

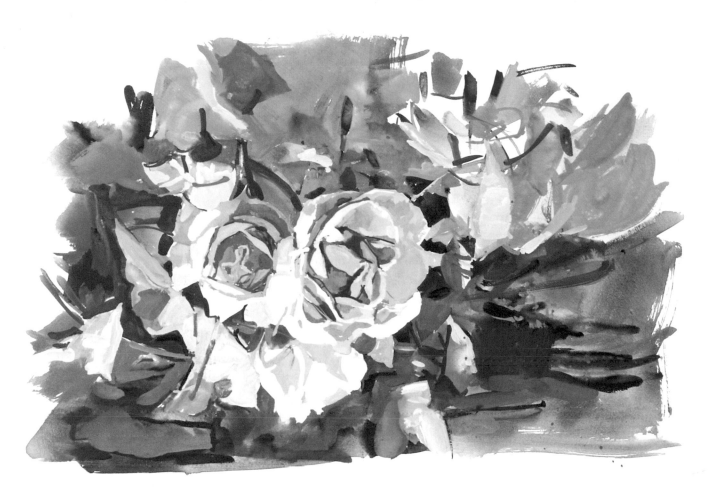

GOUACHE ALONE
Gouache probably increases your chances of rendering a flower as pale colored as this one and allows you to manipulate the light shape against the dark background.

WATERCOLOR, GOUACHE, AND PEN LINE
A pen-and-ink drawing was overlaid with watercolor washes, progressing to body color for the lights and highlights.

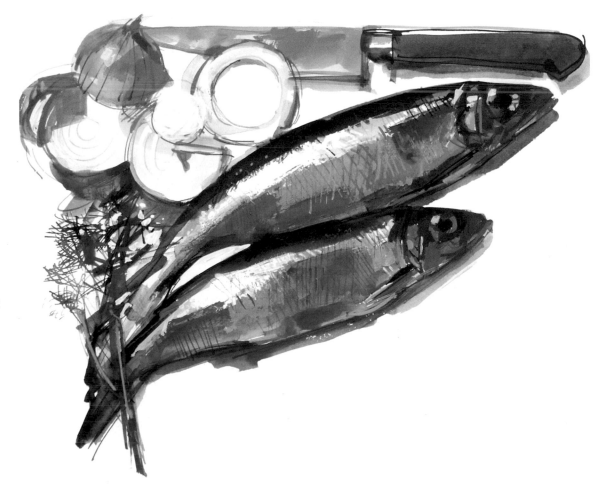

Tiled roofs

Once you have decided to use an opaque medium such as body color or gouache, there is no need to preserve a white surface for your first layers of color, as you can add the lighter tones as the work progresses.

SEE ALSO

• Surfaces, page 17

• Opaque color, page 62

Materials

Stretched NOT surface watercolor paper

Gouache paints:
Ultramarine Blue,
Phthalocyanine Green,
Lamp Black, Raw
Sienna, Jet Black,
Cadmium Orange,
Brilliant Yellow,
Permanent White,
Raw Umber,
Vermilion, Magenta,
Phthalocyanine Blue

Brushes: Large square-ended sable mix brush, large and medium Chinese or round brushes

To demonstrate gouache's ability to cover dark colors with lighter ones, I began this project by applying a medium density, strongly colored overall wash as a basis from which work can progress in both directions, toward light and dark. I chose ultramarine blue as a cool foil to the largely warm colors of the sunlit tiles in this view of roof tops in the south of France.

Painting on a light ground has the added advantage of giving the picture a sense of compositional unity right from the beginning. Because gouache gives you the ability to cover dark colors with lighter ones, there is a danger that you may lose this initial harmony of color by completely obliterating every trace of the unifying underpainting. To avoid this, you should try to retain something of the colored ground as part of the finished painting wherever possible.

Since, in this case, the underpainting is blue—a cool color—it can be allowed to show through in the shadow areas. This can be achieved either by scumbling the overlaid color so that untouched blue shows through, or by applying washes of color in the shadow areas, which allow the blue to shine through. The fact you can completely cover underlying layers does not mean that you must always do so.

1 Lay an Ultramarine Blue wash over the whole surface. You may need to apply a second wash to make the colour strong enough.

2 Using a medium round brush, map out the main elements of the composition, using PhthaloGreen plus Lamp Black for the background hill and darker edges and Raw Sienna plus Jet Black for the first indication of the walls. Put in some spots of Cadmium Orange and Brilliant Yellow, plus White where light catches the roof tops and near wall.

3 Put in the shadowed walls, scumbling the color (that is, dragging paint to allow the underpainting to show through) with a variety of mixtures of Raw Sienna, Raw Umber, and Black. Establish the color of some of the lightest tiles with a mixture of White and Vermilion gouache paints.

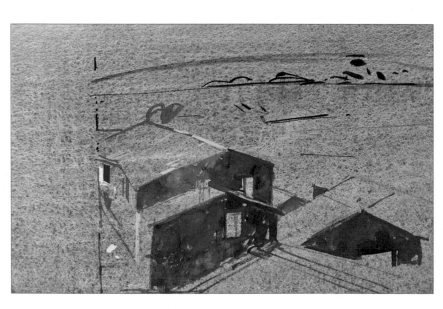

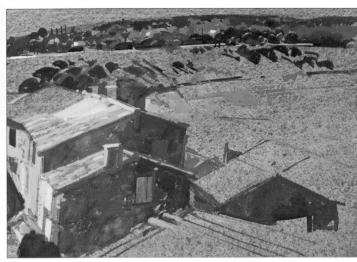

4 Put in the backgound hill and some simple tree shapes in various mixtures of Pthalo Green, Raw Sienna, and Yellow. Begin painting the pale roof colors with light mixtures of Yellow, Orange, and White.

5 Using a large Chinese or round brush, scumble a darker wash of Ultramarine Blue and Jet Black over the near wall as an undercoat. Mix a mauve color from Ultramarine Blue, Magenta, and Brilliant White, and loosely paint the distant hill. Paint the sky in varying mixes of Phthalo Blue and White.

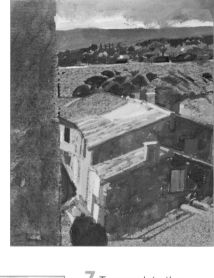

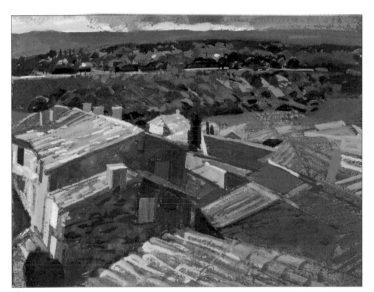

7 To complete the sketch, I reinforced the sunlight on the walls of the foreground houses with warm tints of pale Raw Sienna, Yellow, and nearly White. I also put in the stonework on the foreground wall with various mixes of Raw Umber, Raw Sienna, Black, and White.

6 Continue to add warm tints on the roofs. You do not need to work out the perspective of every building—just look for the pattern that the roofs make with each other. At this stage I also covered most of the underpainting on the slope from the background road with a mid green and added more tree shapes.

8 Finally, I decided to lighten the sky somewhat and to change the color of the far hills. You may feel that these changes were not successful and that the painting was more dramatic before: I am inclined to think so, too, but it serves to show how easy it is to make major changes using gouache.

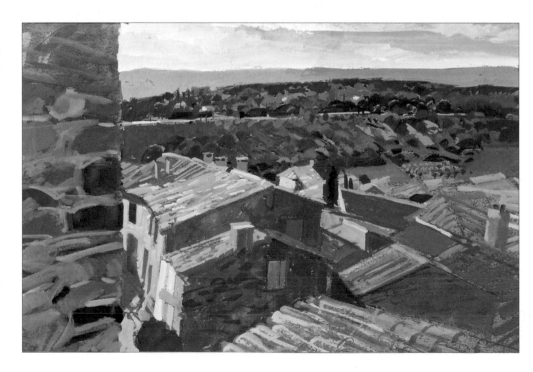

Making pictures
in watercolor

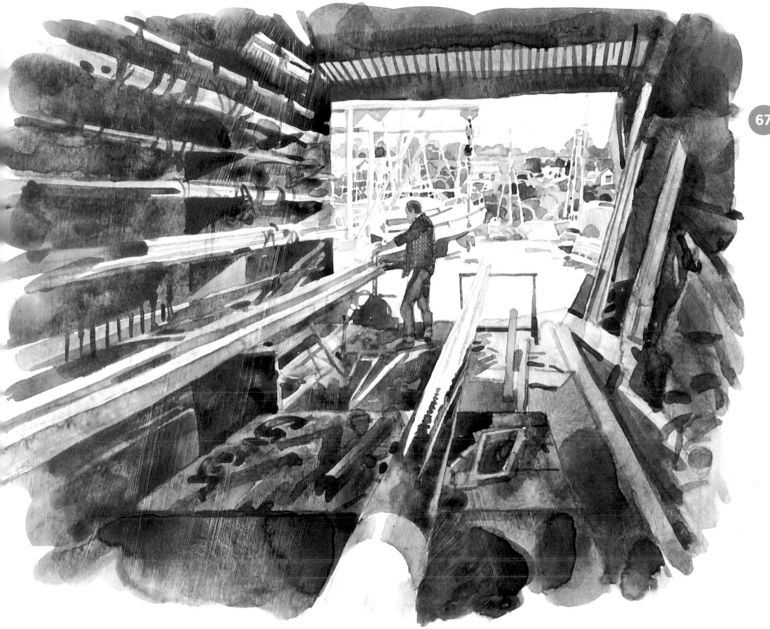

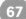

There are some subjects that seem to cry out for the freshness and translucency that watercolors so naturally deliver—flowers and fruit, water, and cloud, for example. Others, such as landscapes and interiors, benefit from multiple washes that combine to build up a greater richness of tones and colors.

Landscape painting has probably benefited most from this particular method of applying washes of clear color, a manner of painting that emerged just when artists were beginning to look for ways of evoking the effects of sunlight and atmosphere.

For interiors, watercolors are not always the medium of first choice: atmospheric effects are less important than in outdoor subjects and there may be regular decorative patterns and objects which give

less scope for interpretative treatment. However, the delicate effects from light entering windows can be beautifully rendered in watercolor.

Probably the most demanding subject for the student watercolorist is the human figure, especially the human face. There is so little room for error. Don't be put off by this: there is nothing inherently more difficult about painting a face—it's just that the viewer is so much more critical.

In the projects that follow I have tried either to match my technique to the subject or to suggest an alternative procedure. I hope that by recounting the way in which I responded to the subject, I will have helped you to make your own decisions about how to proceed—but these are merely suggestions, not a series of steps to be followed by rote.

Fruit and Vegetables

The aim of this project is to create a still life with a rich mixture of texture and color. When selecting your objects, look for a mix of strong forms and clear colors, and a certain amount of man-made pattern.

SEE ALSO

• Balance, page 50

• Types of mask, page 56

• Alternative methods, page 148

Materials

90-lb (185-gsm) rough
watercolor paper,
pre-stretched

Watercolor paints:
Lemon Yellow,
Viridian, Raw Sienna,
Cobalt Blue, Indigo,
Carmine, Cadmium
Yellow, Ultramarine
Blue, Vermilion,
Cadmium Orange,
Lamp Black, Raw
Umber, Phthalo Green

Brushes: large wash,
rounds in varying
sizes

Masking tape

Old toothbrush

Scrap newsprint

Rag or paper towel

There are occasions when the pressure of time and the need for bright, or even raw colors, demand a very direct approach. In oil painting this is called "alla prima" painting: the colors are pre-mixed and applied full strength instead of being built up in layers. To demonstrate this approach in watercolor I set up a colorful still-life group. There is no preliminary drawing and much of the paper is left white.

When arranging a subject for this exercise, choose fruits or vegetables with strong forms and clear colors. I chose celery, an eggplant, a lemon, and some bay leaves. Try to include something with thin stems and light tone that can be placed against a darker object. Unify the group by placing the objects on a plate of some sort, on a dark or a textured background. I placed the red dish on a slate sill and propped up pieces of slate behind the group. If sunlight is available, arrange the group out of doors; otherwise illuminate the still life from the front with a powerful single light (a table lamp will do).

1 Using a pale mixture of Lemon Yellow and Viridian, draw with the brush to establish the main shapes of the celery sticks. Add more Viridian to the Lemon Yellow, and continue drawing to find the form of the lemon. Make up a color for the bulk of the lemon: look at the lit side, which will be very yellow. Judge its size by gauging the spaces between the surrounding leaves for reference. The lemon has dimples in its surface which catch the light: these must be left as bare paper, in order that they can be read as light points. Draw the shape entirely, and look closely at its overall shape: maybe it presents flat planes, not just an egg shape.

2 Draw into the celery leaves, refining their forms. You must determine the light areas first. Draw the darker areas of the leaves and along the length of the celery sticks with darker greens. The direction of the celery determines the location of all the other elements, so be as accurate as possible. Find the brightest pink you can—I used a "brilliant" liquid watercolor—and carefully define the pink highlights of the plate.

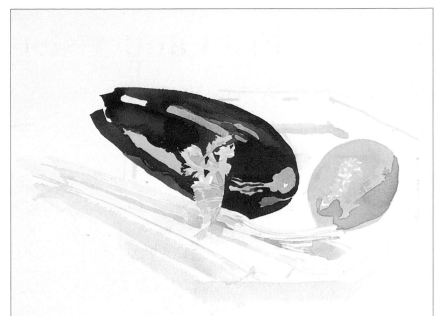

3 Using Lemon Yellow, Raw Sienna, and Cobalt Blue, make a subtle, greenish shadow color for the lemon. Be aware that there may be reflected colors of the bowl in the shaded area of the lemon. Also, drop in the dark dots of the shadow side in the dimples. The highlights on the eggplant are relatively blue, so treat them with a weak Cobalt Blue wash.

4 Use Indigo and Carmine to make a deep purple for the eggplant. Look for places where the edge of this dark color is defined by something you have already drawn. Use the biggest brush you feel comfortable with—you need the sharp point for detail, but the body to maintain the very wet wash. Feel your way out to the edges of the eggplant, using the detail imposed by those other forms as a reference. Remember, the red of the plate will further define the edge where they meet.

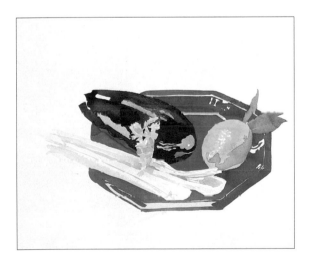

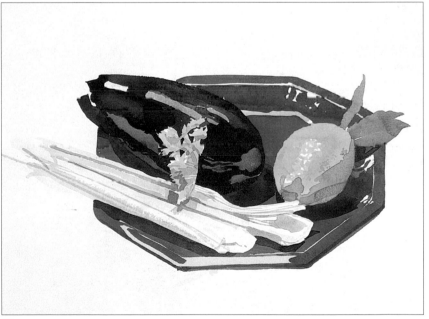

5 Draw the bay leaves in a light green made from Cadmium Yellow and Ultramarine Blue. Mix up a large quantity of red from Vermilion and Cadmium Orange for the plate. Make sure that the painting is entirely dry, as the red encloses all other elements of the painting. Follow the original bright pink marks you made earlier, but adjust them if necessary. All reflections must be left out of this color, so look hard and try not to miss any: they vary from the cool, bright pink already painted to a few pure white shapes at the corners and edges. You are defining the final shape of the fruit here, as well, so make sure their shapes are correct.

6 Make a shadow color for the red plate, from Carmine modified with Indigo. This color is amongst the darkest of all and can be used to redraw any of the fruits. I judged that the green highlights in the eggplant, reflected from the celery, were too pale, so I modified them with a light wash of the main eggplant color. Add another tone into the shaded side of the lemon to indicate the pink reflected light from the plate; this is Cadmium Orange, in a thin wash, which will be modified optically by those colors that preceded it. Also, use a green made from Cobalt Blue and Cadmium Yellow, to draw into the celery, defining its longitudinal strata, paying attention to their curved forms.

7 Paint the top of the eggplant with a blue-green, modified with a bit of yellow, and mix a dark green from Viridian and Lamp Black for the shadow area of the bay leaves. Leave to dry and draw in the bottle with a pale wash made from Cobalt Blue, with perhaps a little Raw Umber. Mix a bluish gray from Ultramarine Blue and Indigo for the background slate that can be seen through the bottle. This enables you to define the top of the eggplant, and any other elements that protrude above the plate. The top of the eggplant is reflected in the bottle; this must be left as white paper. Use a large wash brush, with a Raw Umber and Ultramarine wash, to apply the large, dark areas behind the plate.

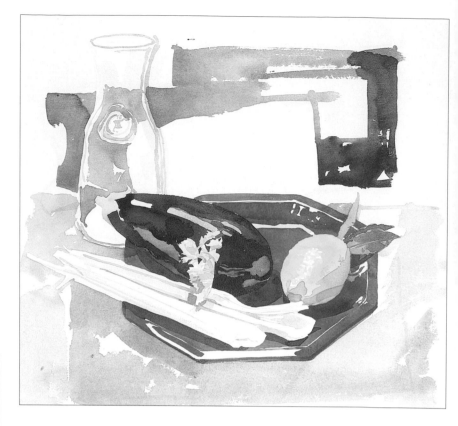

8 Mask off the main plate. This does not need to be done too carefully; just use ripped masking tape and newspaper. Don't press down the masking tape too hard: it only needs to adhere lightly, and you don't want to risk peeling off the surface of the paper. Use a craft knife blade to cut the tape around any protruding leaves if you need to.

9 Use a toothbrush loaded with paint to spatter, and ordinary brushes to paint in, freely, the various colors that occur through and in the slate and the painting behind. If these processes produce some marks that you feel are too strong, and dominate the image, then you can easily blot them with a piece of rag, or tissue. It is a good idea to dry the painting at intervals during these experimental stages so that the marks don't run into one another. Above: Carefully remove the paper and masking tape.

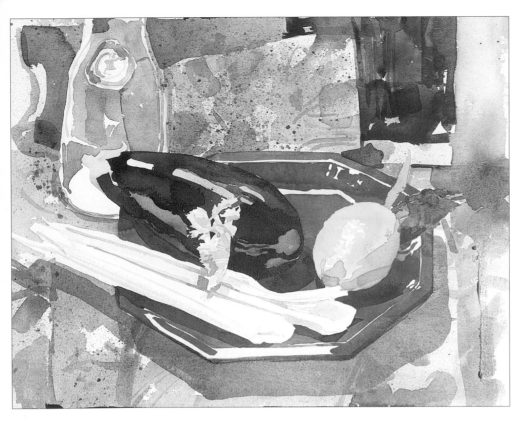

10 Make a strong wash from Raw Umber and Indigo, and paint the deep shadow cast from the plate onto the slate underneath. Here, this is a crisp octagon, broken by the shadows from the protruding fruit—the celery and the eggplant. This and other colors are used to complete the edges between the bottle and the slates. These marks are almost abstract, only lightly inferred from what is actually there.

11 Take a minute or two to reappraise what you have done. I felt, on reflection, that the highlights on the eggplant were too high in value, and the bottle bottom was too bright; also, the bay leaf was affected by paint leaking under the masking tape, and needed to be repainted using Phthalo Green modified with a little black. Using a dark blue gray (Indigo and Raw Umber), I also redrew the complex shapes that occur in the bottle. Also, where the glass is thickest (where the bottle turns away from view), it betrays its natural greenish color, so I indicated this with a suitable green wash.

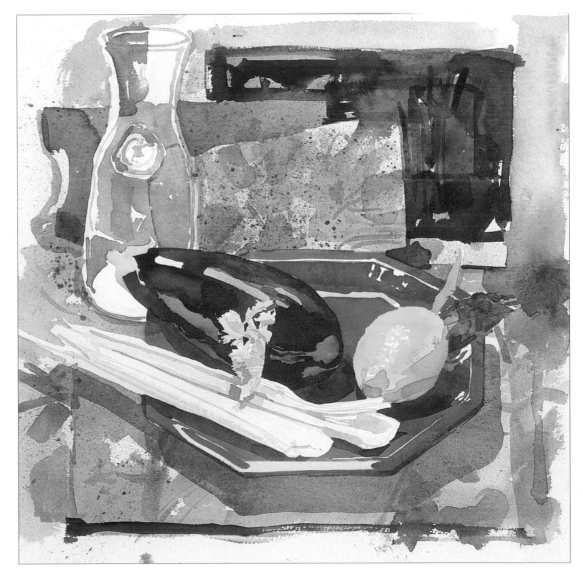

Glass and shells

For this still-life arrangement of sharp, reflective forms, I chose on work on paper on which I had first painted a layer of white acrylic gesso. This is an unusual surface on which to apply watercolor and it may not suit everyone, but it is worth trying at least once.

SEE ALSO

• Surfaces, page 17

Shells and glass tend to have smooth forms with sharply defined edges. The almost pure white interior of this conch shell is partially in shadow but still shows up sharply against the weathered timber in the background. There is also a contrast of textures, the smooth luster of the shell surfaces playing against the flaking paint layers of the boat keel that I found on a beach in Portugal. Natural or man-made forms that have been weather eroded are often very interesting to draw and paint and it's a good idea to have a small collection of such objects for composing still-life groups.

Materials

HB pencil

Watercolor paper primed with acrylic gesso

Watercolor paints: Raw Sienna, Ultramarine Blue, Vermilion, Cobalt Blue, Indigo, Raw Umber, Lamp Black

Brushes: medium round, small sable

1 Using an HB pencil, draw the still-life set-up. A still life as complex as this, and with such sharp edged forms, needs to be drawn up quite carefully. Draw lightly where the color and tonal changes are subtle, as in the inside of the large shell. Elsewhere the edges can be stronger.

2 Mix pale washes of Raw Sienna and Ultramarine Blue and, using a medium round brush, paint the shadowed areas on the interior of the shells. On this non-absorbent surface there is less need to be nervous about applying the first light tones, as they can be easily modified or removed completely. Leave to dry. Apply Raw Sienna over the fishing nets to create the base color of the nets.

3 The shadow on the underside of the big shell is warmer in color and consequently put in with Raw Sienna slightly modified with a touch of Ultramarine Blue. Apply some darker tones to the interior shadow tones to indicate the fluted interior curves, and put in the warm pink of the china egg and the interior of the glass vase with Vermilion.

4 Now put some tone on the small shells inside the main one. It is not possible always to list exactly what colors to use for subtle light tones: to some extent it is a matter of using the remains of previous washes that are on your palette and modifying them to be warmer or colder as you think fit. With care, you can start adding brighter, stronger colors at this stage—on the bright Cobalt Blue of the glass vase, for example.

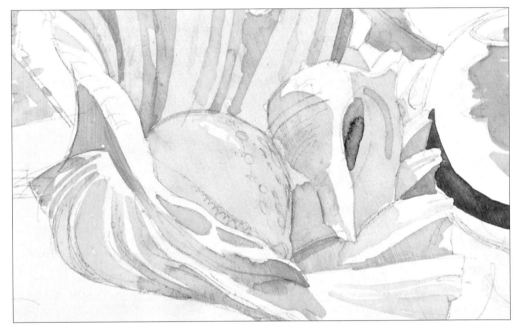

5 Now that the still life is starting to take shape, you can put in a dark tone against which to evaluate the tonality of some of the paler tones. I used a mixture of Indigo and a little Raw Umber, for the very dark shadows under the still-life objects, using a small sable brush to define edges of dark tone. Tilt the board to allow the pigment to settle evenly.

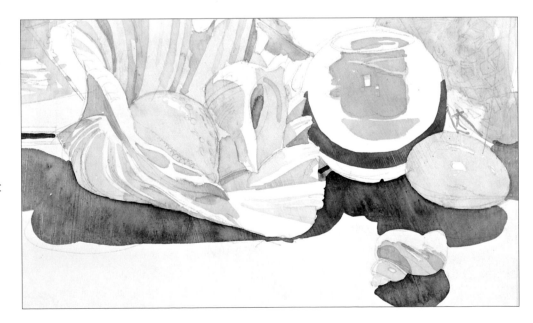

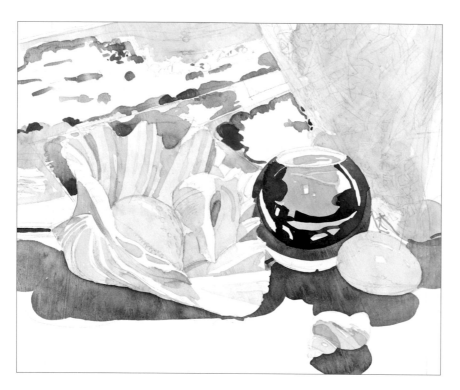

6 Paint the timber of the background boat with a mid blue mixed from Cobalt Blue and a little Lamp Black. Paint the darkest tones on the blue vase with more strongly pigmented washes of Cobalt and Lamp Black.

7 Use a darker blue (Cobalt mixed with Lamp Black) for the top paint layer on timber, leaving only broken edges of lower mid-blue layer showing through.

8 Paint the dark shapes of timber that can be seen through the mesh of the fishing net; this takes time but it's the only way of describing thin, light-colored shapes against dark with watercolor other than using masking fluid.

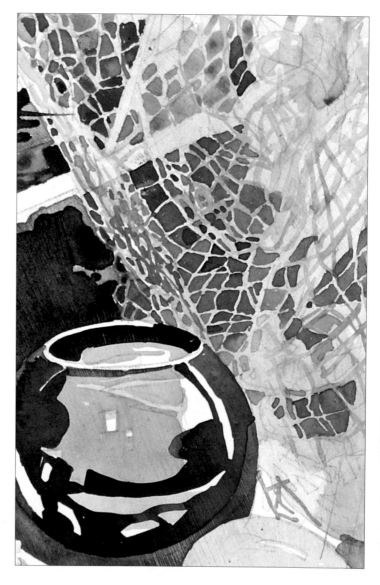

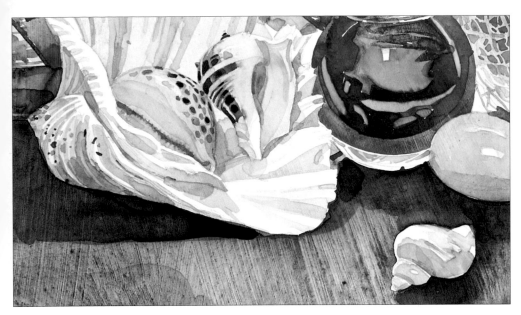

9 Add detail to the outside of the main shell using mixtures of Raw Sienna, Ultramarine Blue, and Lamp Black. Deepen the tone where necessary on the small shells. Apply a final dark wash to the foreground to enable you to judge what tone the light-colored shells need to be; I used strong washes mixed from varying amounts of Lamp Black, Indigo, and Raw Umber and allowed the paint to settle in the brushstrokes that had been created when I applied the gesso ground.

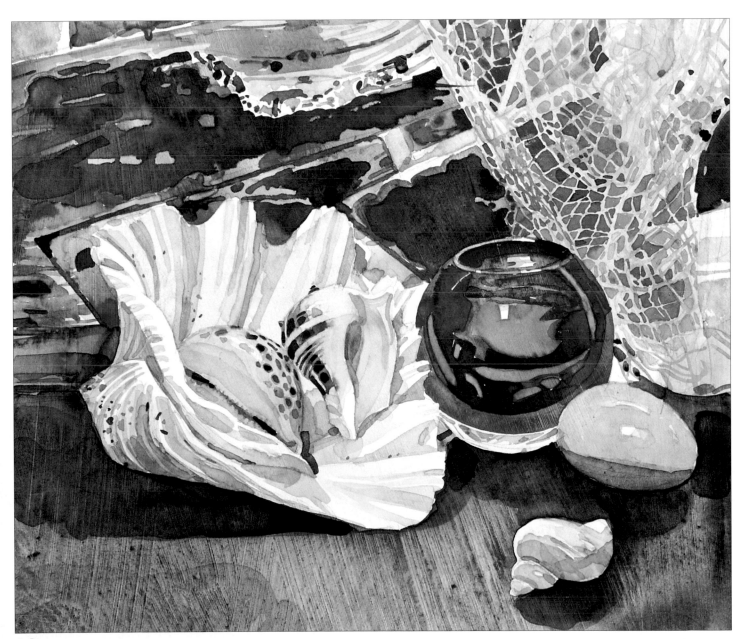

10 Now that all the ground has been covered, you can make your final asssessment of the tones and complete the detailing on the shells.

Trout and almonds

Fish, generally depicted lying on a table or a similar surface arranged with other foodstuffs, have always been popular still-life subjects.

SEE ALSO

• Using tone to create a
 3-D effect, page 36

• Painting from
 photographs, page 142

In this arrangement, the prepared trout have been placed on cooking foil and strewn with flaked almonds and spring onions ready to be cooked. The aluminum foil is highly reflective and produces lots of intersting, differently colored sharp-edged facets as it is crumpled around the fish.

I did not set up the subject in order to paint it, but it looked so interesting that I rushed to find a camera to record it. This type of vignetted design is often used as decoration for cooking books and articles and, as such, it falls into the category of illustration rather more than painting.

Materials

Line board

HB pencil

Tracing paper

Dark gray transfer paper

Watercolor paints:
 Cadmium Yellow,
 Phthalo Green, Lamp
 Black, Cobalt Blue,
 Raw Umber, Burnt
 Sienna, Vermilion,
 Viridian, Magenta

Brushes: fine round

1 Carefully trace your photograph onto tracing paper and tape the trace in position on your painting surface. Place a piece of transfer paper between the two and transfer the image by drawing firmly over the traced lines with a hard pencil sharpened to a fine point or, better still, with a sharp, smooth-pointed instrument such as a dressmaker's seam ripper. Take your time over this stage, as you need to establish at the outset where the lightest areas are going to be.

2 Mix a mid-toned wash of Cadmium Yellow and, using a fine round brush, brush it over the white end of the spring onions. Drop Phthalo Green wet into wet on the green end. Add a touch of Lamp Black into the darker ends. Mix a dilute gray from Cobalt Blue and Lamp Black. Put in the very pale, almost silvery gray on the belly of the topmost fish, working carefully around the almonds.

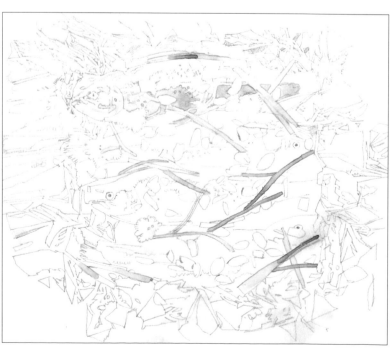

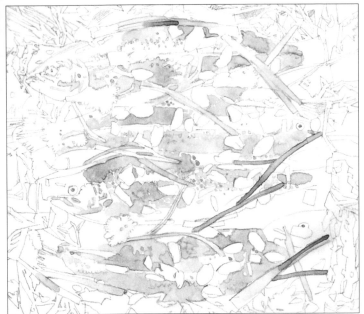

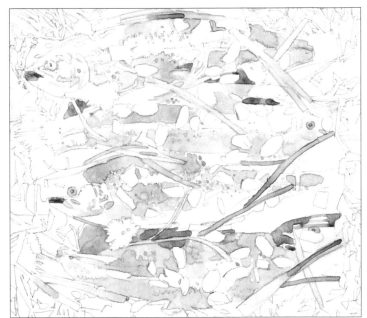

3 Continue painting the fish, ignoring the darks and concentrating on getting the light tones. Paint in the brown areas of the second fish, which is noticeably warmer, using a mixture of Cadmium Yellow and a little Raw Umber, adding some of the previous gray mixture for the bluer areas. Note the line along the body: the body is a different color to one side of this line. While this brown mixture is still on the brush, move on to the third and fourth fishes. Leave to dry.

4 Mix a bright orange from Burnt Sienna and a little Cadmium Yellow. Carefully brush it in wherever you see it in the image, adjusting the proportions of the two pigments in the mixture as necessary. Add a little Vermilion to the mixture for the very hottest areas, such as the head of the fourth fish. The eyes are also quite bright: the center is black, but they tend to have a bright-colored surround.

5 Start painting the backs of the fish using Cobalt Blue, with the addition of a little Lamp Black for the darkest tones. Use the tip of the brush so that you can create crisp edges and paint around reserved highlights.

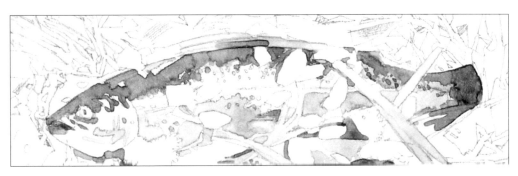

6 Continue with the dark markings, suggesting shadows around the almonds with the dark gray mixture. Add more Lamp Black to the mixture and start to paint the foil next to the fish, looking at where the foil is picking up reflected color from the fish. Now paint the almonds. Mix a pale wash of Cadmium Yellow with a hint of Burnt Sienna, testing the color on a piece of scrap line board before you apply it. You may need to remove some color from the very lightest almonds by lifting it off with a damp brush. Add a touch of Cobalt Blue to the mixture for the cooler, shaded almonds and a little more Burnt Sienna for the warmer-colored ones.

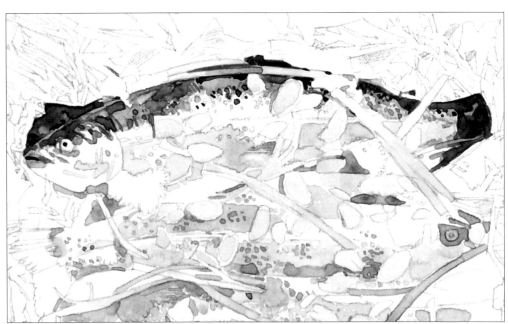

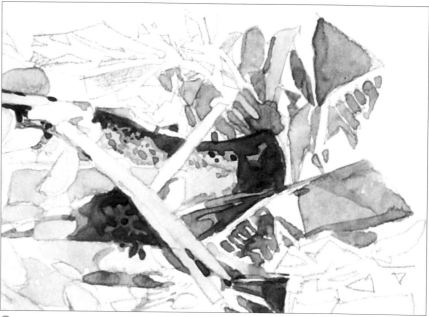

7 Paint the parsley with a wash of Viridian and leave to dry. Mix a darker green from Phthalo Green and Lamp Black and dot it to create the crinkled texture of the leaves, allowing some of the original Viridian to show through some variety of tone. Paint shadows under the parsley in a mixture of Cadmium Yellow and Burnt Sienna.

8 Now work on the aluminum foil, which is picking up reflected colors from the fish, almonds, and surroundings. Use a variety of colors—Cobalt Blue for the very bright blues, grayer mixtures of Cobalt and Lamp Black, and warm mixtures of Burnt Sienna and Cadmium Yellow—allowing the colors to merge wet into wet in places to create soft-edged blocks of color.

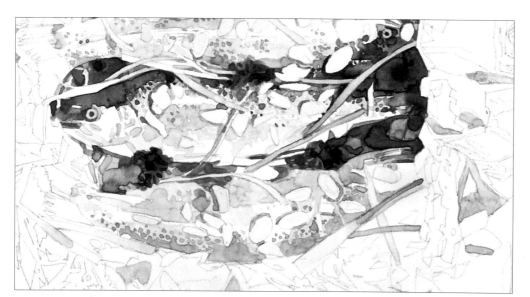

9 Continue building up the colors and density of tone on the aluminum foil. You can't hope to copy the foil exactly, but try to convey the sharp creases and folds. Look at the shapes that the blocks of reflected color make: there are lots of straight edges—triangles, diamonds and straight lines—but not many curves. Dot dark colors into the third fish—particularly on the head and back—working up to the edges so that the fish stands out from the surrounding foil and is clearly defined. Also paint the cast shadows of the almond flakes.

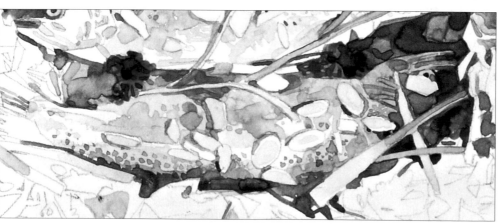

10 Continue painting the dark and warm areas of foil around the fourth fish. You are now working toward covering up all the white areas of paper that you don't want to remain in the finished painting. This is important: the shiny highlight areas won't work unless there is sufficient contrast between them and the rest of the image.

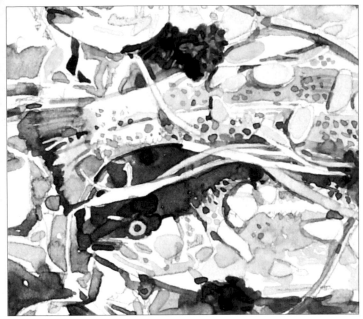

11 Paint the tail of the second fish, using a mixture of Burnt Sienna and Lamp Black for the detailing. Delineate the shadows under the spring onions and almonds. This makes them stand out and brings the image to life. Darken some of the almonds that are angled away from the light with a little Burnt Sienna. Continue refining the reflections in the foil. There are some purplish colors in places: paint these with a mixture of Cobalt Blue and a little Magenta.

12 Continue working on the background foil, using the same colors as before and looking carefully at both the foil and the objects on it to see exactly where colors are reflected. Sometimes your choice of which area to work on will be dictated simply by the need to find a dry spot to rest your hand, but you should also make a conscious effort to move around the painting, rather than concentrating on one area until it's completed, in order to prevent sections from being overworked.

13 Some reinforcement of the dark blue on the top fish and the addition of small washes of a warm Raw Sienna and Cobalt mix to the bodies of the other three provides the final solidity and gives them better separation from the almond flakes.

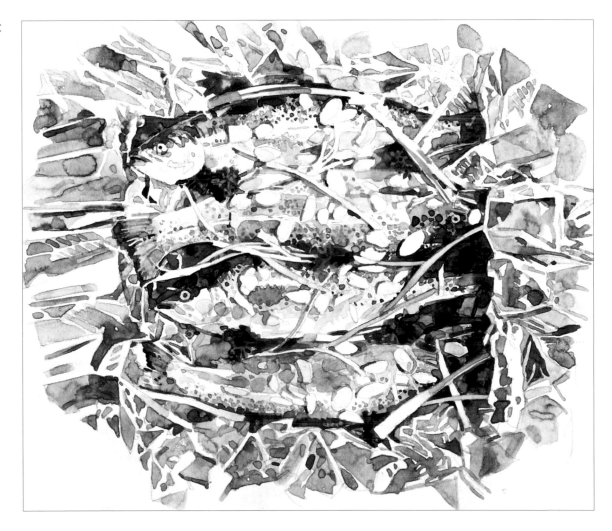

Tulip Study

Making a study of a single flower requires a rather special approach. Instead of treating the flower as just one component of the picture, you must try to describe the specimen's natural color and detail as accurately as possible.

SEE ALSO

• Overlaying color, page 30

• Using tone to create a 3-D effect, page 36

To this end, the lighting needs to be soft and even—no strong sunlight or harsh artificial light to create dark shadows that might obscure details. Ideally the specimen should lie on your drawing board so that you can, if you wish, peer at it very closely indeed.

The primary motive in making a study of this type is to give information in a similar way to that employed in botanical drawing, which is most often used to assist in the identification of flowers and plants. You need to make a careful, precise drawing before you start to apply the color with equal care. At the same time, you should consider the way that the plant sits on the page: some of the best botanical studies, while providing accurate information, are also beautiful decorations.

WILD FRUIT

I gathered these fruits from hedgerows near my home in Cornwall, England, and arranged them on a white background. This emphasized their very different individual shapes while making a beautiful composite pattern. I made the study using a pen and waterproof colored inks with added watercolor.

IRIS

A special coated paper was used for this painting. Papers of this type have a very fine layer of china clay on their surface and are meant for fine line work. Fluid washes laid on them tend to float around without penetrating as they do on normal papers, imparting an interesting, slightly random quality.

Materials

140=lb (300-gsm) NOT
 watercolor paper
HB pencil
Watercolor paints:
 Magenta, Ultramarine
 Blue, Cadmium Yellow,
 Phthalo Green, Raw
 Umber
Brushes: medium round,
 fine round

1 Using an HB pencil lightly sketch the tulip, putting in the broad lines of the petals, stalk, and leaves. Include some of the striations on the leaves and show how the leaves twist over one another.

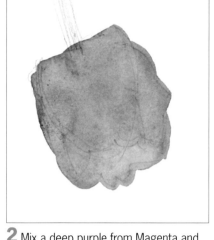

2 Mix a deep purple from Magenta and Ultramarine Blue. Using a medium round brush, brush a pale wash over the flower. Do not try to differentiate the tones at this stage—you are merely attempting to get the overall shape. Drop a little water onto the paint in places, as some of the petals have very pale areas. Go around the edge with a very fine brush to define it. Leave until very nearly dry.

3 Add more Magenta to the mixture to create a warmer tone. Using a fine round brush, delineate the petals. Because the first wash is still a little damp, these subsequent lines spread ever so slightly, softening the edges. Leave to dry.

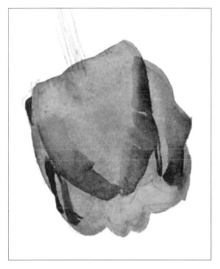

4 Continue adding a darker, more pigmented purple mix on the inside petals. You are now starting to define the individual petals.

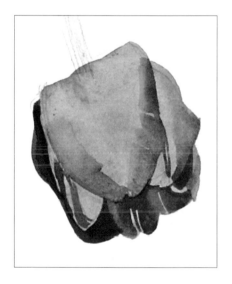

5 Add more Ultramarine Blue to the mixture to paint the shadow detail on the petal on the left. Reinforce the little tucks and creases by leaving one edge sharp and softening the other side by brushing over clean water.

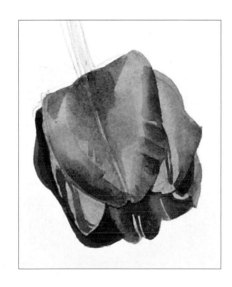

6 Apply the final dark tone to the petals. You can now see the spatial relationship of the petals—it is clear which ones are in front and which ones are behind. Leave to dry.

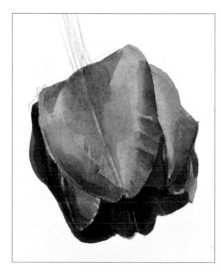

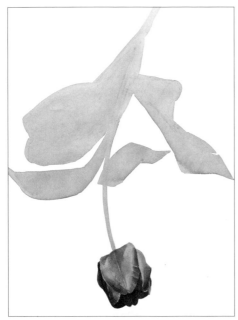

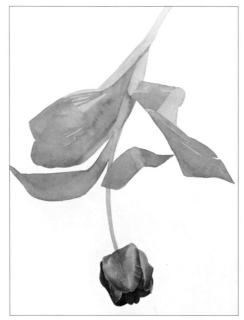

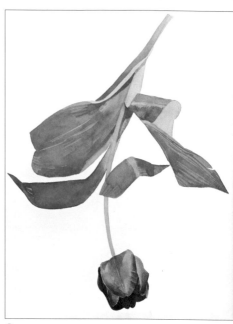

7 Mix a generous amount of a pale green wash from Cadmium Yellow and Phthalo Green. Using a medium round brush, brush this mixture over the leaves and stalk. If the paint starts to run, you may need to tilt the board. Leave to dry. Rub out any pencil markings that are still visible.

8 Mix a darker tone of green by adding more Phthalo Green to the mixture used in Step 7. Brush this over the leaves, leaving the underlying yellow showing through for the very lightest areas. Leave to dry.

9 Add more Phthalo Green to the mixture and reinforce the striations in the leaves. Leave to dry.

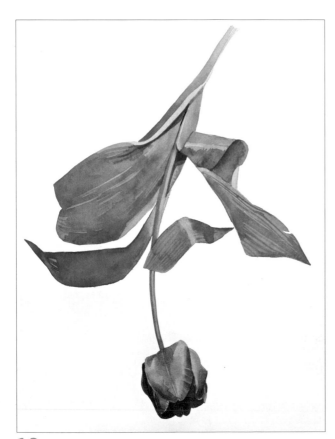

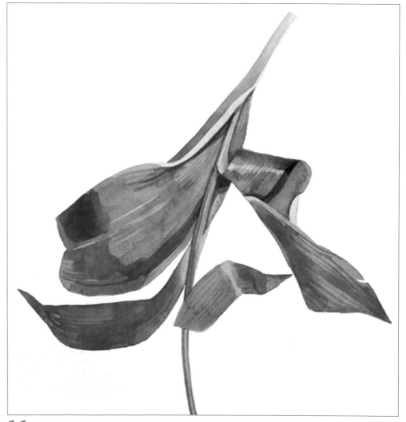

10 Add a little purple to the dark green mixture and put in the crease of the main leaf on the right and the dark areas where the leaves twist and turn away from the stalk. Add more purple for the warm parts of the stalk. Leave to dry.

11 Put in more striations on the leaves in a mixture of Phthalo Green and Cadmium Yellow. Use the purple mixture to put in the darker shadow on the stalk and the darker ends of the leaves on the left. Leave to dry.

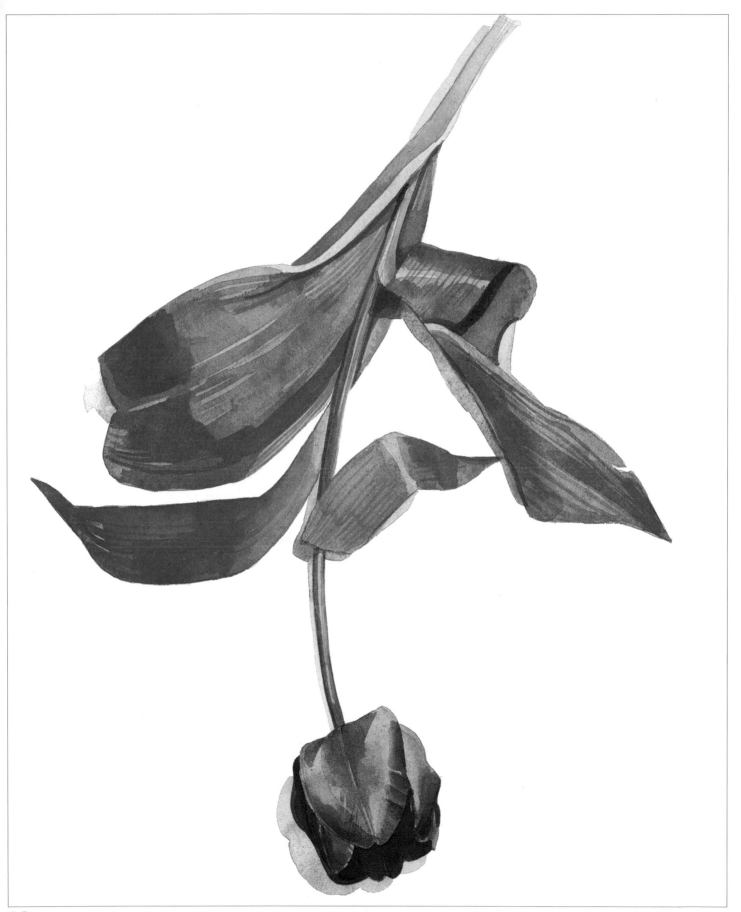

12 Mix a very dilute warm gray from Ultramarine Blue and Raw Umber and brush in the shadows cast by the leave and flower on the white surface. Although this is not strictly a botanical drawing, made for the purposes of identification, you should judge its success by how alike it is to the original flower in essence as well as in detail.

Flowers in a glass vase

Painting flowers in a still-life arrangement gives you the chance to bring in other elements—not only the containing vase, but also other objects in the foreground and the background.

SEE ALSO

• Surfaces, page 17

• Painting from
 photographs, page 142

In this composition, I was particularly drawn to the pattern on the wall behind the vase of flowers. The sunlight streaming into the room cast shadows, which were themselves modified by reflections from the glass-topped table on which the vase was positioned. I photographed the scene to record the strange and transitory effects of the light and then transferred the image to the painting surface by a method known as squaring up, which is described below.

Before transferring the drawing, I primed the paper with acrylic gesso (see page 19), which renders the surface much less absorbent. This means that the washes wander about the surface before drying, with somewhat unpredictable but often interesting results. The risks are, to some extent, countered by the ease with which washes can be relaid or removed from this surface.

Materials

Line board primed with acrylic gesso

HB pencil

Watercolor paints: Magenta, Cerulean Blue, Vermilion,
 Viridian, Lamp Black, Raw Umber, Ultramarine Blue,
 Gamboge, Cobalt Blue, Phthalo Green, Raw Sienna

Brushes: medium round, fine round

1 Divide the photograph from which you are working into a convenient number of squares along the horizontal and vertical axes. Put numbers along one axis and letters along the other.

2 Decide how big you want the finished painting to be; here my original photograph was 4 x 3.5 inches (10 x 9 cm) and I decided to make my painting four times larger, so that the finished size would be 16 x 14 inches (40 x 36 cm). Mark the same number of squares on your chosen surface and copy the photograph onto the scaled-up version, referring to the numbers and letters on the two grids. Although this is done by eye, it is surprisingly easy to piece together an accurate enlarged version.

3 Mix a very pale, dilute wash of Magenta. Using a medium round brush, put in the palest pinks of the flowers. Add a little Cerulean Blue to the Magenta to make a pale purple and paint some of the cooler pinks. Mix a more vivid pink from Vermilion and Magenta and paint the large, deep pink carnation of the left of the arrangement. Picking out a few key flowers in this way establishes a guide to work to.

4 Mix a dark wash of Viridian and paint the leaves and stems of the carnations. Add Lamp Black to the mixture for the darker areas. Although the received wisdom in watercolor painting is that you should put in the lights first, putting in a few darks in the early stages of a complicated painting like this makes it easier to keep track of things.

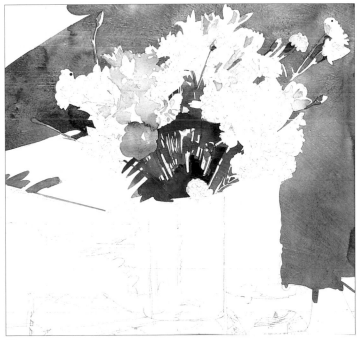

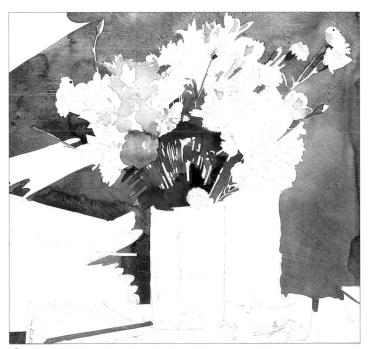

5 Mix a brownish gray from Lamp Black, Raw Umber, Ultramarine Blue, and a touch of Gamboge. This is the color for the large cast shadow on the wall, so make sure you mix a generous amount. Put in the broad shadow areas, carefully going around the flowers with a fine, round brush.

6 Continue with the background shadow wash, tilting the board when you get up to the dark greens so that paint flows away. Remember to stir the paint mixture occasionally to make sure that the pigments are evenly mixed: some pigments, such as the Ultramarine Blue used in this mixture, tend to separate out.

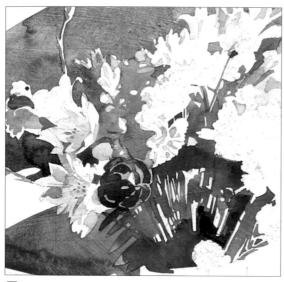

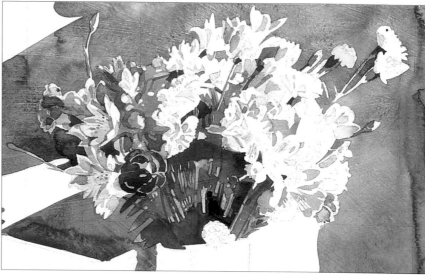

7 Using the same pink mixtures as before, increase the density of tone on the flowers. Using a very fine brush, touch some of the brown background color behind the flowers: the image is quite complicated, but filling in these negative spaces makes it easier to see what's going on and keep track of where you are in the painting.

8 Continue deepening the tones of the pink flowers, working across the whole picture, rather than concentrating on one area at a time. The flowers are quite complex in structure, with many changes of plane, so you need to continually assess the tonal values. Don't attempt to paint every single flower precisely: in an arrangement like this, some can be left as vague, light shapes.

9 Mix a very pale, dilute greenish blue from Cobalt Blue, Lamp Black, and Phthalo Green. Using a medium round brush, put in the paler shadows in the background and the shadowed side of the glass vase and its reflection in the glass-topped table.

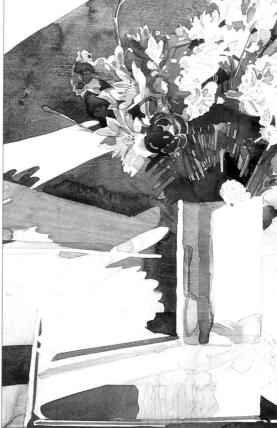

10 Mix a very dilute wash of Lamp Black and paint the reflection of the glass ashtray in the table top. This reflection is itself then reflected back up into the ashtray. In a situation such as this, it is not always easy always to understand the interplay of reflections —just draw what you see!

11 Mix a pale fawn from Raw Sienna and a little Lamp Black. Brush this mixture over the background up to the edge of the shadows—but take great care not to go over the shadows, otherwise the fawn color will blend with the underlying color and pull it off the acrylic gesso surface. Darken the shadow in the vase.

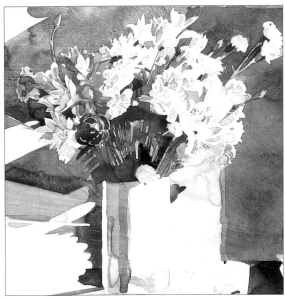

13 Now work on the reflections. Mix a bluish gray from Lamp Black and a little Ultramarine Blue. Using a fine round brush, paint the dark reflections in the glass ashtray and the base of the glass vase. These reflections must be sharp edged and decisive: if they're soft, they won't look like reflections.

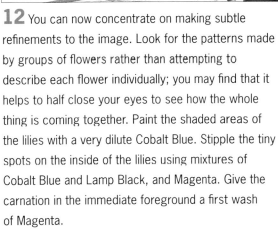

12 You can now concentrate on making subtle refinements to the image. Look for the patterns made by groups of flowers rather than attempting to describe each flower individually; you may find that it helps to half close your eyes to see how the whole thing is coming together. Paint the shaded areas of the lilies with a very dilute Cobalt Blue. Stipple the tiny spots on the inside of the lilies using mixtures of Cobalt Blue and Lamp Black, and Magenta. Give the carnation in the immediate foreground a first wash of Magenta.

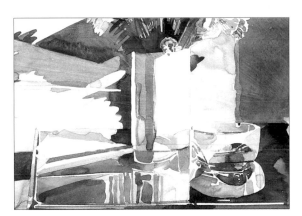

14 Apply a second layer of Magenta to the foreground carnation to define its form. Using the same Cobalt Blue and Lamp Black mixture as before, strengthen the reflections in the table top and define the edge of the table.

15 Darken the shadow at the top by applying a second wash. At this stage the picture could be judged to have been completed, but on standing back I felt that the overall shape of the flowers needed to be dramatized. Although the dark wash of the background shadow was attractively textured, I decided to darken it with another wash. A favorable result, I consider: sometimes it is necessary to sacrifice a small effect for the good of the whole.

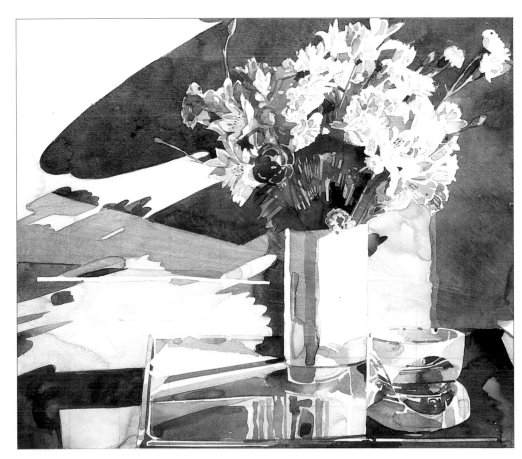

Insect studies

Painting insects and other animals from samples in museums is similar to making botanical studies. The primary objective is to record color and shape as accurately as possible, while still exploiting the possibilities for decoration.

Pseudosphinx
Tetrio

Macropus longimanus

SEE ALSO

• Wet into wet, page 28

• Overlaying colors, page 30

• Color theory, page 40

Butterflies and moths, endlessly varied in pattern and color, are fascinating to observe and paint. The wings of butterflies are often covered with iridescent colors in which minute spots of bright pigment mix optically to produce effects that are like spun silk—difficult and demanding to render in watercolor. You may need to exaggerate the brightness of these areas to make up for the fact that the iridescence is so difficult to capture; alternatively, overlaid broken washes may create a similar effect. The same brilliant iridescence can often be seen on the wing cases of beetles and other flying insects.

NATURAL PATTERNS

The decision to juxtapose this beetle and moth was mine alone: it is unlikely that you would find them in the same museum display case, but I liked the relationship between them, the compact soft shape and earthy colors of the moth against the hard shiny carapace and preposterously long, thin legs and antennae of the beetle.

Materials

140-lb (300-gsm) rough
 watercolor paper,
 pre-stretched
Watercolor paints:
 Lemon Yellow,
 Viridian, Turquoise
 Blue, Cadmium Yellow,
 Phthalo Green, Lamp
 Black, Indigo,
 Ultramarine Blue
Brushes: medium round

1 Sketch the butterfly on rough watercolor paper, indicating the position of the bright green markings on the wings.

2 Mix a bright, acidic green from Lemon Yellow and a tiny amount of Viridian. Brush this mixture over the whole butterfly, dropping in a little more Viridian, wet into wet, as you move closer to the body. Brush Turquoise Blue onto the lower half of the wing near the body—again, wet into wet. Mix a bright, dark green from Turquoise Blue and Phthalo Green and paint the body. Leave to dry.

3 Mix a rich, velvety blue-black from Lamp Black, Indigo, and Ultramarine Blue. Brush this mixture onto the wings, leaving the bright green showing through for the markings. If the color looks too dense, brush on a little clean water in places and lift out some color with the brush. Dab a few little dots of the dark color over the green to break up the lines a little.

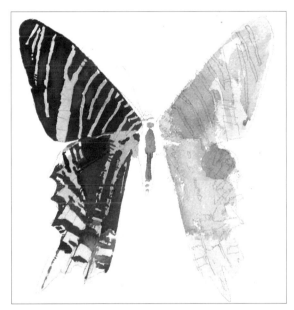

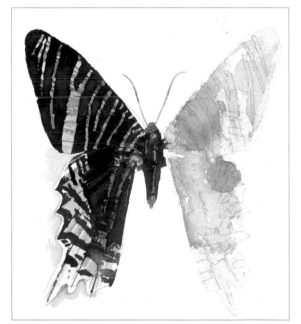

4 Mix a darker green from Lemon Yellow and Viridian. Using a fine round brush, brush very thin horizontal lines over the bright markings for the veins in the wings.

5 Using the same dark mixture as in Step 3 paint the butterfly's body, leaving some of the original green color showing through. Mix Raw Sienna with a tiny amount of Lamp Black and paint the hairs near athe body and the antennae. Comparing the flashes of color on the left wing with the underpainting on the right wing, it is clear how the apparent intensity of colors is increased by being surrounded and isolated by black.

Tabby cat

SEE ALSO

• Washes, page 26

An ever-present problem when you are drawing and painting animals is persuading them to stay still for long enough for you to make studies. There is only so much that can be put down from memory.

Sleeping animals obviously give you the chance to draw and paint, and domestic cats (and wild ones too, I am told), spend long periods of their lives fast asleep. But there is a limit to how many pictures of sleeping animals that you will want to make and that viewers will want to see. Also, the vitality of many animals is fundamental to their character and even when they are not moving, an alert, open-eyed expression can be very attractive.

Painting from photographs is one solution and, whatever they profess to the contrary, almost all specialist wildlife artists rely heavily on photos: for finished, detailed and active poses there is really no alternative.

However, much can be gained by making quick sketches from directly observing animals that are moving or only momentarily still. The concentration necessary to pin down a movement with a gestural line will give you a better feel for the natural shapes adopted by an animal than any number of frozen-action photographs. Then, when you are working from photographic reference, you can use this stored knowledge to select the important information and to reject superfluous details.

Viewed from a distance, the markings on a furry animal can be generalized in much the same way as you would deal with groups of leaves on a tree. But what if you view such markings close up, as in this portrait of a tabby cat? Sometimes, as in this project, you have to accept the need to tackle details if the study is to look convincing.

FUR AS TONE
The vast number of individual hairs that make up the coat of a furry animal must generally be regarded as a series of soft volumes: only perhaps at the edges, and in places where they are longer and more sparse, such as the eyebrows and whiskers, is there any need to draw single hairs.

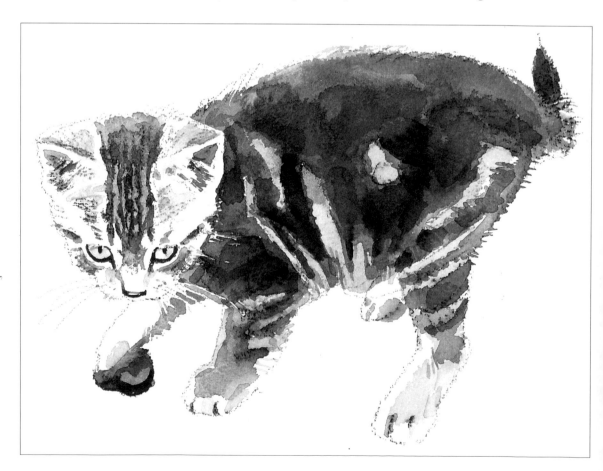

Materials

2B pencil

140-lb (300-gsm) rough
 watercolor paper,
 primed with acrylic
 gesso

Watercolor paints: Raw
 Sienna, Lemon Yellow,
 Burnt Sienna, Lamp
 Black, Raw Umber,
 Ultramarine Blue,
 Magenta

Brushes: medium round,
 fine round

1 Using a 2B pencil, make a careful pencil drawing of your subject. This is essential when you move in so close for an animal portrait.

2 Wherever the fur is not white, apply Raw Sienna as an underpainting using a medium round brush; this necessitates painting around the whiskers. Put in the eyes with Lemon Yellow.

3 Define the tops of the ears with a mixture of Burnt Sienna and Lamp Black. Add more black to the mixture and, using a fine round brush, outline the eyes and put in the pupils.

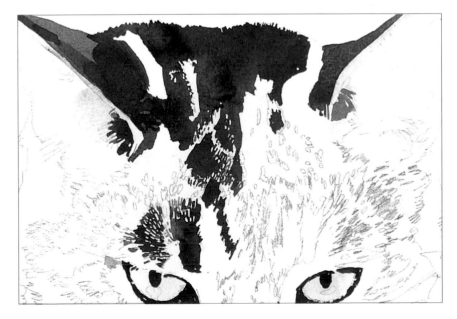

4 Now is the time to discover just how much of the brindled marking needs to be precisely detailed and how much can be depicted with more generalized washes. Working with Lamp Black and Burnt Sienna, paint around the individual lighter hairs with mixtures of burnt sienna and lamp black.

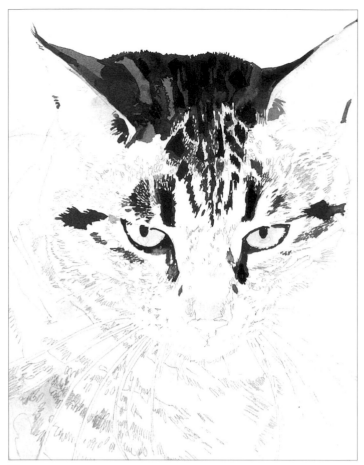

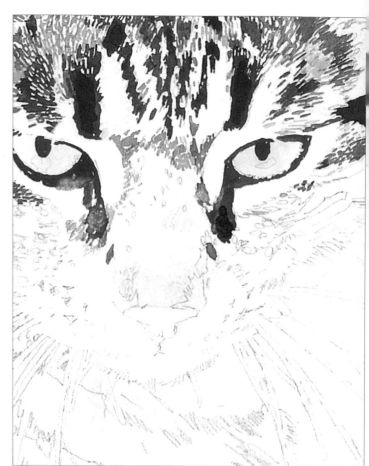

5 Continue working on the fur, using the same colors as before. Where the markings are less strongly contrasted, as on the top of the head, you can make them broader and more fluid.

6 Continuing to paint around the lightest hairs with a watery black and a little Raw Umber, put in the lighter areas of fur above the eyes, beginning to define the nose and continuing upward to connect with the forehead.

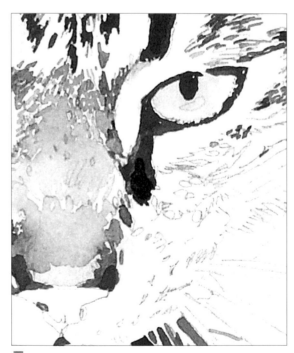

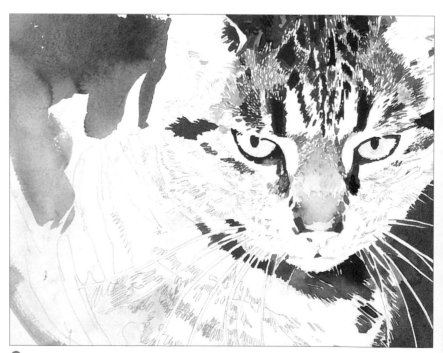

7 The fur on the nose, being short and fine, can be rendered with a wash of pale gray gradating downward to a Raw Sienna. Begin painting carefully around the whiskers, so that they remain white.

8 Using a mixture of Raw Umber and Ultramarine Blue (my favorite shadow mix), paint around the long whiskers on the right-hand side so that they show up as white against the dark background. At this stage I also applied some freer washes on the left-hand side in preparation for some less focused treatment that would act as a foil to the central detail.

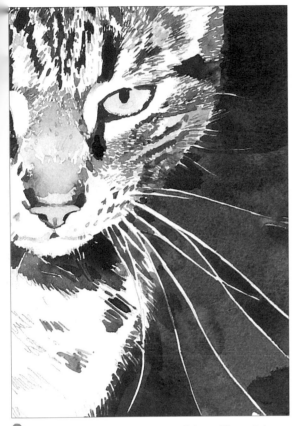

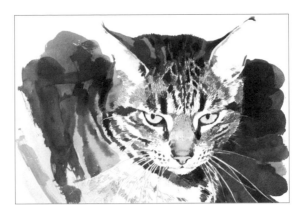

10 Continue to render the cat's markings, allowing some of the tones to mix a little, wet into wet.

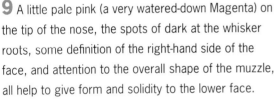

9 A little pale pink (a very watered-down Magenta) on the tip of the nose, the spots of dark at the whisker roots, some definition of the right-hand side of the face, and attention to the overall shape of the muzzle, all help to give form and solidity to the lower face.

11 In order for them to stand out, the whiskers on the left-hand side need to be defined by the fur patterns behind them; this is slightly more difficult than the right side because the background is not one single color. Some gentle washes of very watery, pale Lamp Black over detailed areas of fur on the face help to unify and strengthen the form.

12 Finally, define the hair on the inside of the ears with a pale blue-gray and Burnt Sienna. Although such a painstakingly detailed treatment requires careful control, you should try to keep the painting fresh by using a big brush and loose washes wherever you have the opportunity.

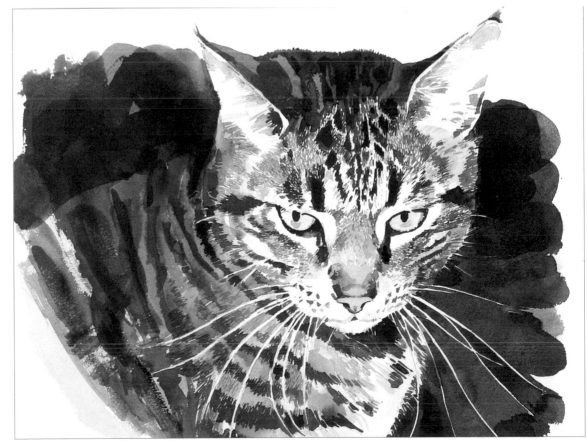

Clouds

If there is any element that watercolor is made for, it is rendering skies. Clouds and mist are made of water: they look like intermingled washes— and washes, if they are boldly applied, look like clouds and mist.

All the best painters of the past who were interested in atmospheric effects spent large amounts of time observing the sky directly and making quick notes. These sketches were mostly in watercolor, even if the final painting was to be in another medium. If you really want to emulate these masters, it is a good idea to carry a small sketchbook and a watercolor kit with you so that you can record, however fragmentarily, any arresting sky effects that take your eye. If you have a camera handy, take some photographs as additional reference—but be prepared for these to be of limited use: only professional photographers can guarantee to capture the drama of cloud formations successfully.

SIMPLE SKY—WET ON PARTIALLY DRY

This is a very easy and quick rendering of sky and clouds. I applied a Cobalt Blue wash, leaving random areas to represent clouds. Without waiting for this to dry, I put down the shadow areas of the clouds with a pale, warm gray (made from Raw Sienna mixed with a little Black), being careful to leave a gap between the two washes to represent the lit cloud edges.

SIMPLE SKY—WET ON WET

Here, I dropped colors onto a slightly dampened surface. Obviously, you must choose the moment when the colors have spread far enough to have soft edges and leave some white—but not so much that they completely run together. With practice, you will be better at making this judgment—but there is always a small element of risk.

Cloudy Sky 1

Although this sky is mostly covered in cloud, some blue sky and warmly sunlit cloud are visible.

Materials

90-lb (185-gsm) rough watercolor paper, pre-stretched
Watercolor paints: Burnt Sienna, Cobalt Blue
Brushes: large wash

Cloudy Sky 2

No open sky is visible in this sky: it is all cloud with hints of incipient light behind.

Materials

90-lb (185-gsm) rough watercolor paper, pre-stretched
Watercolor paints: Raw Sienna, Lamp Black, Ultramarine Blue, Burnt Sienna
Brushes: large wash

1 Using a large wash brush, lay a gradated wash of Burnt Sienna. (It may seem an unlikely color to use under blue, but provided it is not too strong it warms the light areas while only slightly modifying subsequent washes.) Leave to dry.

1 Using a large wash brush, lay a wash of Raw Sienna followed by a wash of Lamp Black. Dab with a paper towel and tip the black wash to and fro to produce a suggestion of broken cloud. Leave to dry.

2 Lay a wash of Cobalt Blue, also gradating downward. While it is still damp, blot out some cloud shapes with a paper towel. Leave to dry.

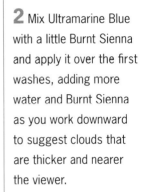

2 Mix Ultramarine Blue with a little Burnt Sienna and apply it over the first washes, adding more water and Burnt Sienna as you work downward to suggest clouds that are thicker and nearer the viewer.

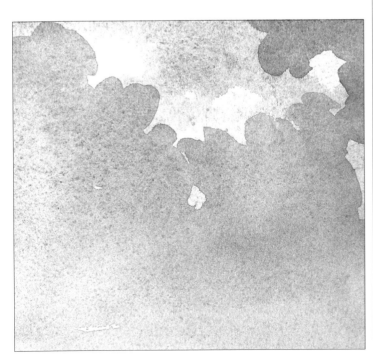

3 Mix a wash from Cobalt Blue and Burnt Sienna and paint the darker clouds that frame the white clouds and blue sky, continuing the wash downward with a lighter version of the same mixture.

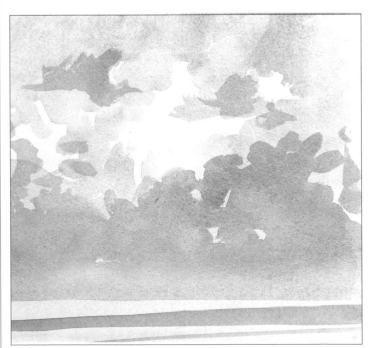

3 Using a similar, but stronger mixture of the same colors, put in even darker clouds, adding more water as you approach the horizon. Finally, paint a suggestion of the land beneath.

Storm clouds

Often the most interesting skies to paint are those in which dense, heavy clouds predominate.

SEE ALSO

• Washes, page 26

• Wet into wet, page 28

• Painting from photographs, page 142

Such skies may include great towers of rising cumulus, presaging disturbed weather conditions to come, or they may be dominated by a dark, lowering cloud base from which rain is already falling.

Clouds take many diverse forms largely determined by their height in the sky and it is often possible to see higher clouds through gaps in lower ones. The drama is increased when shafts of sunlight penetrate the clouds to give flashes of illumination on the predominantly darkened landscape. Of course, the excitement of this type of weather is accompanied by the risk of being caught in a downpour and the view will be constantly changing. Quick sketches are the answer, perhaps supported by visual notes and photographs. When a sky is changing too quickly to be rendered in pencil or paint, it is a good idea to make a brief note of the colors and tones; no matter how dramatic the sky appears, if you rely entirely on your memory, it will almost certain;ly let you down. If your camera permits exposure control, it is best to underexpose the shot a little, or to bracket (that is, take three or four shots at slighly different exposures), to get the best cloud definition.

Sailing Boat Sky

I have included a couple of sailboats in this sky study to give something bright in contrast to the relatively dark tones of the clouds. Including a little landscape in your painting, either lit or in shadow, does make it easier to judge whether or not a sky is really working.

Materials

2B pencil

90-lb (185-gsm) rough watercolor paper, pre-stretched

Watercolor paints: Burnt Sienna, Lamp Black, Ultramarine Blue

Brushes: large wash

1 Using a 2B pencil, lightly sketch the sailing boat. Using a large wash brush, lay a pale wash of Burnt Sienna, leaving the sails white, and leave it to dry. Overlay it with one of Lamp Black, again leaving the sails white. Allow the black wash to dry with a few edges to suggest cloud shapes.

2 Prepare two washes—a fairly pale one of Ultramarine Blue and BurntSsienna and a stronger version containing more Ultramarine. Use the lighter wash for the cloud shapes in the middle of the picture and down to the horizon and the stronger wash for the clouds that are higher up. Leave to dry.

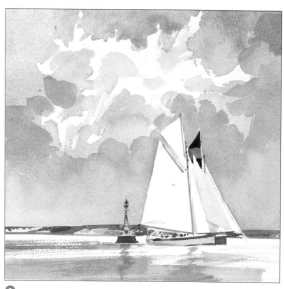

3 Mix a warmer wash of Burnt Sienna and Lamp Black and put in the foreground storm clouds, diluting the wash as it approaches the horizon. Add the far shore, sea, and boat details. Skies that initially look a little too strong often drop into place when you put in the main foreground subject.

Rain clouds

One of the most visually exciting weather situations occurs when a rain storm is approaching: dark disturbed clouds are already overhead, casting long shadows across the landscape, and in the distance swathes of rain can be seen as semi-transparent bands falling from the broken edges of the cloud base, joining it to the earth below.

Materials

90-lb (185-gsm) rough watercolor paper, pre-stretched
Watercolor paints: Burnt Sienna, Cobalt Blue,
 Ultramarine Blue, Lamp Black
Brushes: large wash
Paper towel

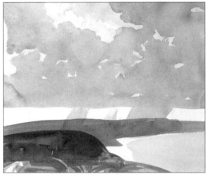

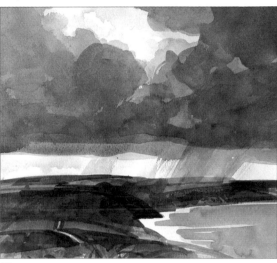

1 Using a large wash brush, apply a pale wash of Burnt Sienna over the paper and leave to dry. Then lay a wash of Cobalt Blue, gradating it from the top downward. Blot out the clouds that are lit by sunlight with paper towel and drop water into the wash to lighten the shadow side of the clouds. Put in the first indications of the landscape using Ultramarine Blue and Lamp Black.

2 Mix two tones of Cobalt Blue and Burnt Sienna. Starting at the top, put in the gathering clouds with the darker mix, changing to the lighter mix at the cloud base and into the swathes of rain falling on the headland. Although the point of this exercise is to make a stormy sky, the landscape beneath such cloud formations will be heavily shadowed and needs to be indicated as such.

3 Apply washes of Ultramarine Blue and Lamp Black to build up the great black clouds and add to the falling rain. The bright intervals of sky high up and at the horizon heighten the drama, as does the sweep of leaden sea with its rim of breaking water.

APPROACHING
STORM
Using the same principles, you can build up complex patterns of sky, sun, and cloud. Here, towering cumulus cloud is moving in front of a variety of wind-blown high clouds and is about to blot out the sun, the last rays of which are visible against its lower formations while the water reflects the still golden light at the horizon.

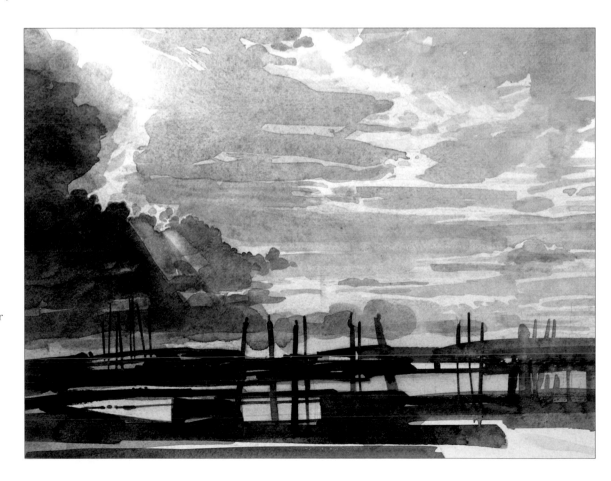

Sky colors

The color of the sky varies greatly, even in full daylight. It is often blue, but can also be almost every color in the visible spectrum.

SEE ALSO

• Washes, page 26

• Wet into wet, page 28

When the sun is high in a cloudless sky, the glare may be such that you can barely see any color at all. Dust particles and water vapor may have refracted the sun's rays sufficiently to render the sky yellow or gray.

The most dramatic changes can be seen in the early morning as the sun rises and in the evening when it sets. At these times, when the sun is close to the horizon, its angle means that the light must penetrate a much thicker layer of atmosphere to reach your eye; as a result, the longer wavelengths of orange and red light are the only ones that can get through. Above your head the sky may still be blue and between the two extremes there may be all the linking hues of yellow and green.

These effects can become oversentimental and clichéd, but provided you do not overuse them they should be part of your repertoire.

A sky largely covered with heavy storm clouds but with a clear area near the horizon where the sun is setting makes for a very dramatic sky.

TRANQUIL SUNSET
You can make a tranquil sunset (or sunrise) by making an upside-down version of the variegated wash exercise on page 29— in other words, starting with blue at the top and gradating through green, yellow, and orange to red. When these washes are dry you can add clouds of orange with a touch of black and imaginary hills with washes to which you add progressively more black pigment.

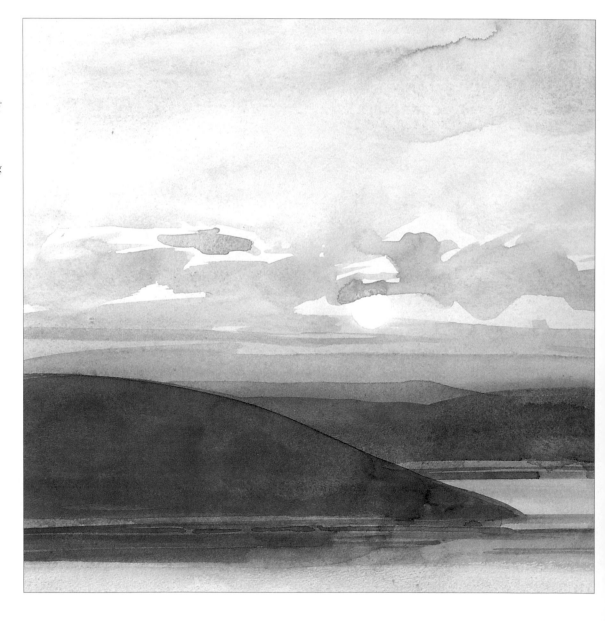

Materials

90-lb (185-gsm) rough
 paper, pre-stretched
Watercolor paints:
 Cadmium Yellow,
 Gamboge, Cadmium
 Orange, Phthalo Blue,
 Vermilion, Lamp
 Black, Ultramarine
 Blue, Raw Umber
Brushes: large wash

1 Cover the whole area of the picture first with a strong wash of Cadmium Yellow. This will form the basis of the brightest clear sky near the horizon.

2 There was only one area of really bright yellow in this sky, so I laid a wash of Gamboge over everything except this dagger pointing in from the right. The "cauliflower" of uneven drying seen in this wash is of no consequence, as it will be lost underneath much stronger later colors.

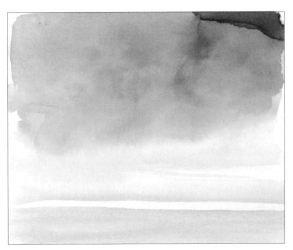

3 Lay a wash of Cadmium Orange over the top third of the paper, changing to Gamboge to just above the horizon. Establish the horizon with a few strokes of Phthalo Blue. While the wash is still wet, drop Lamp Black and Vermilion into it.

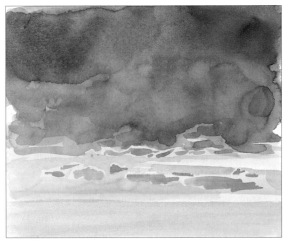

4 Suggest the main clouds with washes of Vermilion and Black, making them darker at the top. Add smaller clouds near the horizon, surrounding them with Cadmium Orange to which a little blue has been added and leaving their edges to show they catch the light.

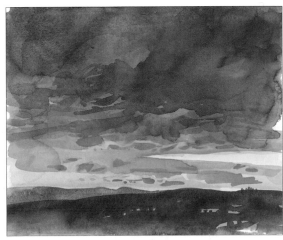

5 Add more, even darker clouds to the main cloud mass and more Orange to isolate the remaining "dagger" of bright sky. Under such a sky the landscape would be quite dark, so apply Ultramarine Blue and Raw Umber washes to give it the necessary contrast.

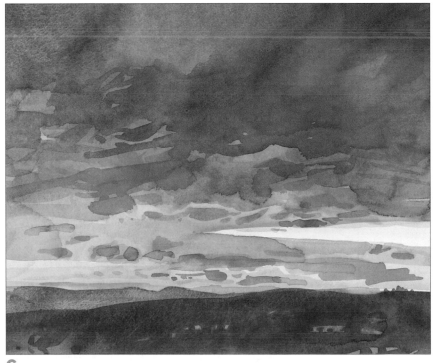

6 On standing back I felt the upper clouds were too dark, and so I washed them down a little with a brush and clean water. The final result is about as dramatic as a sky can be—a rare happening, perhaps, but in the right circumstances such skies do appear.

Open landscape

The technique of overlaying transparent layers is ideal for rendering the progression of tones from foreground to far distance, giving a very real sense of the varying thicknesses of atmosphere through which the view is seen.

SEE ALSO

• Washes, page 26

• Overlaying colors, page 30

• Seeing in tone, page 34

• Balance, page 50

The greater the distance that can be seen in a given view, the more likely it is that the furthest vistas will appear predominantly blue or mauve, and have subtle tonal variations. As you move toward the foreground, on the other hand, objects increasingly take on their "normal" color and are likely to have stronger contrast.

To avoid a broad sweep of landscape becoming compositionally boring, choose a viewpoint that includes some near-center feature that will catch the eye. In this case, there is a prominent house by a turn in the road in the middle ground, which leads the viewer into the picture. The scene features contre-jour lighting: the sun is in front of you so everything is lit from behind, which means that you get light, unpainted strips around the edge of objects. Although at first sight there seems to be a great profusion of detail in the view, you must try to discover the typical overall patterns: don't try to include everything.

Materials

140-lb (300-gsm) rough watercolour paper, pre-stretched

Paints: Cobalt Blue, Ultramarine Blue, Gamboge, Raw Umber, Phthalo Green, Vermilion, Cadmium Orange, Lamp Black, Burnt Sienna

Brushes: large wash, medium round

1 Mix a generous wash of pale Cobalt Blue with a tiny amount of Ultramarine Blue and another wash of Gamboge. Using a large wash brush and starting at the top of the paper, lay a gradated blue wash to about halfway down the paper, leaving a few gaps for clouds. Switch to the Gamboge wash and lay a gradated wash over the rest of the paper, paling to almost no color at the base. Leave to dry.

2 Add more Cobalt Blue pigment to the blue wash and, using the large wash brush, brush in the outline of the most distant hill, tilting the board to prevent the wash running too far down the paper if necessary. Leave to dry. Add Raw Umber to the mixture to make a greener blue and brush in the next hill, softening the bottom edge of the hills with clean water. Run a stroke of pale Gamboge along the lower edge of the hills, wet into wet. Leave to dry.

4 Mix an acid, yellow-green from Gamboge with a little Phthalo Green. Using a large wash brush, put in the lightest foliage and grass colors. Assess the tones of the hills against this: if they look too blue, brush some of the green color over them. Leave to dry.

3 Mix a pale green from Gamboge and Phthalo Green. Using a medium round brush, "draw" the line of the road and wash the green mixture over the lower half of the painting. Leave to dry. Mix a warm terracotta color from Vermilion with a little Cadmium Orange. Using a medium round brush, put in some of the light-colored roofs. Mix a mid-toned green from Raw Umber and Phthalo Green and lightly brush in some of the field boundaries; these will serve as guidelines in the absence of a preliminary drawing. Leave to dry.

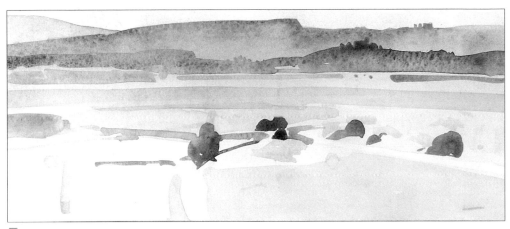

5 Mix a dark blue-green from Raw Umber and Ultramarine Blue. Paint the nearest hill. Go over the lines of the of the hedges set down in Step 3 and put in the rough shapes of some of the larger trees. These dark blocks of color help to define the shapes of the houses.

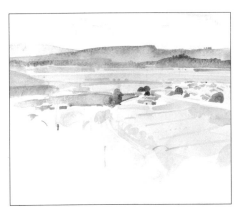

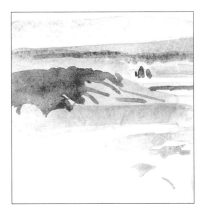

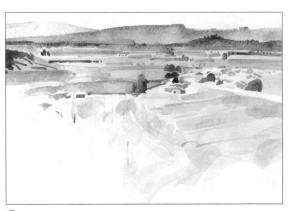

6 Continue building up the greens in the middle distance of the landscape, dipping into the various greens on the palette as appropriate. Paint more of the field boundaries, such as the fields that slope up to the road, and tree shapes. You need to establish features that the eye can dwell on in what would otherwise be a very open landscape. Mix Ultramarine Blue and Raw Umber and paint the shaded fronts and shadows cast by the houses.

7 Mix a strong, dark green from Phthalo Green and Lamp Black and block in the wooded hill on the left, allowing some of the underlying color to show through in places. Even though you're now starting to put in some of the detail, make sure your brush is fully loaded and that you flood the color on: if your brushstrokes are too dry, the painting will look tired and tight.

8 Paint over the foreground fields with a mixture of Gamboge and a little Phthalo Green. The colors need to be brighter and warmer in the foreground than in the distance, as this helps to create a sense of recession. Leave to dry.

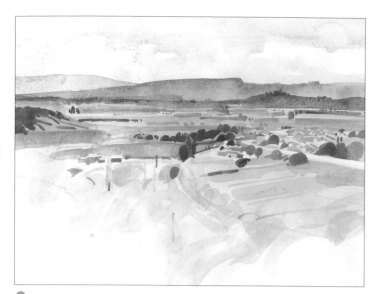

9 Use progressively darker greens as you move toward the foreground. Make broad strokes of a warm green in the foreground to establish the generalized shapes of the tree masses.

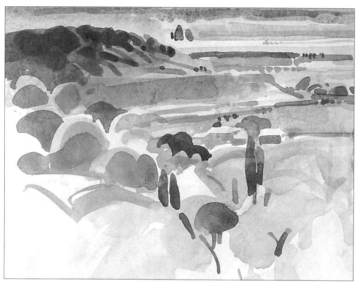

10 Continue working on the trees on the left-hand side of the image, making generalized "fan" shapes rather than trying to paint each shape precisely. Use various dark green mixtures and gradually moving toward the foreground. Note how the contre-jour lighting creates an arc-shaped rim around the edges of the trees; leave these rims unpainted to establish a sense of light and shade in the painting.

11 Mix a dark, blue-black from Lamp Black and Ultramarine Blue and paint the structure in the foreground on the right of the painting. Paint more general tree shapes in the foreground. Add Burnt Sienna to some of the general green mixtures and, using a fine brush, put in some of the tree trunks and the foreground fence posts.

Taking Stock

The painting is now well on the way to completion and from here onward you can consolidate specific areas. Work on the greens, again using and modifying all the mixtures already on the palette as appropriate. There are so many different tones and hues of green in a scene like this that it is neither possible nor desirable to be very precise about what to use where; trust your instincts and concentrate instead on assessing the tonal values as a whole.

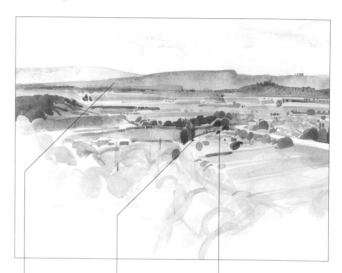

The use of different tones of blue on the hills helps to create a sense of recession.

These mid-greens help define the edges of the buildings and create a sense of them being completely surrounded by greenery.

Some trees are browner than others; add a little Cadmium Orange to your green mixtures for these areas.

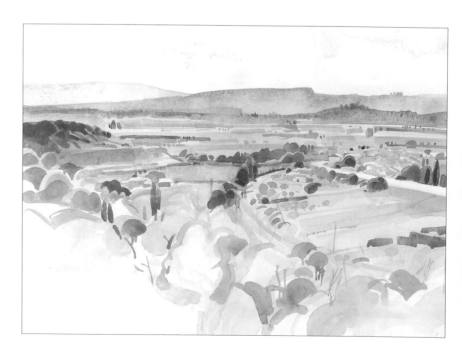

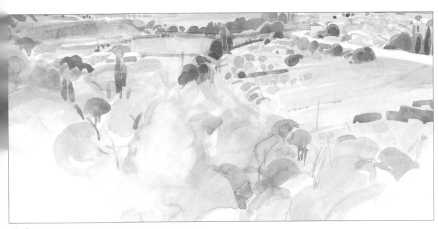

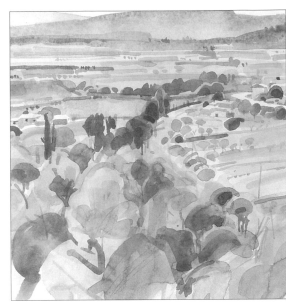

12 Continue putting in the foreground trees, using bold brush strokes and various mixtures of green. Keep readjusting the tonal values as necessary as you work, since a change in one area may alter the balance of the painting as a whole. Here, for example, I judged that the left-hand side was too yellow and so I brushed a pale green mixture over this area. Provided any underlying washes are completely dry when you do this, they will remain in place—so don't be afraid to work boldly and flood the paper with color.

13 Continue putting in the very dark greens of the foreground trees, mixing the greens as before.

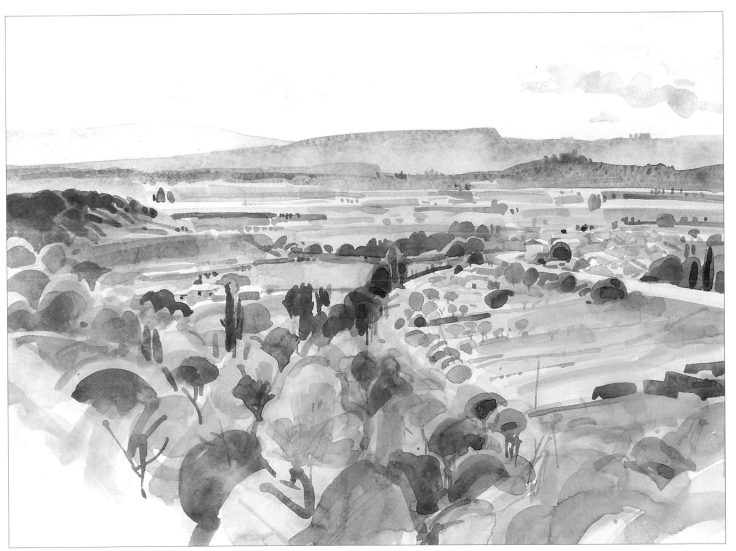

14 Mix a dark cloud color from Cobalt Blue and Raw Umber and brush in the clouds that you left unpainted in Step 1. Mix a very pale wash of Cobalt Blue and wash it over the unpainted road, which now looks too start in comparison with the rest of the painting. Adjust the density of tone on the dark sides of the buildings, if necessary, and put in the very last dark foliage areas. It may be that the original center of interest, the turn in the road, has now extended to include the row of darker trees that arc toward it, but I think this is a perfectly acceptable development.

River scene

A river provides an immediate center of interest in a landscape, rather as a road does—but with perhaps more possibilities of variation.

SEE ALSO

• Overlaying colors, page 30

• Balance, page 50

• Textures and additives, page 60

Water is reflective, reacting to the ambient light and physical surroundings. The way reflections appear in river water can vary considerably. In a fast-flowing river there may be virtually no reflections other than a general resemblance in color to that of the sky. A slow-flowing river may have a mirrorlike surface, which can then be broken up by a puff of wind. In shallow water you may be able to see through the reflections to the river bed itself.

Rendering these effects requires careful, unbiased observation. There are no hard-and-fast rules governing the appearance of reflections: in clear, very still water they may be virtually indistinguishable from an upside-down version of the real thing, still water that is not clear may tone them down a little, and even slightly wavy water behaves like a broken mirror. The best course is to paint the shapes that you see. Try not to think too much about the water surface and all will be well.

Materials

90-lb (185-gsm) NOT watercolor paper, pre-stretched

2B pencil

Watercolors :Phthalo Green, Lemon Yellow, Phthalo Blue, Burnt Sienna, Magenta, Lamp Black, Cobalt Blue, Gamboge, Cadmium Yellow, Raw Sienna, Indigo

Brushes: large wash, medium round, small round

1 Using a 2B pencil, lightly indicate the main shapes. Mix a light green wash with Phthalo Green and Lemon Yellow and, using a large wash brush, define the rounded shape of the wooded hill that provides the backdrop to this calm scene. Leave to dry.

2 The natural center of interest is the sharp point of land where the river makes a double turn. Establish this turn very carefully by defining the two points of bank, one just in front of the other, with a pale blue (Phthalo Blue) which represents the river surface. Just above this there is a glimpse of the only building in the scene, its roof a pinky red mixed from Burnt Sienna with a little Magenta. Between the two, put in some small shapes of riverside trees beyond the second turn, using a small brush and a medium dark mix of Pthalo Green and Lamp Black, leaving some of the background light green between these fan-like shapes to represent the light edges of contre-jour lighting. Paint couple of nearer trees, which break the horizon, using a medium brush and a slightly stronger mix of Phthalo Green and Lemon Yellow.

3 Mix a pale wash of Phthalo Blue and Cobalt Blue and, using the large wash brush, loosely put in the reflection of the sky in the water.

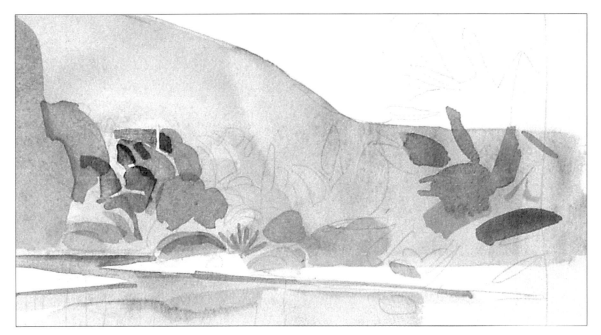

4 Mix a yellowish green from Gamboge and a dash of Phthalo Green and put in any trees that have this variation from the more universal mid–green.

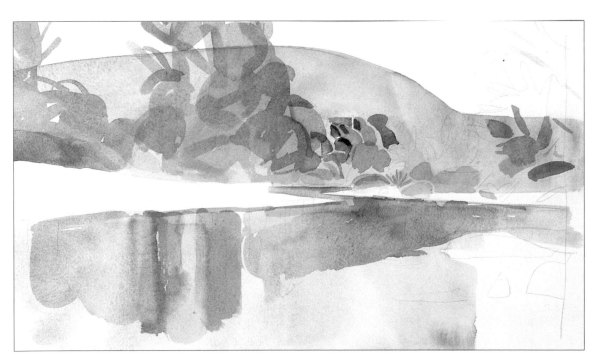

5 Mix a medium green from Phthalo Green, Cadmium Yellow, and a little Lamp Black and, using the medium brush, make broad brushstrokes to indicate the foliage of the two larger trees. Begin putting in the reflections, using different mixtures of the same colors and vertical brushstrokes. The slight ripple on the surface of this river makes the reflections look rather like a series of columns.

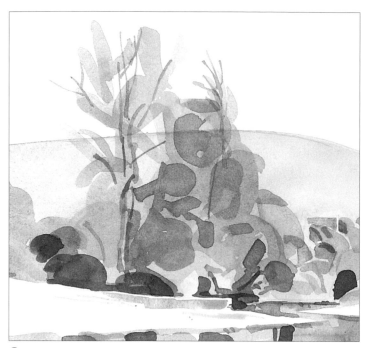

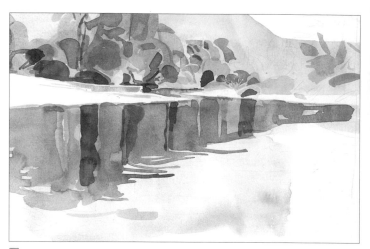

6 Using a small round brush and varied mixtures of Phthalo Green and Lamp Black (tree trunks at this distance rarely look brown), draw in the branches and trunks. Don't try to draw every branch—just look for the overall pattern. Color the shadow side of the low wall in the center with a sort of warm gray, leaving its top edge light, and heighten the contrast by adding darker shadows (Phthalo Green plus Lamp Black) to the bushes behind it and slightly less intense shdows on the trees above them. Use the same dark green mix to put in more vertical reflections.

7 Apply a mid-toned green over the whole of the reflection and leave to dry. Add some darker green reflections to show how ripples disturb the surface of the water. Using the same dark mixture, continue building up the darks on the biggest tree.

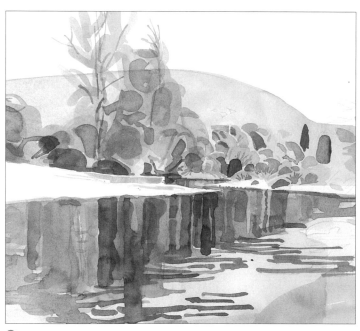

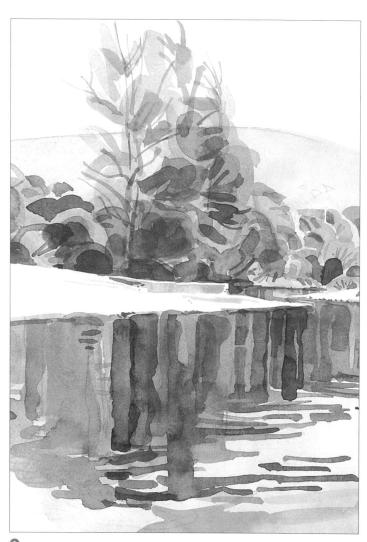

8 Continue working on the reflections, expanding the ripples out into the sky reflection. In the right foreground, the angle of view has allowed the color of the river bed to overpower the reflection of the sky; indicate this with a wash of Raw Sienna mixed with a touch of Cobalt Blue.

9 Continue building up the contre-jour tones in the main trees by adding more detailed tones and leaving edges to represent the light from behind and beyond them. As the trees become darker so should their reflections, so observe where they occur and build them up to, literally, reflect the colors of the trees.

10 Now it is time to put some detail on the tree-covered hill. Using a medium round brush and the same mid-toned greens used for the reflections, make generalized "fan" shapes to indicate the shaded portions of the distant trees. Note how, as in the previous demonstration, the contre-jour lighting creates an arc-shaped rim around the edges of the trees, leaving the original wash as the light edges.

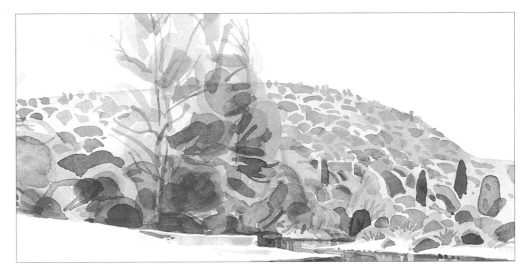

11 At Step 10, even though some ripples have been put in, the water still did not seem to have a surface: adding ripples with quite dark strokes of Indigo plus Lamp Black on top of the reflections gives it that surface.

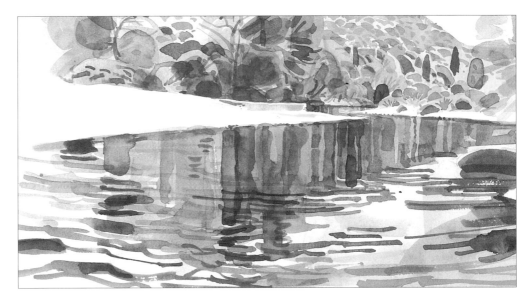

12 Finally, using an old toothbrush, spatter Raw Sienna and the pale green mixture over the river bank to give the impression of its pebbly texture and bring the tree on the right forward in the scene with darker strokes of the Phthalo Green and Lamp Black mixture.

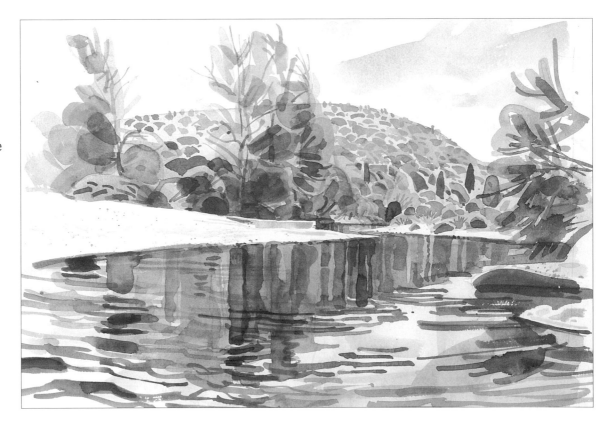

Building in a landscape

Painting landscapes is not just a matter of searching out wide vistas, the prospects that are always described as magnificent views. More intimate views also have their charms.

SEE ALSO

• Washes, page 26

Materials

2B pencil

90-lb (185-gsm) watercolor paper, pre-stretched

Watercolor paints: Cobalt Blue, Cadmium Orange, Raw Sienna, Phthalo Green, Lamp Black, Lemon Yellow, Light Red, Viridian, Burnt Sienna, Raw Umber, Ultramarine Blue

Brushes: medium wash, medium Chinese, small round

Trees such as these almond trees in the Algarve, southern Portugal, have few leaves at certain times of the year, so revealing the basic structure and color of their trunks and branches. Sunlight not only reveals the form by lighting the limbs directly, but it also casts shadows from branches onto other branches and onto the ground.

Framed by this series of patterns is the homestead itself, a simple white, sunlit building with vines around the door. To achieve the necessary impression of space between the foreground almond trees and the building, you need to treat the latter with delicacy and the former with a bold touch. For this reason it is probably best to start with the homestead and progress to the strong shapes of the trees and branches as you grow more confident and feel able to apply the strongest washes.

Incidentally, I do feel strongly that this is the best way for a watercolor painting to progress: although first washes may be broad, they are normally light, building up to the robust ones in the later stages. Details can be put in at any stage not necessarily the last. It is better to end with a bang than with a whimper.

1 Using a 2B pencil, lightly sketch the scene. Look for recurring patterns, such as the brickwork and the tiles on the roof, as they will help you to understand the way the building is constructed and the character and textures involved. Similarly, look for the growth pattern of the overhanging branches of the almond trees in the foreground; the way they curve is characteristic of this tree and will help to give your painting conviction.

2 Mix a generous amount of Cobalt Blue and, using a medium wash brush, lay a wash over the sky, cutting in around the farmhouse and branches. Be particularly careful around the chimney, as it's important to reserve the white of the paper here. Work with the board flat to prevent paint from trickling into areas where you don't want it to go. Leave to dry.

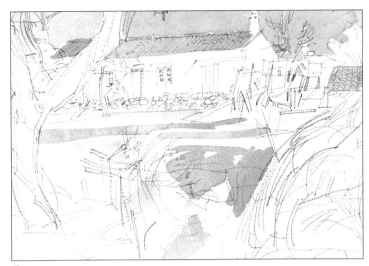

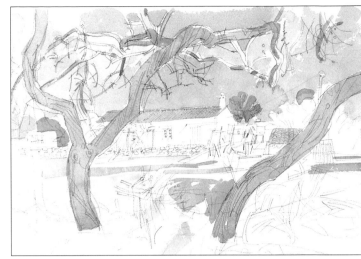

3 Mix a pale wash of Cadmium Orange and, using a medium Chinese brush, paint the tiled roof. Use the same color for the parched soil in the foreground and Raw Sienna, both on its own and dropped wet into wet into the Cadmium Orange, for the browner areas of soil. Leave to dry.

4 Mix a very pale, cool green from Phthalo Green, Raw Sienna, Cobalt Blue, and a little Lamp Black. Using a medium round brush, apply this mixture over the trees to establish the underlying color of the trunks and branches. Paint the bright foliage of the tree to the left of the farmhouse in a mixture of Phthalo Green and Lemon Yellow.

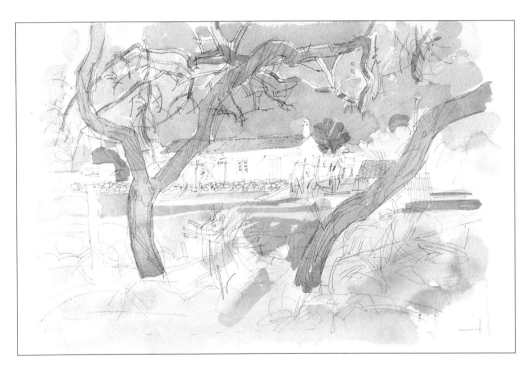

5 Apply a very pale wash of Cobalt Blue over the top of the image to increase the density of the sky and ensure that no white patches are left, avoiding the chimney. Apply a very pale wash of Raw Sienna over the foreground, leaving the farmhouse white and working around the trunks of the trees. Leave to dry.

6 Using a small, round brush, begin putting in some of the detail—the pale blue door (Cobalt); the shadows under the eaves, the shadow cast over the front of the building by the vine, and the glass of the windows (various mixtures of Cobalt Blue and Lamp Black); the reddish brown shadows on and around the outbuildings (a mixture of Lamp Black and Raw Sienna); and the reddish brown right-hand door (Light Red). Mix a bright green from Phthalo Green and Lemon Yellow and put in the trees in the middle distance around the farmhouse. Add a little Cobalt Blue to the mixture for the vine over the door.

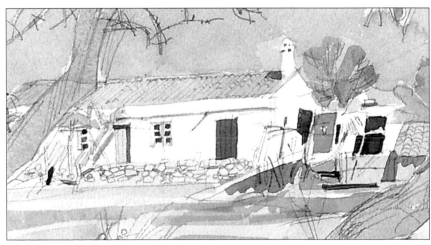

7 Mix a cool green from Viridian, Lamp Black, and raw sienna. Using a medium Chinese brush, put in some of the cast shadows and texture on the overhanging branches. Leave to dry.

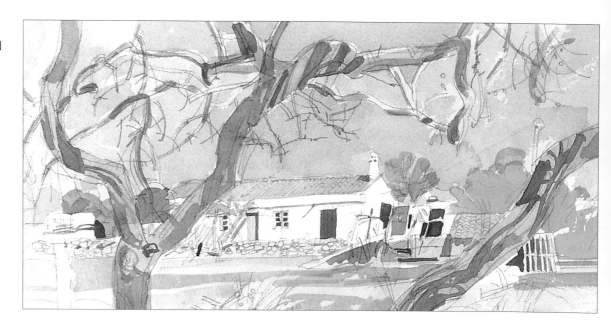

8 Mix various reddish browns from Raw Sienna and Burnt Sienna and, making loose, calligraphic strokes, imply the color and texture of the bare earth in the foreground.

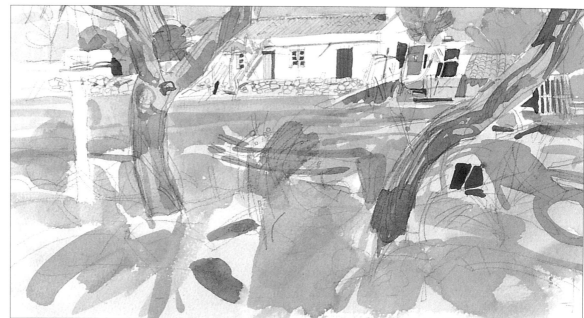

9 Mix a dark, greenish black from Lamp Black and Phthalo Green. Put in the cast shadows on the branches and the shaded sides of the branches themselves.

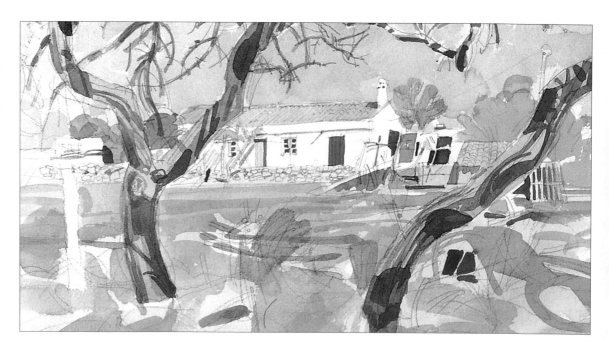

10 Mix a dark shadow color from Raw Umber and Ultramarine Blue and put in the shadows cast on the ground. Contrive to do this with boldness and conviction—it won't work if you are timid. As you may deduce from the number of times it recurs in the projects, this is one of my favorite shadow mixes. It looks rich in any proportions: when the Ultramarine dominates, it is cool in color temperature; and when the Raw Umber takes precedence, the shadow becomes warmer.

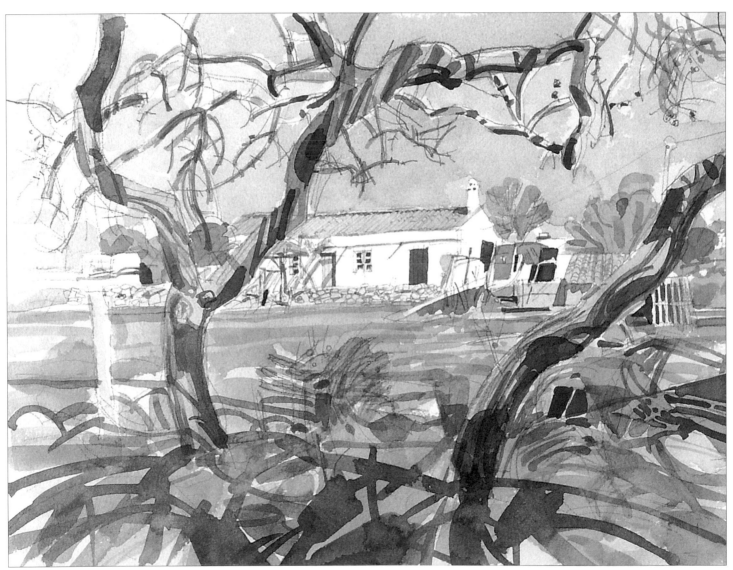

11 Here I put in the bright green of the foliage on the trees next to the farmhouse using a mixture of Phthalo Green and Lemon Yellow. Casting your eye over the picture at the last may reveal a few details such as this that need to be added, but try not to get too fussy: it is remarkably easy to go too far and water down the impact.

Cork forest

Forest and woodland would seem to provide the ultimate natural scene, untouched by human hand. In practice, unless you are willing to go to the depths of a Brazilian rainforest, most forests are managed to some degree.

SEE ALSO

• Washes, page 26

• Overlaying colors, page 30

• Seeing in tone, page 34

• Types of mask, page 56

In the mountains of southern Portugal, forests of cork oak trees are cultivated to provide cork for sealing bottles of wine and for insulation. Our interest is in their appearance. The cork is harvested at approximately ten-year intervals by stripping the bark of the main trunk and some distance up the main limbs, revealing an astonishing red color as though the trees were bleeding; indeed, some runs of red sap can often be seen. The trees are then painted with a number denoting the year in which they were stripped, which remains visible as the bark beneath it is gradually replaced until the whole process is repeated in ten years' time.

Freshly harvested trees therefore only constitute about 10 percent of the forest, but they provide a great opportunity to use strong reds in the kind of scene in which greens and browns usually predominate.

Materials

2B pencil

90-lb (185-gsm) NOT watercolor paper, pre-stretched

Steel-nibbed dip pen

Masking fluid

Watercolor paints: Raw Sienna, Lamp Black, Raw Umber, Gamboge, Burnt Sienna, Cadmium Orange, IUltramarine Blue, Phthalo Green, Lemon Yellow, Vermilion, Magenta, Viridian

Brushes: large wash, medium round, medium Chinese

1 Using a 2B pencil, lightly sketch the main tree trunks and foliage areas and indicate the general pattern of the light-colored grasses in the foreground.

2 Using a steel-nibbed dip pen and masking fluid, mask out the foreground grasses. Although you've drawn them in pencil, the pencil marks will come off when you remove the masking fluid in the final stages of the painting. Leave the masking fluid to dry completely.

3 Mix a pale brown from Raw Sienna and a little Lamp Black. Using a large wash brush, wash this mixture over the sandy foreground area in the bottom right of the picture. Leave to dry. Mix a slightly greener brown from Raw Sienna and Raw Umber and loosely brush it over the first wash to give some tonal variation. Leave to dry.

4 Mix a browny orange from Gamboge and Burnt Sienna. Using a medium round brush, paint the darkest areas of the cork tree trunks. Paint the more brightly lit tree trunks with a mid-toned wash of Cadmium Orange. Note where the branches cut in front of one another and where foliage masses obscure the branches and leave gaps at these points. Leave to dry.

6 Using your fingertips, gently rub off the masking fluid to reveal the lines of the foreground grasses. Run your fingers over the surface of th paper to make sure all the masking fluid has been removed.

5 The branches that have not been stripped of their bark are gray in color. Using a Chinese brush, which is particularly good for flowing lines, paint them in Lamp Black. As Lamp Black is naturally a cool color, warm up the color in places by dropping in a little Burnt Sienna, wet into wet. Make up two mixtures of Raw Umber and Ultramarine Blue, one bluer than the other, and paint the exposed rocks in the foreground.

7 Using the Raw Umber and Ultramarine Blue mixtures from Step 5 and a medium Chinese brush, put in some dark shadows in the foreground, painting bchind and around the exposed lines of the grasses so that they stand out clearly in comparison.

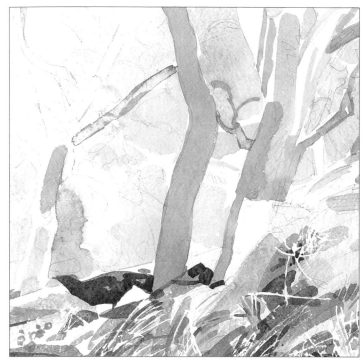

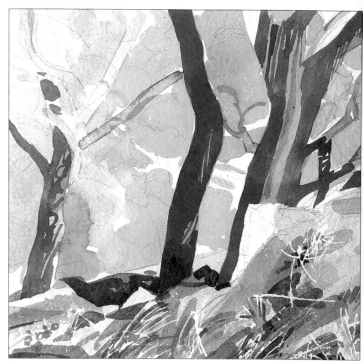

8 Mix an olivey green from Gamboge with a little Phthalo Green and a lighter green from Phthalo Green and Lemon Yellow and, using a medium Chinese brush, begin to put some background color on the trees. Alternate between the two mixtures to get some variation in color in the foliage.

9 Mix a deep, orangey red from Burnt Sienna, Vermilion, and a little Magenta and brush over the tree trunks where the bark has been stripped away, allowing some of the underlying orange to show through where light hits the trunks.

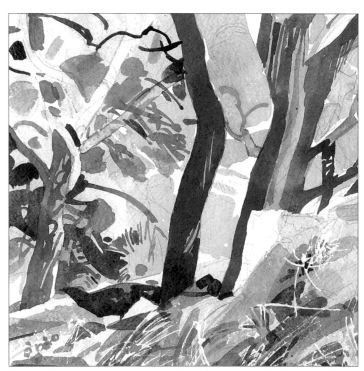

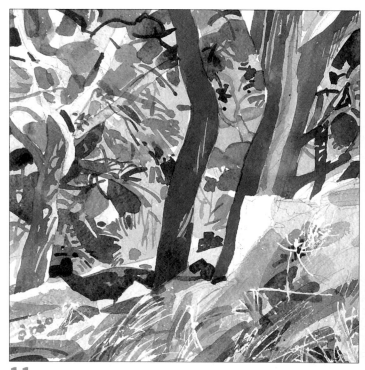

10 Now you can begin to work on the foliage and really bring the picture to life. Mix a yellowy green from Viridian and Raw Sienna and a bluer version of the same mixture, using more Viridian. Alternating between the two mixtures, paint the foliage. Note how using two tones helps to bring more of a sense of three dimensions to the image: it is becoming easier to see which areas of foliage are in shade and which are in bright sunlight.

11 Continue putting in greens as before, making sure you retain plenty of spaces to see through to the light background greens. Note how putting in dark blocks of foliage helps to define the crisp edges of the tree trunks. Leave to dry.

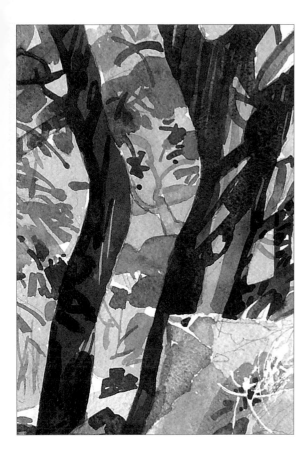

12 Mix a neutral gray from Raw Umber and Ultramarine Blue and, using a medium Chinese brush, paint the shadows on the tree trunks, allowing some of the underlying color to show through. (Note how the gray is modified by the underlying red.) Use the same mixture for the dark branches of the trees on the right.

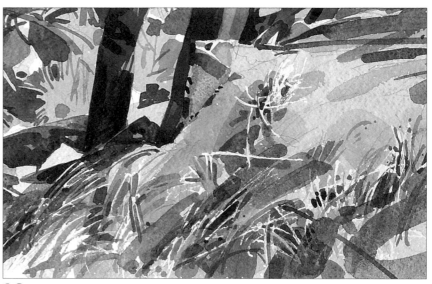

13 Use the same color and brush to paint the shadows on the sandy ground under the trees in loose, swirling strokes.

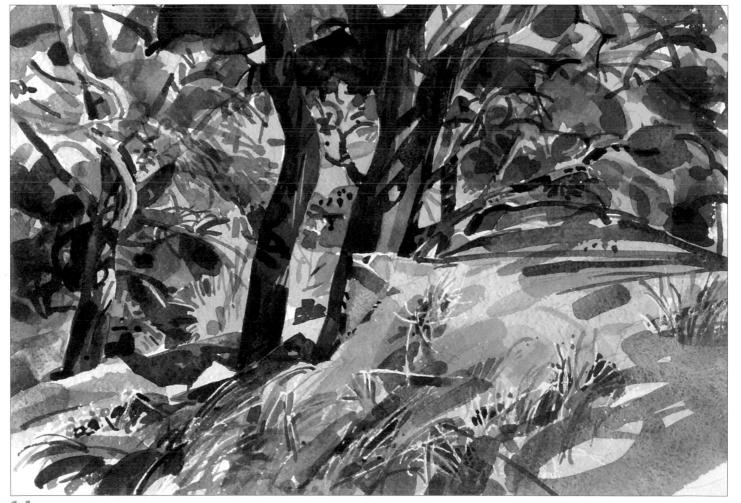

14 Mix a dark green from Viridian, Gamboge, and a tiny amount of Lamp Black. Use this green to unify the broken areas of green in the top half of the image. Adjust the shadow colors where necessary, using the same mixtures as before.

Sea and cliffs

With so many moods, so many different juxtapositions with the land, the sea is an infinitely rich subject for the artist and probably deserves a book in its own right.

SEE ALSO

• Textures and additives, page 60

Indeed there are already many such books and many of them devote a great deal of space to the depiction of crashing waves—which is precisely why I shall not be doing so. Don't misunderstand me—I am as excited as anyone by the sun shining through the green lip of a wave just before it rolls over and crashes into a welter of flying foam, but photographs capture it well and paintings of it have become just a bit clichéd.

Just as interesting is the interaction between the sea and the shore, the never-ending breaking-down and shaping of rocks and building-up of sand dunes. Millions of years of erosion have exposed the underlying structure of the cliffs, the strata bent and twisted by the colossal forces of land upheaval and plate techtonics, while isolated rocks may be sculpted into fantastic shapes by the action of the elements.

LOOKING DOWN ON BASSET COVE

There days when the sea is clear, calm and impossibly blue, gently lapping a beach of white sand. The clarity of the water makes the underwater scene visible, the sand showing translucent turquoise, the seaweed-covered rocks almost indigo. Sea cliffs grow their own hardy flora, too—millions of tiny blooms on these ancient cliff tops.

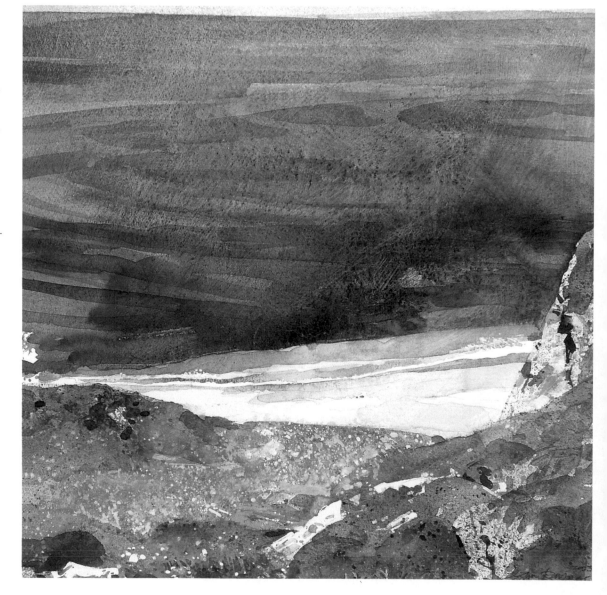

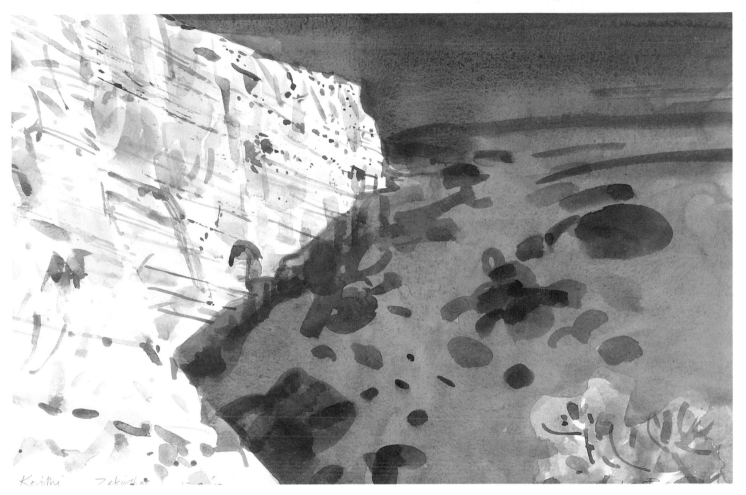

Kavithi Zakinthos

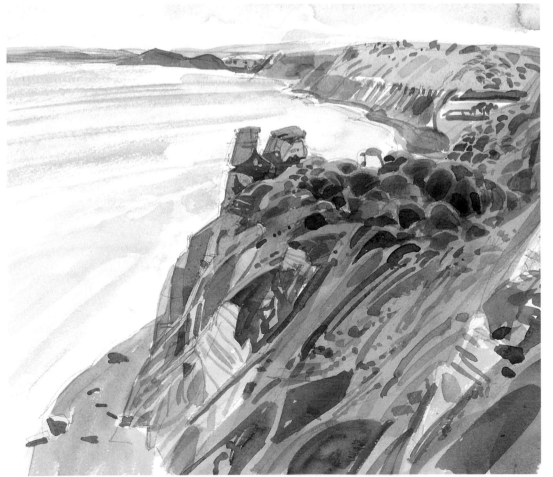

ZAKINTHOS
The dipping strata of this dazzling white cliff on the Greek island of Zakinthos plunge into an extraordinarily deep blue, translucent sea, every variation in the sea floor clearly visible.

SOUTH DEVON COAST, ENGLAND
Evidence of the action of erosion on this land/sea interface is ever present, sometimes producing shapes that appear to be man made.

Beach patterns

Seaside cliffs and beaches are a source of endlessly fascinating shapes and patterns. Because they are subject to the constant bombardment of the sea, they are never exactly the same, but change sometimes with each tide.

SEE ALSO

• Wet into wet, page 28

• Overlaying colors, page 30

This beach is one of many on a coastline near my home that I know well: they all have surf waves, sand and rocky oucrops. Many, like this one, have small streams that flow onto and through them. As a result, sand is moved around, with channels forming and bars appearing, the changing subtly every day and at different times of the day. Sometimes the waves dominate; atother times the stream takes over.

Here the tide has receded; the stream is finding its way through the beach, washing sand from some of the rocks and forming a pattern of water flow that is unique to each tide. Where the beach has been freshly exposed, its surface is still wet and reflects the cloudy sky like a mirror. Wet-into-wet applications are the perfect technique to use to depict this.

The lines of surf in the background look as if they have been drawn with a straightedge. Although they form a relatively small part of the picture, the deep blue of the sea and dark green of the far shore form a strong horizontal counterpoint to the swirling patterns in the wet foreground, balancing the image.

Materials

90-lb (140-gsm) rough watercolour paper, pre-stretched

HB pencil

Watercolor paints:
Cobalt Blue, Ultramarine Blue, Raw Umber, Lamp Black, Cerulean Blue, Phthalo Green, Gamboge, Raw Sienna

Brushes: large mop, medium round, large flat

Paper towel

Medium steel-nibbed dip pen

Masking fluid

1 Using an HB pencil, sketch the scene. There are some very strong shapes here: they will be covered by subsequent watercolor washes, but take care not to make the light areas too dark or the pencil marks will show through.

2 Using a sponge or a large mop brush, dampen the water area and those parts of the sand in which the sky is reflected with clean water. Drop Cobalt Blue, wet into wet, for the reflections of the sky in the sand. Mix a dark gray from Ultramarine Blue and Raw Umber and paint the reflections of the clouds in the sand. Press a paper towel onto the paint to soften the edges, turning the paper in your hand each time to prevent dabbing paint back on. Leave to dry.

3 Using the same dark gray mixture and a medium round brush, block in the dark rocks. These sharp shapes, painted wet on dry, contrast with the blurriness of the previous stage. Mix a deep blue wash from Ultramarine Blue with a little Lamp Black. Brush in the dark sea area and breaking wavelets in the background. Paint the dark area of sand that juts into the left of the picture in a mixture of Ultramarine Blue and Raw Umber. Working wet into wet, drop in some pure Raw Umber in places to get some variety of tone. Leave to dry.

4 Using a medium, steel-nibbed dip pen, dot in the small, pale-colored houses on the distant hill with masking fluid. Leave to dry. Using a medium round brush, paint around the wave in the background in Cerulean Blue. Leave to dry. The water is now beginning to take on more depth of color and variety of tone.

5 Lay a wash of Cobalt Blue over the sky, leaving some gaps for clouds. Leave to dry. Mix a dark, rich green from Phthalo Green, the Ultramarine and Raw Umber mixture, and Gamboge. Brush in the land area at the top of the picture, leaving a few slivers untouched at the base of the headland for the tiny beaches there. Leave to dry.

6 Mix a darker green from Phthalo Green, a tiny amount of Raw Umber, and Lamp Black. Using a medium round brush, dot in tree shapes and make broad strokes of color on the hill, leaving some of the underlying green showing through for the areas that are hit by sunlight.

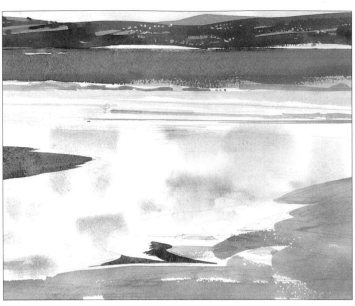

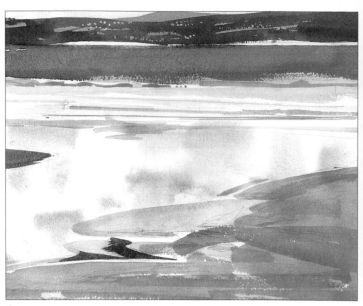

7 Mix a dark blue from Ultramarine Blue and a little Lamp Black. Using a large flat brush, put in the dark foreground water, dragging the brush to give a slightly broken texture in places.

8 Mix a pale gray from Cobalt Blue, Cerulean Blue, and a tiny amount of Lamp Black. Using a medium round brush, paint loose swirls over the foreground sand to deepen the tone in places.

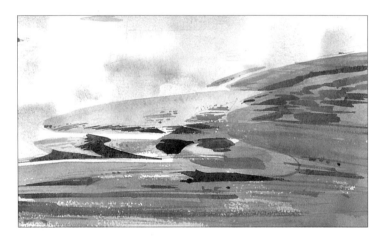

9 Using a medium round brush and a mixture of Ultramarine Blue and Raw Umber, paint the ripples in the water in the foreground.

10 Using the dark blue mixture used in Step 3 and a large mop brush, make broad sweeps across the dark sea area in the background and along the bottom of the picture. Use the same color to put some ripples into the water in the immediate foreground and the middle distance. Indicate the tiny figure of the surfer.

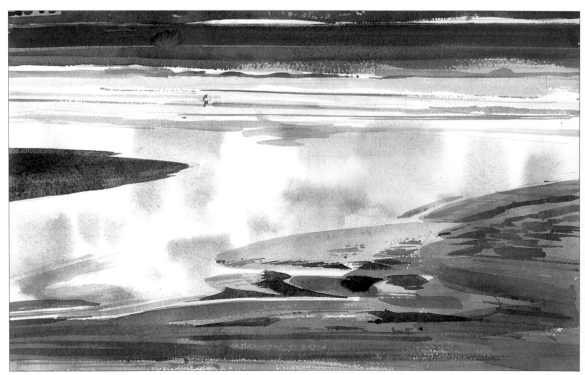

11 Mix a greenish blue from Ultramarine Blue and Phthalo Green. Using a medium round brush, brush this color into the waves in the background to reinforce the colors of the water and give it more variety of tone. Also put some more dark patterning into the waterlogged sand area in the foreground. Add a touch of Gamboge to the surfer's board. Rub off the masking fluid on the far hill and wash over some blue-gray.

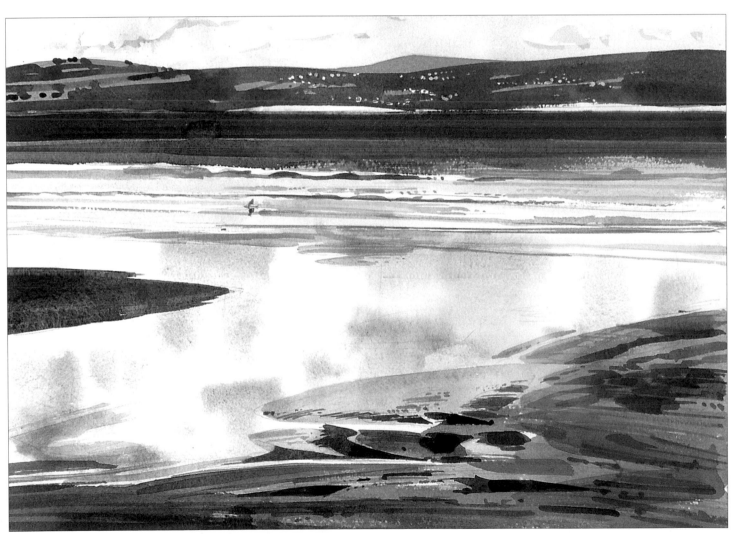

12 Mix a pale gray from Ultramarine Blue and Lamp Black and wash this onto the underside of the clouds to give them some form. Using a darker version of the same mixture, put in some more foreground pattern. Brush Ultramarine Blue and black over parts of the foreground to knock out some of the lights. Finally, mix an olive green color from Raw Sienna and Lamp Black and put in the extreme foreground.

Ruined abbey

Ruined buildings have always held a fascination for artists—perhaps because, although they are man made, they are in the process of returning to the earth and therefore seem to be a more integral part of the landscape.

SEE ALSO

• Washes, page 26

• Wet into wet, page 28

Materials
2B pencil
Watercolor board
Watercolor paints: Raw
Sienna, Burnt Sienna,
Cobalt Blue, Gamboge,
Raw Umber, Lamp
Black, Light Red
Brushes: large wash,
small round

In any case, as long as there are sufficient elements of the original structure remaining, a ruined building can provide an entertaining exercise in perspective, with perhaps more interesting lighting as result of the often missing roof and a wall or two.

This wonderful edifice is what remains of Tintern Abbey in South Wales: John Sell Cotman, the father of the English style of watercolor, painted it and many others have done since. On my visit the sunlight was slanting through the openings in the walls, creating dramatic passages of light and shade and leaving one wall with its grand window silhouetted against the blue sky. Such a subject requires a bold treatment.

2 Mix a generous amount of a very pale Raw Sienna wash with a tiny amount of Burnt Sienna and, using a large wash brush, lay a wash over the whole paper. Leave to dry. You can always apply a second wash if necessary; in fact, I applied three washes here before I judged that the tone was correct, allowing each one to dry before I applied the next one. Add a little more pigment to the paint mixture and apply a gradated wash over the top third of the paper. Leave to dry.

1 Using a 2B pencil, lightly sketch the scene paying particular attention to the angles and perspective lines. This scene shows the abbey in the early morning, which means that lots of areas are in deep shadow and many of the shadows are long: make a careful note of where the light hits the building, as this is what enables you both to see the detail in the stonework and to convey a sense of the building's form.

3 Mix a wash of Cobalt Blue and apply it over the sky, carefully cutting in around the lines of the abbey. Leave some gaps for cloud and dab off paint with a paper towel if necessary. Note how the underlying Sienna wash modifies the color of the Cobalt. Leave to dry.

4 Mix a strong, yellow-biased stone color from Raw Sienna and Gamboge and, still using the large wash brush, lay a wash over the stonework, carefully brushing around the blue of the sky that is visible through the arches. Leave to dry.

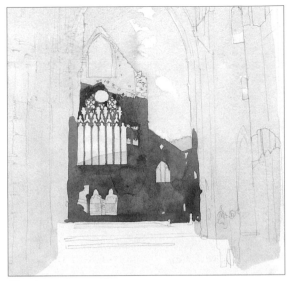

5 Mix a greenish brown from Raw Umber, Lamp Black, and Light Red. Using a small round brush, put in some of the darker tones in the stonework of the main arched window. Remember to use plenty of water, even though you're painting fine detail, otherwise your brushstrokes will look tight and mean when they dry. Drop in Raw Sienna in places to give some tonal variation, as this adds texture to the stonework.

6 Using the same greenish brown mixture and a medium round brush, start putting in dark tones on the first and second arches, again dropping in some Raw Sienna occasionally to give some tonal variation in the stonework. It's vital to keep these shades interesting, as they occupy a large area of the painting, so don't let them get murky and dark.

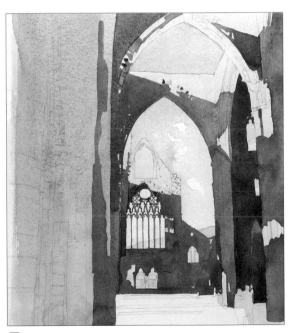

7 Mix a cool neutral brown from Cobalt Blue and Raw Umber and apply a pale wash over the large foreground column on the left-hand side. Add some Raw Sienna to the mixture to make it a little warmer as you move in toward the center of the painting. Leave to dry. Using the greenish brown mixture from Step 5, carefully paint the darkest shadows on the right-hand side. Once you've established the boundaries of a shadow area, you can drop in other colors, wet into wet, to modify the tones without the paint running outside this area.

8 Mix a dark but vivid green from Phthalo Green and Lemon Yellow, and paint the dark strips of grass in the foreground, adding more lemon yellow for the brighter strip in the center. Leave to dry. Although the strips of green are very small elements in the total composition, they are very important in establishing the ground plane and directing the eye through the building to the almost free-standing wall.

9 Mix a warm gray from Raw Sienna, Raw Umber, and Lamp Black and, using a medium round brush, start to put in the dark lines of the moldings on the arch.

10 At this point, I realized that I'd made a mistake in the top right-hand corner: the whole of this area should be sky, but I'd mistakenly drawn the beginnings of another arch. To correct it, I wetted the area with clean water to get rid of the hard edge and applied more Cobalt Blue. No matter how experienced you are, don't assume that your underdrawing is 100 percent accurate! Keep checking things throughout the painting.

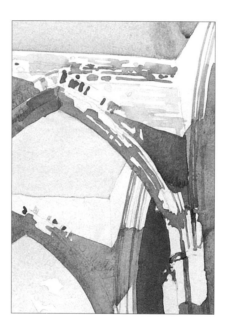

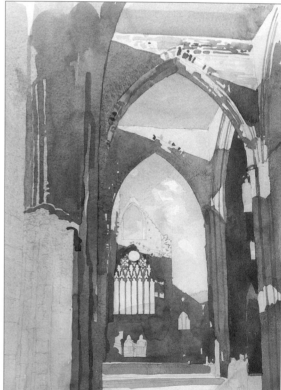

11 Using the same mixtures as before, continue putting in detail on the right-hand arch. Note that the stones have worn and aged in different ways and so there are different colors within this deeply shaded area. When I'm painting straight lines such as the columns that support the arches, I find it easier to paint from left to right rather than vertically, and so I usually turn the drawing board around. Begin indicating the texture in the stonework at the top of the first arch. Don't attempt to describe every individual stone, but concentrate on establishing the general pattern.

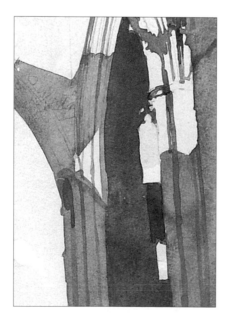

12 The painting was now nearing completion, so I spent some time assessing whether or not the tonal values were correct. I made the blue of the sky a little stronger. I also decided that the lightest stones looked too bright and that the whole image needed to be warmed up a little, and so I laid a wash of very pale Gamboge over the whole painting. If you're worried that this wash will modify the blue of the sky too much, test it on a small area that will fall outside the picture. Once you've applied an overall wash, you can add more pigment to selected areas if you think it's necessary.

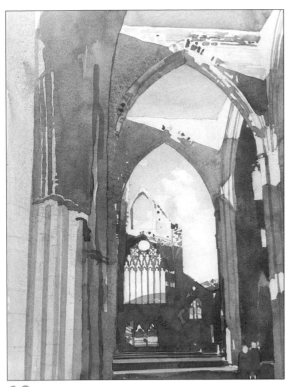

14 Using the same mixture as in Step 12, put in more detail on the columns on the left-hand side. When the detailing is dry, you may need to darken the left-hand side of the painting with a very pale wash of the stone color.

13 Mix a dark stone color from Raw Umber and Lamp Black. Using a fine round brush, put in more detail around the top of the first arch, using short horizontal strokes as before to establish the overall pattern of the stonework. Use the same mixture for the shadow area on the ground, adding a little Indigo to cool the mixture down on the right-hand side. (The Raw Umber and Indigo give some variation of color: pure black would look too heavy.) Paint the hills and trees that are just visible through the arches.

15 By this stage you should be interpreting the scene and deciding what works best visually, rather than slavishly copying what you see before you. For example, although I could see virtually no detail in the dark area at the base of the picture, painting it in this way would look too heavy and so I decided to leave some tonal variation. Using the same mixtures as before, I darkened the tones in various parts of the image to allow the very lightest areas to stand out more clearly.

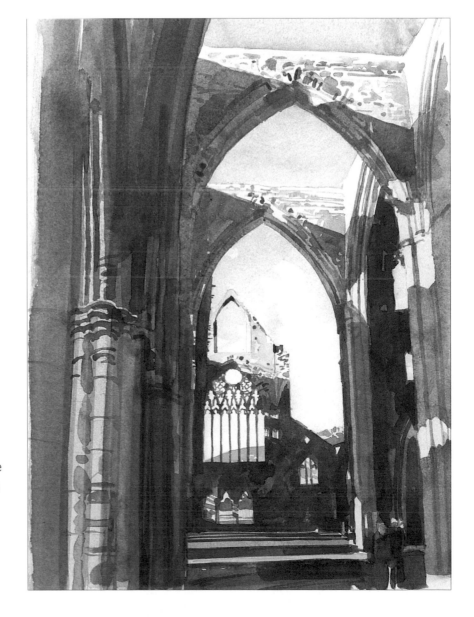

Modern cityscape

A strong composition with startling contrasts of tone, color, and styles of architecture can make an initially unappealing subject into a dramatic painting.

SEE ALSO

• Overlaying colors, page 30

• Painting from photographs, page 142

To many people, the hard lines and curtain glass windows typical of many modern buildings in large cities might not at first sight seem to be tempting subjects for a watercolor painting, but I believe thatched cottages and clapboard houses with picket fences should not have a monopoly on the picturesque. Most cities have evolved to include a rich mixture of styles and periods of architecture. There

will be views such as this one, in which a brick-built façade with decorated renderings sits alongside an uncompromising slab of white concrete punctuated by lines of geometrically sharp windows. There is pattern to be found in their silhouettes against the sky—in this case, a blue deepened by its contrast with the sunlit white of the skyscraper.

THE ORIGINAL SCENE
Looking up at tall buildings gives them a perspective that makes all their vertical elements appear to converge upward. The nearer you are to the building, the more extreme is this effect: view the same building from afar and the uprights more nearly approach the vertical. For this painting, I decided to "correct" the perspective by straightening up the face of the right-hand building and tried out various versions on my computer until I came up with something I liked.

Materials

90-lb (185-gsm) NOT watercolor paper,
 pre-stretched
HB pencil
Watercolor paints: Cobalt Blue,
 Ultramarine Blue, Lamp Black, Indigo,
 Raw Umber, Magenta, Burnt Sienna,
 Cadmium Orange, Cerulean Blue
Brushes: large wash, medium Chinese,
 fine-tipped round

1 Using an HB pencil, sketch the scene. I generally use a 2B pencil for underdrawings, but here I wanted the lines to be a little harder and sharper to suit the crisp lines of the subject. You don't need to put in every single pane or course of bricks: a general indication of them is sufficient.

2 Mix a generous wash of Cobalt Blue mixed with a little Ultramarine Blue. The intense color of the sky is the key to this image, but you won't be able to achieve this with a single layer. Taking great care not to touch the white building, paint the sky visible between the buildings. Use the same color over the dark, silhouetted areas; it doesn't matter if these areas dry unevenly, as they'll be covered up later, but try to keep the color of the sky as flat as possible. Leave to dry.

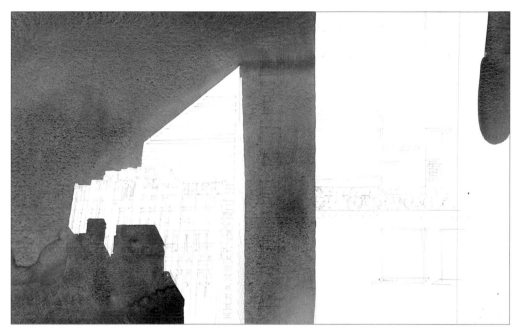

3 Using a fine-tipped brush, apply a mid-toned wash of Lamp Black over the fire escapes, as the pencil markings won't show up once you've applied the next washes over this dark area. Don't make the paint too thick, otherwise it may lift off when you apply the next wash. Leave to dry.

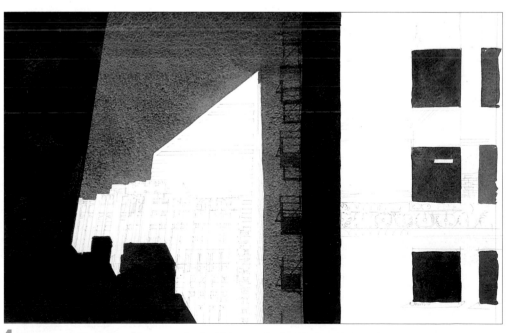

4 Wash pure Ultramarine Blue over the first blue wash. (I added a third wash to achieve the right density of tone.) Leave to dry. Mix a strong wash of Lamp Black and, using a large wash brush, apply it over the silhouetted area on the left. To make it more interesting, drop in Indigo and Raw Umber, wet into wet. Add Raw Umber to the black and paint the black area of the building on the right, with the fire escapes. Paint the window bottom right and the dark areas of the brick buildings.

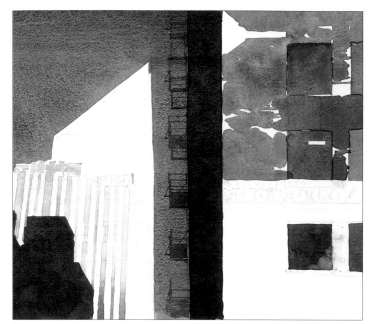

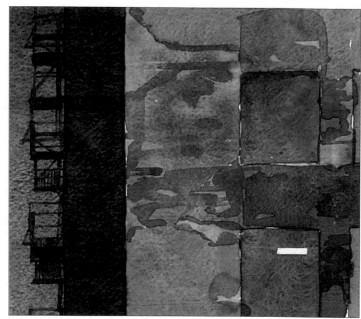

5 Mix a pale, warm gray from Lamp Black and a little Magenta. Using a medium Chinese brush, put in the building in front of the white skyscraper, leaving white edges along the windows. Mix three washes for the brickwork building: a warm brown (Burnt Sienna/Lamp Black), a redder mix (Burnt Sienna/Magenta), and an orangey brown (Burnt Sienna/Cadmium Orange). Alternating between them, brush them loosely over the brown brickwork to create interesting variations in tone.

6 Mix a very pale gray from Lamp Black and a little Magenta and apply it over the light-colored portion of the building on the right. (You can even use your fingertips for this, to create more texture than is possible with the brush.) Continue putting in colors on the brickwork, as in Step 5, using linear strokes to imply the pattern of the bricks without attempting to put in every single line. Reinforce the fire escapes in Lamp Black.

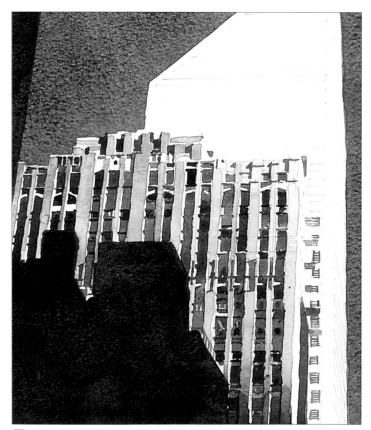

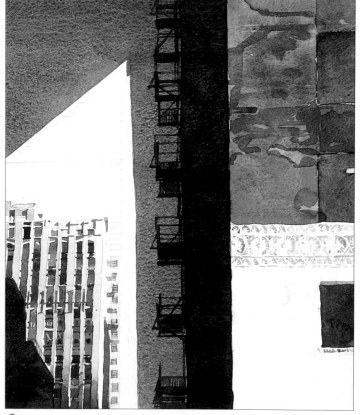

7 Alternating between the sky color and a pale Lamp Black, put in the dark colors of the windows of the darker building on the left. Look for the abstract pattern of color: some degree of simplification is required and, to an extent, it's up to you to decide what colors go where.

8 Mix a very pale wash of blue from Cerulean and Cobalt Blues and apply it over the white skyscraper. Using a pale gray-blue and a fine-tipped brush, start putting in the detail of the stuccowork of the building on the right.

9 Mix a dark version of the Ultramarine sky color and, using a fine brush, carefully put in the horizontal lines of the windows on the white skyscraper.

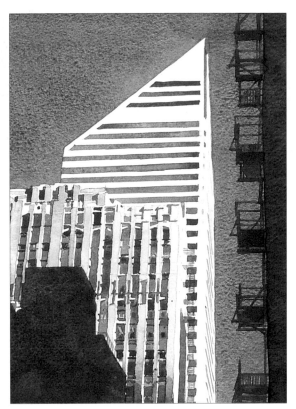

10 Using various mixtures of Burnt Sienna and Lamp Black and a fine-tipped brush, start putting in some texture and detail in the brickwork of the building on the right. (General indications of the pattern are sufficient.) Mix a blue-gray from Lamp Black with a little Ultramarine Blue and put in the sills of the windows of the building on the right.

11 Using the same colors as before, reinforce the dark panes of glass in the building on the right. Using the Lamp Black and Raw Umber mixture from Step 4, put more detailing in the brickwork. Mix a purplish brown from Magenta, Burnt Sienna, and Ultramarine Blue and, using a medium round brush, loosely brush it over the silhouetted buildings on the right.

Interior in line and wash

As you can see in the photograph of this private library, the lighting in some areas is quite subdued. Although this is pleasingly dramatic, I thought it better to employ a method that gives a lighter, fresher appearance.

SEE ALSO

• Pencils and pens, page 22

Drawing and painting combined, page 52

This is a complex interior, with the strong beams supporting the ceiling competing for attention with the closely stacked shelves of books. Drawing all the details in line first and adding color later is an ideal method for such a subject. To avoid the line work running when the washes are added, use waterproof inks. If, when all the washes have been applied, the linework looks to have been overpowered, there is no reason why you should not revert to pen and ink to strengthen it further, in order to create the look of a line drawing with washes added. Although you could use pen and black ink, it is considerably less risky to water down the ink in the early stages and I decided to introduce some colored inks, too. Colors such as yellow, which are tonally light, can be further diluted so that perspective lines, vanishing points, and other structural features can be drawn in with the certainty that they will be virtually undetectable when the washes are applied.

Materials

140-lb (300-gsm) rough watercolor paper, pre-stretched

Medium dip pen

Waterproof inks: black, yellow, vermilion, green, ultramarine blue, sepia

Watercolor paints: Raw Sienna, Raw Umber, Lamp Black, Cadmium Orange, Gamboge, Viridian, Cerulean Blue, Cadmium Yellow, Sepia, Ultramarine Blue, Vermilion

Brushes: medium Chinese, medium round

The scene

This view is close enough to being in one point perspective and by following the lines of the bookshelves, and noting where they intersect, the vanishing point can be determined. Make sure that all horizontal shelves, window ledges and so on vanish consistently to this point.

1 Dip your pen in black and yellow waterproof inks to make a greenish gray and lightly sketch the main lines, ignoring any decorative details such as the yucca plant in the foreground. Use light dots, rather than solid, unbroken lines, as this allows you to see indicate where things are without committing yourself irrevocably.

2 Once the overall structure is right, you can begin to put in more details, using slightly less watery ink. Also put in some color as a guide to where the washes will go later—vermilion ink for the sofa edge and the red books above the door and green for the box on the desk. Some areas are so dark that they contain virtually no color; mark them with dots, ticks, or (as here) small crosses to help you identify the tones of the washes later.

3 Now draw the plants in the foreground. Rather than trying to draw each leaf explicitly, try to convey the feeling that all the leaves splay outward from a central stem. I used green ink for the yucca, and a watered-down version containing a little yellow for the lighter, more feathery-looking spider plant on the right, as drawing with colors that approximate to the real color of the object makes it easier to identify the different elements of the scene.

4 Begin to add the things that lie behind the plants, such as the bookshelves (drawn with undiluted black ink) and the pink-colored cushion on the sofa (drawn in a mixture of vermilion and yellow ink). See if any blocks of color, such as two or three red books together, stand out: half close your eyes as you do this, as this makes it easier to see the patterns. Reinforce the roof structure, using sepia ink for the beams and black for the steel tie bars.

5 Using the same colors as before, continue to reinforce the roof structure and the patterns of color across the scene. Whenever you have one color on the pen, look to see where else you can use it: here, for example, I used ultramarine blue for the sofa cushion and the castellated pattern around the edge of the rug, and then added black for some of the darker-colored books. Similarly, I used vermilion for the red areas of the rug, dulling the color in shaded areas by adding sepia.

6 Mix a watery mid-tone from Raw Sienna, Raw Umber, and Lamp Black watercolor paints. Working carefully around the windows, which are the brightest highlights, apply this wash over the ceiling beams. The wash is very pale: its purpose is simply to unify the painting. Leave to dry. Mix Raw Sienna, Cadmium Orange, and a little Gamboge watercolor paints, and paint the bookshelves on the left and the back of the wing chair in the foreground. Leave to dry.

7 Change to a medium round brush. Mix a pale green from Viridian and Cerulean Blue watercolor paints and paint all the yucca leaves. Add Cadmium Yellow and paint the lighter-colored leaves on the right-hand side. Leave to dry. Mix a dark brown from Sepia and Ultramarine Blue watercolor paints and paint the sides of the desk, the back of the chair at the desk, and any other dark areas.

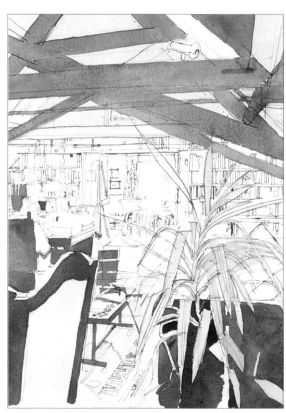

8 Mix a rich brown from Sepia and Raw Sienna watercolor paints and brush it onto the cross-beams, adding more Raw Sienna toward the right-hand side where the color is warmer. While the paint is still wet, add a little black to the mixture and drop it onto the cross-beams in places to imitate knots in the wood. Mix Sepia, Raw Sienna, and Ultramarine Blue watercolor paints and carefully paint the dark tone behind the yucca leaves and the side and back of the wing chair in the foreground.

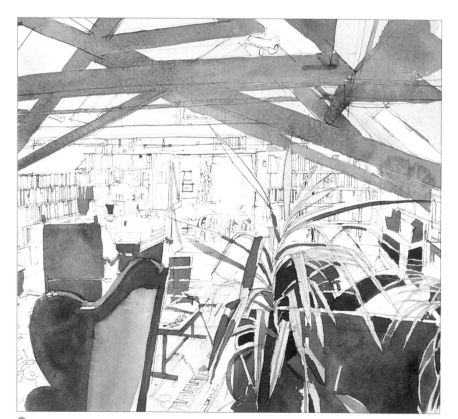

9 Using a strong Ultramarine Blue watercolor paint, paint the cushions on the sofa, carefully painting around the fronds of the yucca. Mix Ultramarine Blue, Viridian, and Sepia watercolor paints to make a rich, dark green, and use this mixture for the darkest green yucca leaves and some of the dark areas behind them. Paint the back of the wing chair using a mixture of Raw Sienna, Vermilion, and Ultramarine Blue.

Taking Stock

At this stage, you need to continually assess the tonal values in order to achieve that all-important sense of light and shade. Begin building up contrasts of tone across the whole picture.

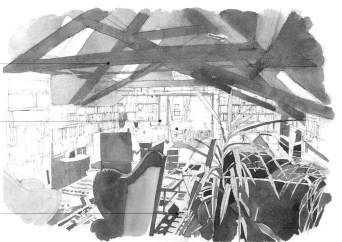

Darken the beams with Ultramarine Blue, so that the light coming in through the skylight looks really bright by comparison.

Strengthen the colors of the bookshelves by brushing on Cadmium Orange.

The rug here is in shade, so the colors need to be duller than those on the other side of the chair. Add a little Ultramarine Blue to the red to achieve this.

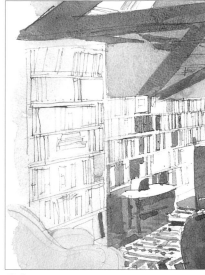

10 Wash a very pale, watery mixture of Ultramarine Blue and Raw Umber over the left-hand side of the painting so that the whole area appears to be in shadow. Use a less dilute version of the same mixture for the blocks of dark color marked with crosses in Step 2. Continue building up the kaleidoscopic pattern of colors on the book spines and rug, taking care not to touch any paint that is wet. Paint the lampshade in a pure, bright yellow so that it stands out clearly.

11 By now the tones should be getting close to their true density. Brush a mixture of Ultramarine Blue and Raw Sienna over the darkest beams, adding black for the steel tie bar. Darken the shadows where necessary with a mixture of Ultramarine Blue and Raw Umber. Knock back very bright highlight areas, such as the top of the sofa, with Sepia.

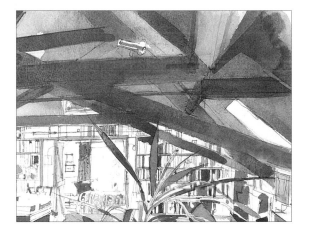

12 Continue adding colors to the book spines. You don't need to paint every single book; try to convey the general feel and color distribution. Intensify the colors where necessary: here, I added Cadmium Orange to the bookcases and darkened the leaves and shadows of the plants with Viridian. I also painted knots in the ceiling beams with a dark mixture of Sepia, Raw Umber, and Ultramarine Blue (see far right).

13 Finally, use the dip pen and a mixture of sepia and black ink to give the ceiling beams some detailing and texture and define the edges of the beams.

Head-and-shoulders portrait

Probably the subject for which there is the greatest need of carefully judged drawing is the human head and face. One way to be sure of this is to make a detailed preliminary drawing in pencil.

SEE ALSO

• Seeing in tone, page 34

134

MAKING PICTURES IN WATERCOLOR

Materials
B or HB pencil
90-lb (185-gsm) rough
 watercolor paper,
 pre-stretched
Watercolor paints:
 Cadmium Orange, Raw
 Sienna, Cadmium
 Yellow, Cobalt Blue,
 Lamp Black, Lemon
 Yellow, Burnt Sienna,
 Burnt Umber, Vermilion,
 Carmine, Ultramarine
 Blue or Violet,
 Gamboge, Raw Umber
Brushes: medium wash,
 medium Chinese, small
 Chinese

Catching a likeness requires accurate placing of the facial features. The shape of each individual feature should be right, too, but unless they are all placed in the proper relationship to each other, the likeness will never be really convincing. So look at the shapes between the facial features and try to sense the bony skull beneath.

Be conscious of the angle of the front of the face and how the nose protrudes from it. Pay particular attention to the ear position—how far it is from the near eye and how much of the head there is behind it. There is almost always more head relative to the face than you initially think. It is important to identify the cheek bones, the angled bones beneath the eyes, as they define the main change from the side to the front of the face. Watch the

space between the eyes and try to judge the shape of the inverted triangle that can be drawn to join the centers of the eyes to the center of the mouth: I find this a good way to define the overall shape of a face.

Traditionally, most portraits are of the head and shoulders. The primary interest is always the head and face; the head looks strange entirely on its own, without the neck and some suggestion of the shoulders supporting the neck.

The three-quarter view is also common. I generally prefer it to the profile or full face because it gives more information about the person than the profile alone—and, by seeing some of the side planes, you have more chance to say something about the structure of the head and the shape of the nose.

1 First, make a careful drawing of your subject on stretched paper. You can use any method—squaring up, tracing a photograph, or even direct observation—so long as you position the features accurately.

2 Mix a very pale wash of Cadmium Orange and, using a medium wash brush, apply it over the whole facial area, leaving the obvious highlights on the cheek and the tip of the nose untouched, as well as the mouth.

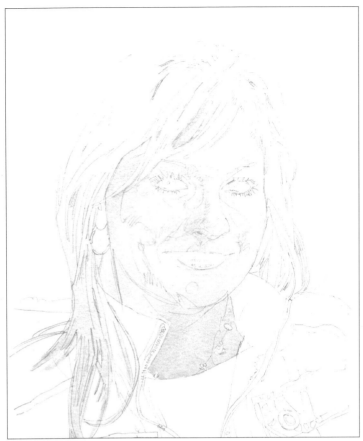

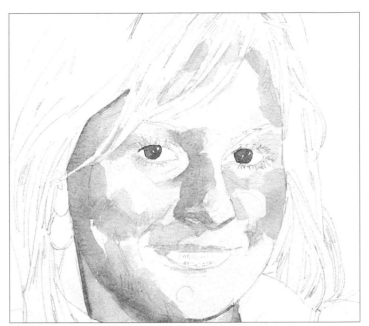

3 Mix a very pale brown wash from Raw Sienna and Cadmium Yellow and, using a medium wash brush, apply it over the hair. This wash will represent the lightest tone of the hair.

4 Mix Cobalt Blue with a little Lamp Black and paint the irises, adding a spot of Lemon Yellow in the center while it is still slightly wet and leaving the highlights white. While the eyes are drying, add more tone to the face, using various mixtures of Burnt Sienna and Cadmium Orange. Try to work out where the main changes of plane occur on the face and neck. At this stage the nose needs to be shown to rise from the plane of the face at the correct angle. Look for the tonal area edges at the side of the nose and also under it. Tones on noses are generally fairly warm.

5 The order in which you work is not critical, but work in a way that minimizes the risk of you putting your hand in a wet wash or letting one wash run into another. Mix a pale gray from Cobalt Blue with a hint of Lamp Black and apply it to the eyelids. Put in the pupil with a fine-tipped brush, leaving the highlight white. Add some shadows under the hair, using washes mixed from varying amounts of Burnt Umber and Raw Sienna. Paint the lips in a mixture of Vermilion and Carmine.

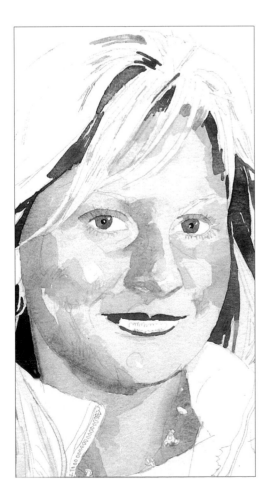

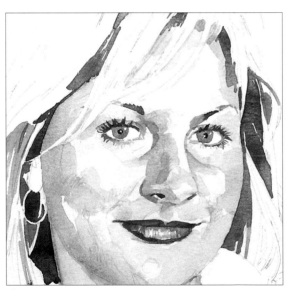

6 Using the same skin colors as before, build up tone on the shaded side of the nose and around the eye socket. Note how the portrait is now beginning to look much more three-dimensional. Using a fine-tipped round brush, paint the eyelashes in with a diluted Lamp Black and the eyebrows with Burnt Sienna reinforced with a little Black. Secondary tones of pinky red (pale Vermilion mixed with Carmine, the latter dominating) begin to solidify the lower lip.

7 Continue the modeling on the cheeks, forehead, and nose, using warm tones of Vermilion and Raw Sienna on the cheeks but adding small amounts of Cobalt Blue for the cooler tones around her jaw. The girl's coloring is generally warm (tanned), but the shadows are a little cooler. Mix a mid-toned wash of Cobalt Blue and, using a medium round brush, apply the first wash to the jacket. Leave to dry. The purplish hue on the inside of her collar can be mixed with either Violet plus Black or Ultramarine with a little Black and Carmine.

8 Paint the T-shirt in a flat wash of Lamp Black and apply a second layer of Ultramarine Blue to the shaded areas and creases in the jacket so that you begin to get some idea of how the fabric folds over the body. Apply the first bright mixes of Carmine, Vermilion and Gamboge to the background.

9 Put in the intermediate tones on the hair using a variety of mixes of Raw Sienna, Raw Umber, and Burnt Sienna. Note how the original pale wash of Raw Sienna and Cadmium Yellow now comes into its own as the highlights.

10 Complete the background colors. The lighter colors on the right side are slightly thrown into shadow by an overwash of Lamp Black and Raw Umber, thereby holding the lighter edge of her hair.

11 The painting is nearing completion. Put in the detailing on the jacket using a fine-tipped brush and Ultramarine Blue, carefully painting around and behind the strands of hair that hang over the girl's shoulders. Little spots of Cobalt Blue and Lamp Black mixes leaving white highlights are enough to render the necklace.

12 Now apply the darkest shadows to the face and neck, using the same skin colors as before. Have the courage to place these areas boldly. If the change is too sudden, use a bridging in-between tone when they are dry; this will look more punchy than a soft gradation. A few finishing touches completed the painting: I gave the irises slightly darker edges, toned down the highlight on the left cheek a little, and gave more definition to the extreme edge of her jaw. Take care not to let accents such as this become too dark and dead looking: I used virtually pure Burnt Sienna for this jaw line.

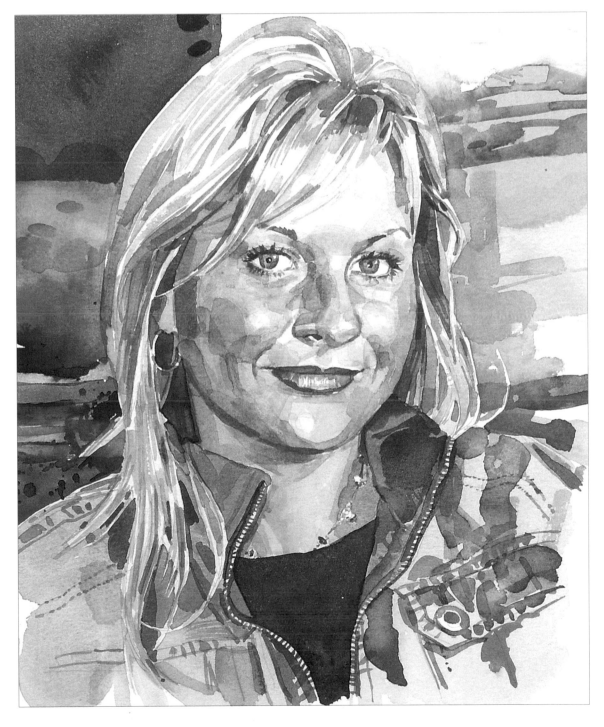

Group portrait

This project is about making a sketch portrait. It happens to be of a group of two people, but the same principles apply to a single figure or a larger group. It is also a more spontaneous, less controlled, approach to making a picture.

SEE ALSO

• Seeing in tone, page 34

• Using tone to create a 3-D effect, page 36

• Balance, page 50

I should say at this point that this project and the one before it represent the tip of the iceberg as far as portraiture is concerned. One would need an entire book to do the subject justice. Moreover, watercolor is not the most common method used for formal portraiture—oil paint is the more favored medium, especially for large-scale works. For taking advantage of a fortuitous subject such as these two young people relaxing on a sofa, pencil and watercolor is ideal, however—and the fact that they are paying such close attention to the television renders them relatively immobile is an added bonus.

Of course, you still need to think about composition and in this case that mostly involves deciding how much of the figures to include. Too much, drawing down to include the lower legs and feet, would place the heads rather too much to the extreme right; but you need to include more than just the heads to express the relaxation of their poses. Choosing to draw some of the background, but not all, gives you the chance to manipulate the composition so that the heads remain the center of interest.

As to the method, although it may seem here that drawing and color application follow each other in an apparently random sequence, it is really a matter of drawing lines and applying washes as and when you feel the need.

Materials

90-lb (185-gsm) rough watercolor paper, pre-stretched

2B pencil

Watercolor paints: Cadmium Red, Raw Sienna, Lamp Black, Burnt Sienna, Phthalo Green, Cadmium Orange, Raw Umber, Ultramarine Blue, Phthalo Blue

Brushes: large round, medium round

1 The most important lines to establish early were the two profiles, followed by quite loose sugestions of their head shapes and shoulders. If you feel confident, use a 2B pencil as I have; if not, choose a harder grade—an HB, perhaps, which does not require such a delicate touch. Some pale washes were put in at this stage—mixes of Cadmium Red and Raw Sienna for the first indications of facial shadows, Raw Sienna for the girl's hair, and Raw Sienna plus a little Lamp Black for the boy's head.

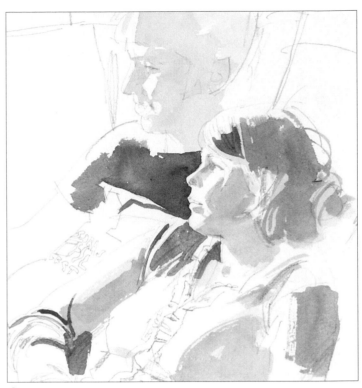

2 I then returned to the pencil drawing to establish the positions of the torsos and arms and some details of the girl's collar and the lettering on the boy's T-shirt. Some lines to suggest the back of the settee were also put in.

3 Once you're happy with the general arrangement, put in the first black wash on the boy's T-shirt to define the line of the girl's profile. I then put in the main shapes of her hair with mixtures of Raw Sienna and Lamp Black and a little Burnt Sienna. I used various olivey greens, made from mixtures of Phthalo Green, Cadmium Orange, and Lamp Black, to further define the form of her arms and torso.

4 I then turned my attention to the male head and used Raw and Burnt Sienna mixtures for the shadows around the eye, nose and mouth with small additions of Cadmium Red for the mouth and the cheeks. Adding some Raw Umber to the mix produced a slightly cooler tone where needed—on the neck, for instance.

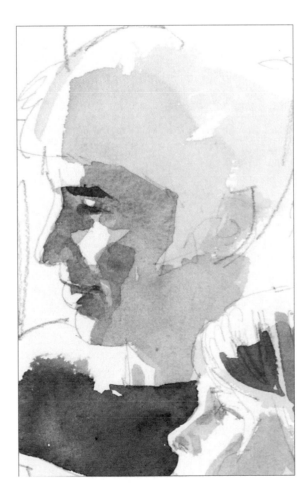

5 I used more Lamp Black with a spot of Ultramarine on the boy's T-shirt, which helps to define the shape of his chin. I mixed Raw Umber and Lamp Black to represent the lightest tone of his nearly black hair. I also painted the arm of the settee in Burnt Sienna, taking care not to allow it to dominate the image so as to concentrate attention on the two figures.

6 Following the principle I mentioned in the introduction of letting line and tone progress together, I began to draw the girl's hand, more details on the decorative fastening to her top, and some indication of the boy's left arm.

7 The subtle olive green of the girl's top was a mix of Phthalo Green and Cadmium Orange laid down with a slightly larger brush. When this was dry I put in the shadow areas, using a stronger mixture of the same colors to which I had added a little black. Note how the brush strokes in the angle of her sleeve describe the folds and define the form. I then decided to extend color to include their jean-clad thighs, which received a broad wash of Phthalo Blue.

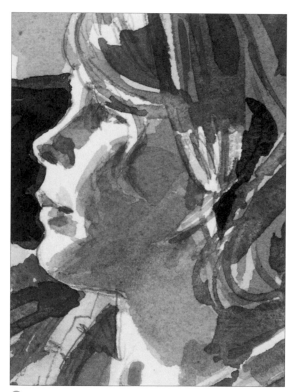

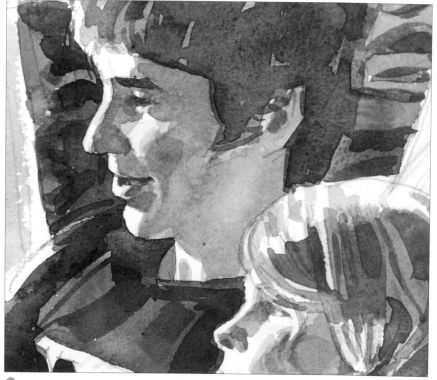

8 With the same medium brush (there is really hardly any need to use more than one brush, provided it combines good wash-carrying capacity with a reasonably fine point), I painted the shaded area of the girl's face, using various mixtures of Cadmium Orange, Cadmium Red, and Raw Sienna.

9 Using colors similar to the ones on the girl's face, but with a little more red to warm them slightly, I completed the shadow areas on the boy's face. The dark blue and red pillow behind his head served to define his profile, which had therefore to be painted very carefully as no correction is possible without resorting to body color. I painted the boy's hair with a mixture of Lamp Black and a little Ultramarine Blue. I paused at this stage to consider whether the picture, as a watercolor sketch, had gone as far as it needed to.

10 A couple more stages would, I thought, be worthwhile. I added the shadow tones to the jeans with a mixture of Phthalo Blue and Lamp Black. A few free strokes of Burnt Sienna and Lamp Black on the settee arm gave the sketch some context.

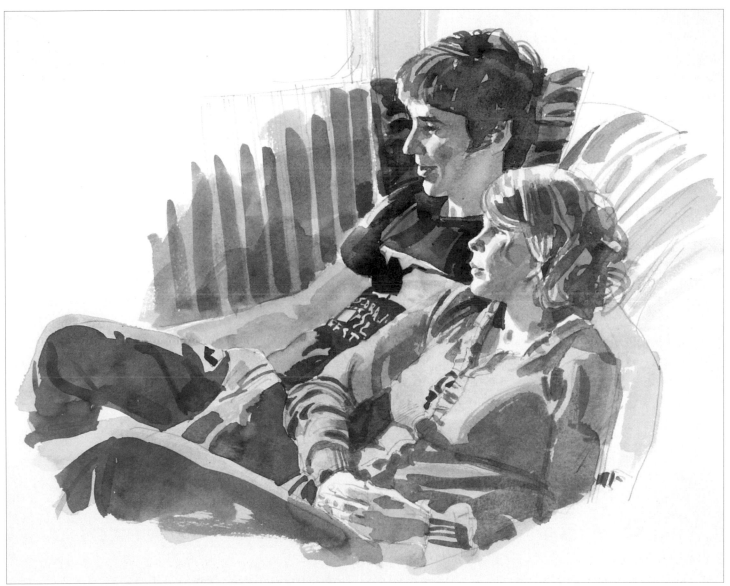

11 To complete the painting I drew and washed in the boy's left arm (around her shoulders) and indicated the back of the settee to give the figures some credible support. A dash of pale Raw Sienna by the boy's head hints at other elements in the surroundings and a very pale dash of Phthalo Blue modifies the glaring white of the design on his T-shirt.

Interpreting the scene

In some ways, I maintain it is actually harder to make an interesting painting from a photograph than to observe and interpret the real thing. You really need to be able to paint without photographs before you can use them as a useful reference source without slavishly copying.

SEE ALSO

• Modern cityscape,
 page 126

As soon as photography was invented, artists made use of it. Some subjects are virtually impossible to render without it. For example, unless you possess phenomenal photographic vision and memory, fast-moving objects cannot be seen, let alone captured, without the assistance of a camera. Complex subjects viewed in conditions that do not allow for long study are made possible by a photograph or two to supplement your memory and any sketches you are able to make.

The point about being able to do without photographs is that observing directly obliges you to select and interpret: if you can do this, then with a photograph in front of you, you know what and how to select what is important and significant to you.

The trick is to train yourself to observe your photos very carefully and decide how you want to interpret the scene, without worrying too much about the degree to which your painting resembles the reference – it's what you do with the photograph that counts.

I was intrigued by the converging perspective of all the masts in this shed and the way that they point out to the sunlit scene. The first photograph I took gave me the information I needed about the brightly lit exterior.

I exposed this second photograph to give me more information about the interior of the mast shed.

FIGURE SKETCHES

I needed someone working on a similar level to the propped masts. This figure was front lit, but to put him into a back-lit situation I simply made him tonally darker overall.

The point of this demonstration is to show you how I went about interpreting one particular scene; I therefore haven't been too precise about how each stage was done or what materials I used, but rather have tried to explain my thought processes so that you can try out similar approaches with your own reference photos. The whole point about painting from photos is to interpret and decide what mood you want to create, rather than slavishly to follow your reference material.

COMPOSITION 1 (BELOW)

The finished and unfinished masts and the long timbers, all converging to the same point, created compelling compositions. I began with a compositional sketch looking into the mast shed, but it lacked background interest

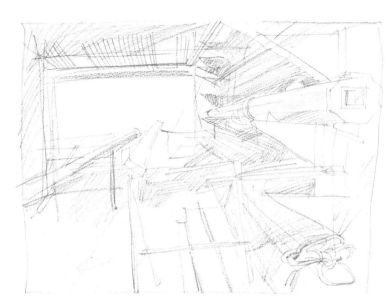

COMPOSITION 2

This sketch composition, made with water-soluble crayons, looks out from the mast shed, a newly varnished mast dominating the foreground. I added a figure from my sketchbook for further middle-ground interest.

1 Referring to the first reference photo, I began drawing the view that you can see through the open door of the mast shed. The acrylic board is very rough so marks always look two or three grades softer on it than they really are, so I elected to use a 6H pencil in order to get reasonably sharp marks. The photo has been exposed to take the view through the open door, so pretty much everything within the mast shed is underexposed and relatively little detail is visible.

2 Next I moved on to putting down the underdrawing for the interior of the shed—such as the tools and the lines of the timber. Here I used a photo that was exposed to pick up detail in the shadows, hence the view through the door is overexposed and bleached out. To add interest to the composition I put in the figure of the man working on the mast. When you import a feature from another location, remember to keep the lighting consistent: here the figure had to be rendered dark against light, although the drawing was made from a front-lit figure.

3 I used a mid-toned wash of Cerulean Blue (slightly more intense than in the photo) for the sky and a very pale mixture of Raw Sienna and Gamboge for the sunlit ground. It was important to keep this area very light, as I felt that the contrast between the dark interior and the bright scene outside was the key to the whole painting. I also began to introduce some color into the interior, using various mixtures of Cobalt and Phthalo Blue where the varnished wood reflected the sky from outside the shed and dropping in Raw Sienna occasionally for the timber in the shadowed area of the shed.

4 Still working on the view through the doorway, I established the foliage colors with greens mixed from Lemon Yellow with a tiny amount of Phthalo Blue. Once I was sure that the colors laid down in Step 3 were completely dry, I put in some of the darks around the doorway, using a strong mixture of Ultramarine Blue and Raw Umber with Raw Sienna dropped in, wet into wet, to make the tones more interesting. Unless you want colors to run together, you need to be careful when applying washes to the edges of previous ones on a prepared acrylic ground. Even if the first wash is dry, it may still run if a new wet wash impinges upon it.

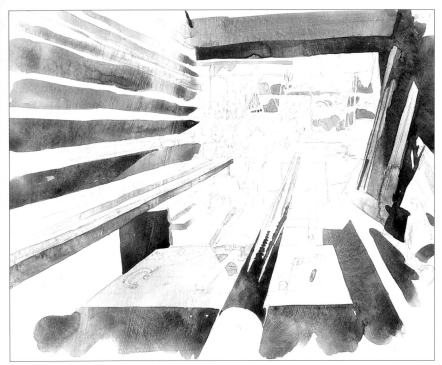

5 The central mast, newly varnished, was a vital element in the composition, its far end reflecting the blue of the sky and the near end the dark shed interior. Having delineated these reflections quite sharply, I started working on some of the darker areas within the shed, using various blue-grays mixed from Ultramarine Blue with additions of Lamp Black and Raw Umber. Don't follow your photo slavishly: adjust the colors in your palette by varying the proportions of the pigments in your mixes, making them warmer or cooler as appropriate depending on how you want to interpret the scene. The left-hand wall, for example, is noticeably warmer, so I added some Burnt Sienna to the washes.

6 I continued working around the interior of the mast shed, looking for the patterns of light and shade. The exact colors in a very contrasty scene like this aren't critical; the aim is to attain a good balance between light and dark areas. I used various mixtures of the wood colors used in earlier stages, with some Burnt Sienna, trusting my intuition and trying to build up a convincing pattern of colors rather than to match the photo exactly.

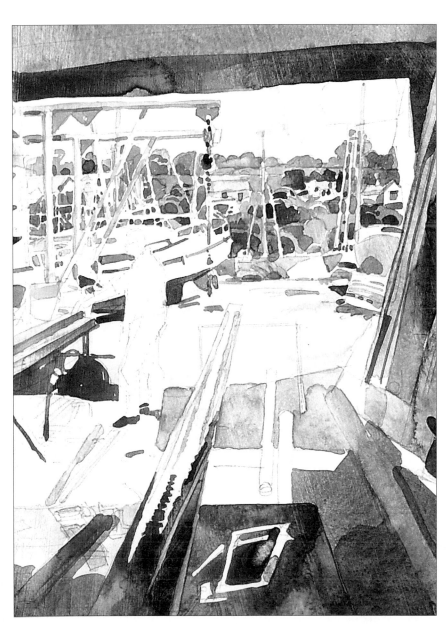

7 I did more work on the sunlit scene through the doorway. It would be easy to put in too much detail, as the reference photo of this area is relatively clear, but as I wanted to retain the impression of dazzling sunlight in contrast to the dark interior of the shed I made a conscious effort to simplify the scene, reducing the number of tonal changes and slightly intensifying the color changes.

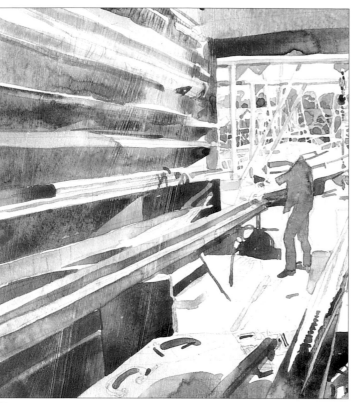

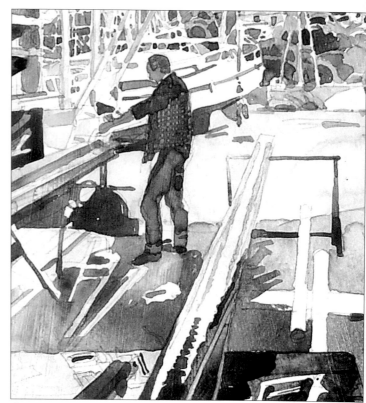

8 I then painted the figure, using Phthalo Blue for both his jacket and jeans. While the figure was drying, I added more detail to the masts on the racks on the wall, using the previous Ultramarine Blue and Raw Umber mixtures to indicate where the sky was reflected in the varnish. I also put in some dark stripes of Lamp Black for the deeply shaded spaces between the rows of masts and used a mixture of blue and black for the frame around the doorway.

9 Using a mixture of Ultramarine Blue and Lamp Black, I put in the plaid pattern of the man's jacket and some of the folds in the fabric of his jeans. The painting was now nearing its final stages, and I put in the floor in the foreground, using the same dark wood colors as before. This dark area on either side of the central mast helps to lead the eye along the mast to the bright sunlit scene outside. By this stage, I was looking for the subtle details that help to hold the scene together, such as the trestle supporting the central mast.

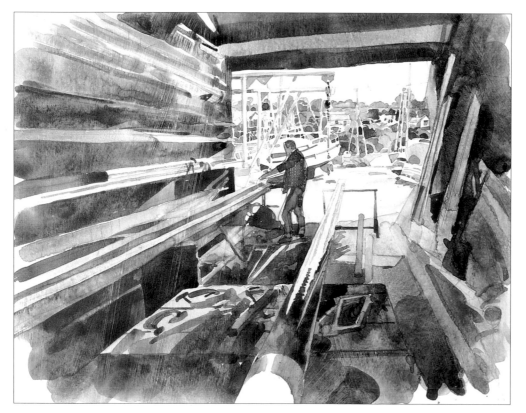

10 Using various blue and brown mixtures, I intensified the colors and covered up any exposed white in the interior. Throughout the painting, I have been interpreting the scene and looking for patterns and shapes rather than copying my photographs precisely. I wanted to keep the scene free and loose and so, using loose brushstrokes, I sketched out rough various shapes on the table to suggest the tools and other paraphernalia.

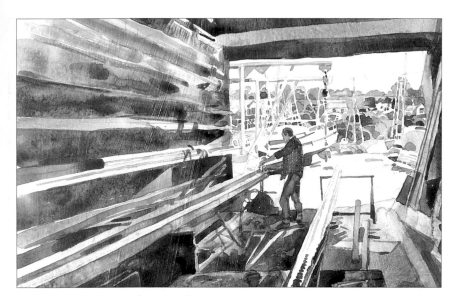

11 I felt that some areas (on the left of the shed, in particular) were too light in relation to the rest, so I applied a thin wash of Cobalt mixed with Lamp Black to tone them down a little. In any painting, but particularly one that relies so heavily on the contrast between light and dark, it's essential to assess the tonal values continually as you work. I used the same mixture to add a few dark accents, again keeping the brushstrokes loose and putting in what I felt was necessary to the composition rather than copying every detail of the photographs.

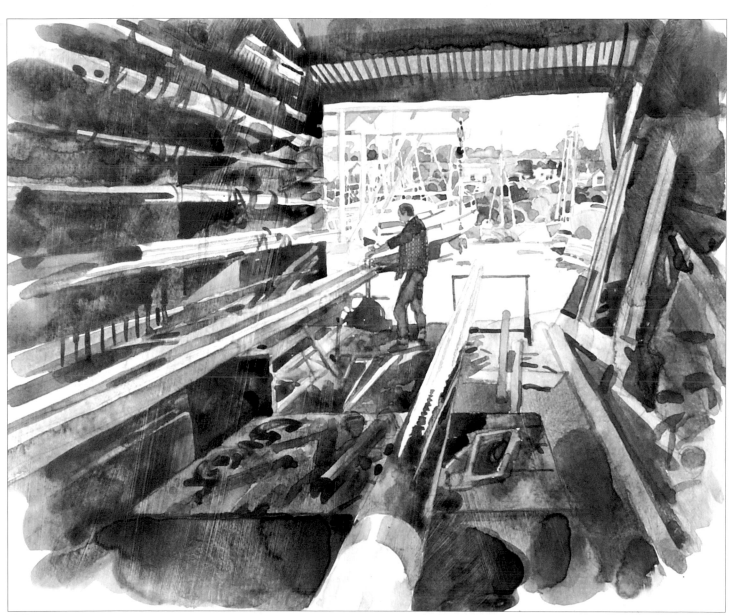

12 For the finishing stages, I mixed a strong dark from Ultramarine Blue, Raw Umber, and Lamp Black and darkened the frame of the doorway. It is the strength of the contrast between dark and light that makes the sunlit areas look really bright. I used the same mixture to darken the shaded areas of the racks.

Alternative methods

SEE ALSO

• Types of mask, page 56

MAKING PICTURES IN WATERCOLOR

For the most part I have concentrated in this book on traditional techniques, using brushes to lay and overlay transparent washes. While I believe that this method maximizes the intrinsic beauty of watercolor, there are ways of using the medium more experimentally.

CONTROLLED SPATTERING
Controlled spattering can be achieved by holding a brush that is fully loaded with paint in one hand and tapping it with the forefinger of the other.

RANDOM SPATTERING
Rather less controlled spattering results from tapping the loaded brush against the other hand.

TEXTURE FROM CRUMPLED PAPER
Crumpled paper dipped in a wash and repeatedly applied to the paper surface gives an interesting texture.

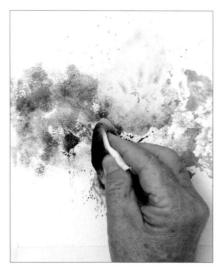

TEXTURE FROM FABRIC
A different print pattern can be applied by pressing fabric dipped in color onto the paper surface.

I hesitate to call these methods "tricks," and if you expect the painting to be resolved by wholesale application of alternative methods alone, you will be disappointed. Some of these methods are described on pages 56–7 and others have been introduced in perhaps one stage of later projects. On these two pages, you can see an abstract-style image that has been built up using these "alternative" methods.

Transparent washes may still be at the core of what are usually described as "mixed media" paintings, but body color, inks, crayons and so on can be introduced as you feel the subject demands.

Textures that cannot easily be resolved into general shapes and tones may be better expressed by spattering color: to confine this, masking will be necessary. This can be achieved with tape, torn paper, your own hand, anything you like. Masking fluid can be applied in a variety of ways, including spattering.

You may like to stick paper shapes on the painting surface (collage), either pre-colored or to be modified when they are in place.

You can scratch into dry paint, using the tip of a scalpel, craft knife, or other sharp implement to lift off fine lines and points of color—useful for creating small highlights, such as sunlight sparkling on water. Working on a "gesso" ground (see page 19) will allow you to scratch and scrape more robustly.

Use these alternative methods only when they seem appropriate to the subject or mood that you want to create. Don't be tempted to try things out just for the sake of it: it is the painting that is the important thing, not the methods you use to produce it.

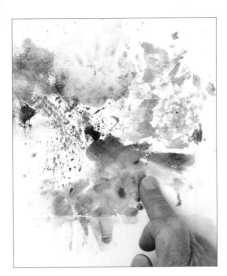

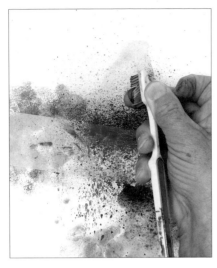

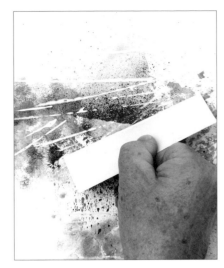

FINGERPRINTING
Color applied with a finger gives a mixture of splotches and fingerprints.

FINE SPATTER
A finer textured spatter of watercolor can be applied by pulling a finger over the bristles of an old toothbrush loaded with color. The receiving area can be masked with low-tack masking tape.

MASKING STRAIGHT LINES
Applying masking fluid with the edge of a piece of card gives straight. loosely defined lines.

MASKING DOTS
A toothbrush dipped in masking fluid will mask a pattern of dots...and stuck onto the surface.

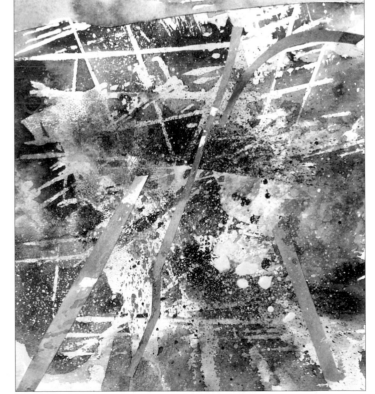

COLLAGE
Strips of paper cut from a sheet on which various washes have been freely applied can be brushed with gum arabic

THE FINAL RESULT

Woodland collage

SEE ALSO

• Types of mask, page 56

• Textures and additives, page 60

• Alternative methods, page 148

Having rehearsed some of the less standard ways of applying watercolor, it is now time to put them to practical use in making a picture.

This scene, with sunlight filtering through the relatively bare springtime branches and casting a network of shadows on the ground, was a challenge. The shadows, combined with the complexities of grass, mosses, plants, and twig debris, contributed to a very particular series of small patterns that were difficult to render by normal wash applications. Similar networks occurred in the entanglement of tree branches pierced by slabs and pinpoints

of light from the blue sky behind them. It all called out for some sort of pointillist treatment: spraying and spattering seemed to be ideal.

To maximize the possibilities of fairly harsh treatment—applying masking tape, scraping, and so on— I chose a heavy paper and applied a generous coat of acrylic gesso, allowing it to dry hard before I began painting.

ATMOSPHERIC TEXTURES

Woodland that includes quite large trees, as well as small saplings and undergrowth, provides a great opportunity for exploring varied textures.

Materials

300lb (640-gsm) rough
 watercolor paper
 primed with acrylic
 gesso
HB pencil
Watercolor paints:
 Cobalt Blue, Cerulean
 Blue, Ultramarine Blue,
 Raw Umber, Phthalo
 Green, Gamboge,
 Lamp Plack
Gouache paints: Brilliant
 Yellow, Winsor Green,
 Permanent White, Jet
 Black, Raw Sienna,
 Indigo
Brushes: medium round,
 medium Chinese
Bamboo pen
Masking fluid
Old toothbrush
Thin paper
Gum arabic

1 Using an HB pencil, sketch the scene. This particular woodland landscape is predominantly brown and green and the little patches of blue between the trees provide the only relief. To make it easier for yourself to keep track of where the blue is, mark these areas with a letter "B" or a tick while you make the pencil underdrawing. You can also loosely shade in any areas that you know are going to be very dark as they'll be covered over later.

2 Mix a sky color from Cobalt Blue and Cerulean Blue. Using a medium round brush, loosely put in the patches of sky that are visible through the trees. Mix a grassy green from Phthalo Green and Gamboge and put in the greens on the ground and at the bases of the trees. Mix a general ground color from Raw Sienna with a touch of Raw Umber. Loosely brush this over the foreground and leave it to dry.

3 Using a bamboo pen, mask out the long grasses on the ground and some of the thinner branches, which are lighter than their surroundings. Using an old toothbrush, spatter masking fluid over the foreground, pulling the bristles back with your fingers. Be bold: if some fluid falls in places where you don't want it, you can rub it off once it is dry. Using an old brush, mask the blue sky and leave the masking fluid to dry.

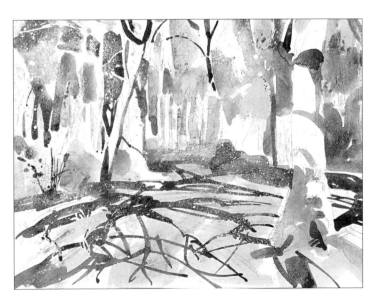

4 Mix a rich, brownish black from Ultramarine Blue and Raw Umber. Using a medium round or Chinese brush, paint the shadows under the trees with broad, calligraphic strokes. Leave to dry. Use the same color to paint the shadowed side of the trees. Working very loosely, put in some general colors in the foliage, using Phthalo Green mixed with Gamboge and Phthalo green on its own. Leave to dry. Remove all the masking fluid that is not protecting the blue sky areas.

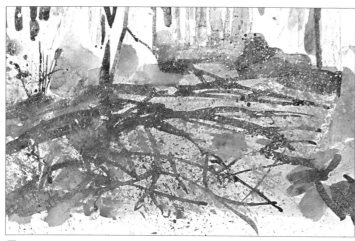

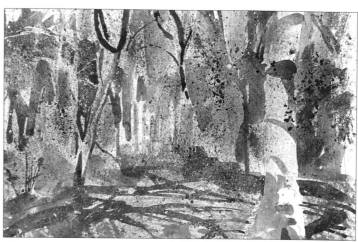

5 Mix a pale brown from Raw Sienna, White, and Black gouache paints and spatter it over the foregound, protecting the upper part of the painting with a sheet of newspaper. The aim is to cover the foreground area with something that aproximates to the right tone, but still gives an indication of the pebbly texture. Blot the spatters with paper to spread them a little. Mix White and Winsor Green gouache, and Indigo and Black gouache, and spatter these mixes over the foreground.

6 Cover the bottom half of the painting with newspaper and mask out the lighter trunks. Spatter a mix of Winsor Green and Black gouache over the trees to begin indicating the foliage. Spatter Yellow, too, and Yellow mixed with Blue. It takes a long time to build up the spatters to the density you want. Use greener and bluer mixes on the upper half of the painting. Make larger spatters by tapping a fully loaded paintbrush over the paper.

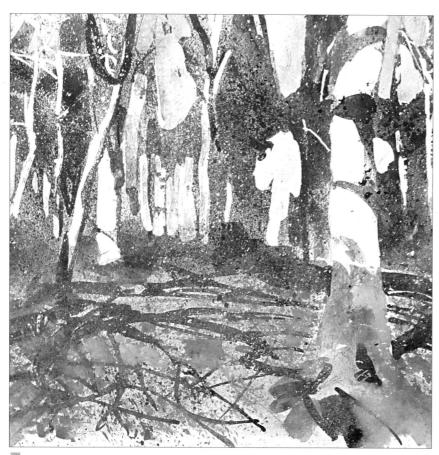

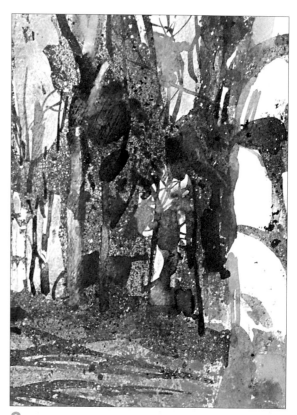

7 Mix a very pale orangey brown from Permanent White and Raw Sienna gouache paints and brush it over the lighter parts of the foreground, using broad strokes in some areas and little dots and dashes in others. Put in some strokes of Viridian watercolor in the upper part of the trees: note the contrast in texture between the watercolor and the gouache. Leave to dry. The spatter is lively and unpredictable, but the whole point of this painting is to create an impression of textures and light and shade, rather than a photorealistic rendition. Rub off the masking fluid over the tree trunks and sky.

8 Now begin to give the trees some substance and form. Mix a yellowy green from Viridian plus Gamboge, a darker one from Viridian and Lamp Black, and a purplish shadow color from Indigo and Ultramarine Blue. Brush the light green over the foliage areas at the top of the picture and scumble the darker green over the middle ground. Use the indigo mix to reinforce the shadows at the bases of the trees and a paler version of it for the shadows that fall across the tree trunks.

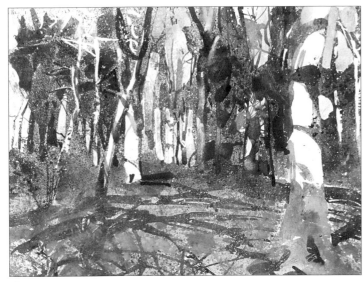

9 Mix a gray from Ultramarine Blue and Raw Umber and paint the darker trunks and the markings on the light trunks. Reinforce the cast shadows on the ground, using the same colors as before.

10 Step back and decide how much further you need to go. I intensified the sky with Cobalt Blue and added shadows to some of the lighter branches.

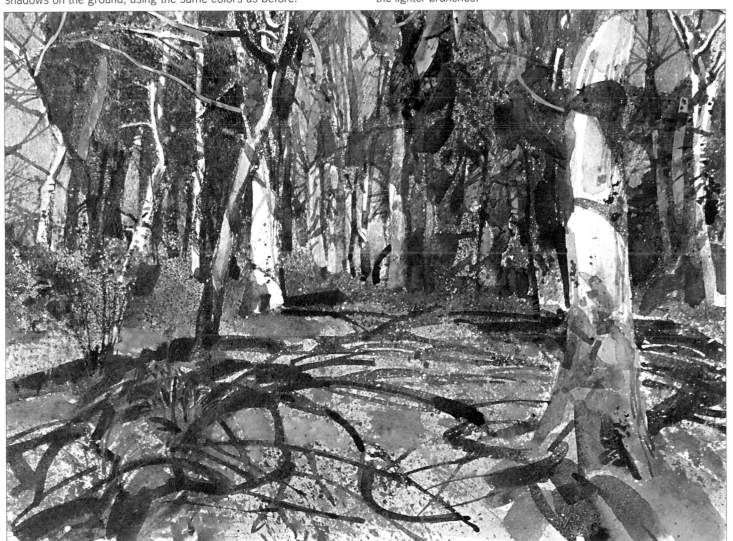

11 Inevitably, some details will disappear in the process of masking and spattering, and you may find you have lost interesting shapes that you would prefer to replace. Anticipating this, apply some varied color washes to a spare piece of fairly thin paper from which, when dry, you can cut some shapes to replace the lost ones. Although the lost shapes (generally lighter and generally branches) could be put in with gouache, there is a crispness about a cut shape that lends another element of decoration to the piece. You may find it difficult to see them in this painting; they do tend to disappear, but I can assure you that they are there!

This section is about making corrections—what to do if your brush slips and you accidentally paint over an area, how to repair an accident with a pen and waterproof ink, how to take one step back when you have gone to far.

The very quality that makes watercolor especially appealing—its transparency—is the one that makes mistakes difficult to repair. Watercolors progress from light to dark: to reverse the procedure and retrieve lighter tones and colors once they have been covered is not easy—unless you revert to using body color and forfeit transparency. However, it is possible to wash off color if you are careful. Blotting with a paper towel or a cloth will largely remove a wash if it is done immediately after it has been laid, before it has had a chance to dry. You can also try washing areas with a brush or even a cotton bud dipped clean water. The quicker you attempt either procedure after applying the wash, the better it will work—but take care not to damage the paper surface.

For small areas, you can try gently scraping off color with a scalpel or craft knife, in the same way that you would to scrape out white highlights; again, work

Overpatching

What if you spill black ink on a line-and-wash drawing? Small splashes can be scraped out with a sharp blade but the large splotch on the wall in the right of this image is too big to eradicate without trace. A surface patch could be the answer.

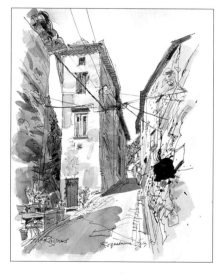

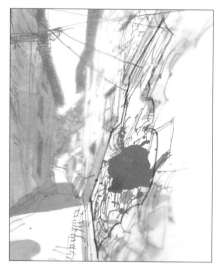

1 First trace an area for the patch, following some existing pen lines. The more the shape meanders, the more difficult will it be to spot the patch when it is in place.

2 Take a piece of similar surfaced but quite thin paper and cut out your traced shape. Turn it over and, using a sharp scalpel or craft knife, carefully pare down the edges until they are as thin as possible. (You could use fine sand paper as an alternative.)

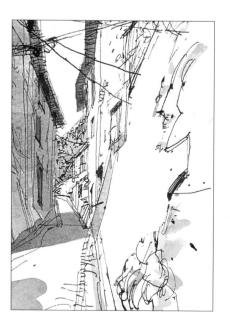

3 Stick the patch in place. I used a spray adhesive, but any secure adhesive will do. If you have pared the edges thinly enough, they will not catch the light and betray themselves.

carefully so that you do not cut into the surface of the paper, as this will be very evident even when you have painted over the offending area.

For radical changes, where you need to get rid of a larger area, it is better to resort to one of the following strategies. These involve one of two methods of patching (one inset and one laid over), painting out and washing out. These are all last-resort strategies, but when you've put a lot of work into creating a painting, it is very disheartening to abandon it totally; far better to make a rescue attempt and it can be surprisingly satisfying when you carry it out successfully and invisibly.

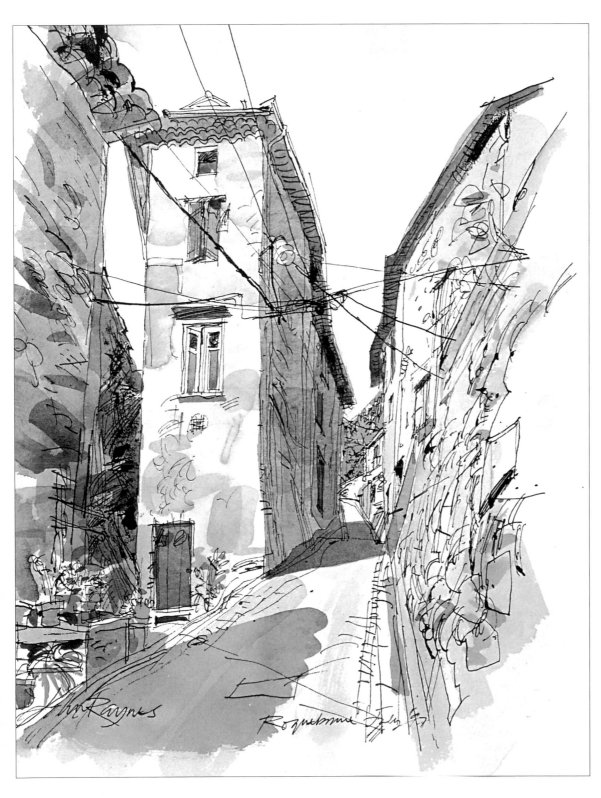

4 Now redraw with pen and ink and apply washes to match the surrounding picture, extending the existing drawing to include a splash or two. It is amazing how difficult it is to spot a patch of this sort.

Cutting out and overpatching

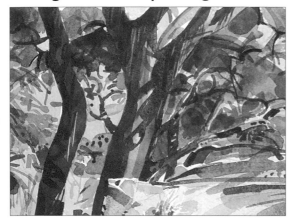

One of the bright background views through the branches here has been painted too dark, a situation in which washing out is not an option. Replacing the area with a new piece of paper will allow you to apply fresh color.

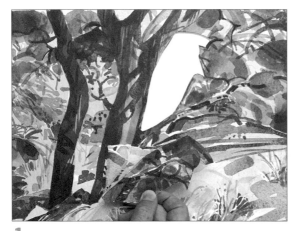

1 Tape another piece of the same paper on which you are working to the underside of the painting. Using a sharp blade, cut around the area you wish to replace, cutting through both layers. Remove the top layer, replace it with the pristine lower one, and tape it in place from beneath.

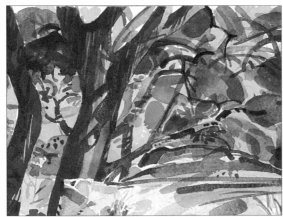

2 It only remains to paint the patch as you really wanted it to be. Because there is no edge to the patch, it will be virtually invisible.

Repainting the ground and washing out

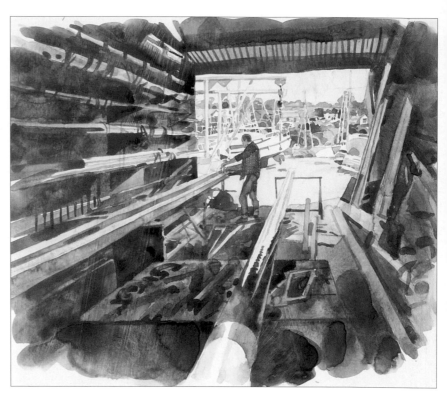

I was never entirely happy with the last stage of this painting on a prepared ground, and altering it serves to demonstrate how you can recover an earlier state if you go just a little too far.

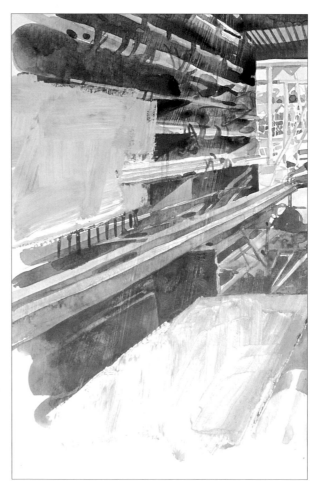

1 There are two ways to recover a white surface on a gesso ground. One way is to paint out areas that are to be repainted with a couple of coats of the original ground paint. This is the first one which is discolored by the washes beneath.

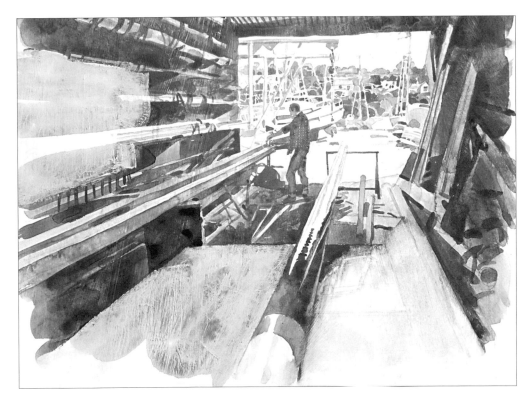

2 The second solution is to wash out the area to be repainted (right foreground). The color can be removed much more easily from a prepared non-absorbent ground and will tolerate harsher treatment than untreated paper. The areas on the left have received the first of the new washes.

3 This is the new, slightly lighter repaint. Note that the washed-out area has retained the brushstroke pattern of the original ground, while the painted out areas have new under-patterns. You must choose which is preferable: I tend to favor the former.

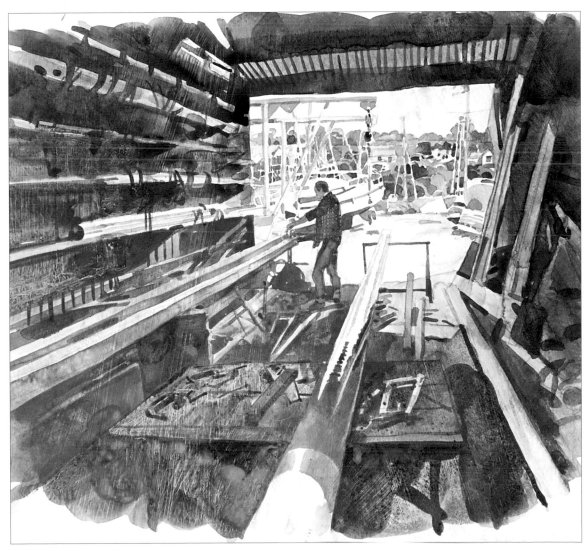

INDEX

ACKNOWLEDGMENTS

Painting on page 6: "Greta Bridge, Yorkshire"
1810 (watercolor on paper) by John Sell Cotman
(1782–1842).

Courtesy of Norfolk Museums Service (Norwich
Castle Museum) UK/Bridgeman Art Library.